THE FEMALE NUDE

THE FEMALE NUDE

Art, Obscenity and Sexuality

Lynda Nead

London and New York

First published 1992
by Routledge
11 New Fetter Lane, London EC4P 4EE

Simultaneously published in the USA and Canada
by Routledge
29 West 35th Street, New York, NY 10001

Reprinted in 1993, 1994

Typeset in 10/12pt Times by Florencetype Ltd, Kewstoke, Avon

Printed and bound in Great Britain by
Butler & Tanner Ltd, Frome and London

British Library Cataloguing in Publication Data

Nead, Lynda
Female Nude, The : Art, Obscenity and Sexuality
I. Title
704.9

Library of Congress Cataloging in Publication Data

Nead, Lynda.
The female nude: art, obscenity, and sexuality / Lynda Nead.
p. cm.
Includes bibliographical references and index.
1. Nude in art. 2. Women in art. 3. Sexuality in ar
I. Title.
N7573.N4 1992
704.9'424—dc 20 92-10516

ISBN 0-415-02677-6 — ISBN 0-415-02678-4 (pbk)

For Sam Connor

CONTENTS

PLATES

ix

16 Brassaï, *Matisse with his Model*, n.d. (Victoria and Albert Museum, London. Photograph by Brassaï. Copyright © 1992 Gilberte Brassaï.)

17 From F. Serra and J.M. Parramon, *Painting the Nude* (Kings Langley: Fountain Press, 1976): 91. (By permission of the British Library.)

18 'Posing the Model', from Patricia Monahan, *How to Draw and Paint the Nude*, The Macdonald Academy of Art (London and Sydney: Macdonald, 1986): 6–7. (By permission of the British Library.)

19 'Three Dimensional Anatomy: Male and Female', from Klaus Dunkelberg, *Drawing the Nude: The Body, Figures, Forms* (New York: Van Nostrand Reinhold Company, 1984): 20. (By permission of the British Library.)

20 Diagrammatic painting from Douglas Graves, *Figure Painting in Oil* (New York: Watson Guptill; London: Pitman, 1979): 69.

21 'Painting from Reference Sources', from Douglas Graves, *Figure Painting in Oil* (New York: Watson Guptill; London: Pitman, 1979): 150–1.

22 From Joseph Sheppard, *Drawing the Female Figure* (New York: Watson Guptill; London: Pitman, 1975): 25.

23 'The Foreshortened Figure', from Joseph Sheppard, *Drawing the Female Figure* (New York: Watson Guptill; London: Pitman, 1975): 124.

24 Virginia Woolf place-setting, from Judy Chicago, *The Dinner Party*, 1975–9. (Copyright © 1979 Judy Chicago. Photo credit: McNally.)

25 Judy Chicago, *Red Flag*, 1971. (Copyright © 1971 Judy Chicago.)

26 Carolee Schneemann, *Interior Scroll*, 1975. (Photo: Carolee Schneemann.)

27 Chila Kumari Burman, 'Body print', 1990. (Copyright © 1990 Chila Kumari Burman.)

28 Yves Klein, *Anthropométrie de l'époque bleue*, 1960. (Copyright © 1992 ADAGP, Paris, and DACS, London. Photo: Musée National d'Art Moderne, Centre Georges Pompidou, Paris.)

29 Yves Klein, 'Realisation d'une anthropométrie. Une femme pinceau', 1960.

30 Chila Kumari Burman, 'Reclaim Our Bodies. One Love One Art', detail of installation at the ICA exhibition, *The Thin Black Line*, 1985. (Copyright © 1985 Chila Kumari Burman.)

31 Lesley Sanderson, *Time for A Change*, 1989. (Photo: Lesley Sanderson.)

32–34 Mary Duffy, from *Cutting the Ties that Bind*, 1987. (Copyright © 1987 Mary Duffy.)

35 Mary Duffy, from *Stories of a Body*, 1990. (Copyright © 1990 Mary Duffy.)

36 Jo Spence (in collaboration with Tim Sheard), 'Included', from *Narratives of Dis-ease*. (Copyright © Jo Spence.)

37 Jo Spence (in collaboration with Tim Sheard), 'Exiled', from *Narratives of Dis-ease*. (Copyright © Jo Spence.)
38 Jo Spence (in collaboration with Rosy Martin), installation of *Libido Uprising*. (Copyright © Jo Spence.)
39 Jo Spence (in collaboration with Rosy Martin), from *Libido Uprising*. (Copyright © Jo Spence.)
40 Jo Spence (in collaboration with Rosy Martin, Ya'acov Khan and David Roberts), from the fifth triptych from *Triple Somersaults*. (Copyright © Jo Spence.)

Every effort has been made to seek permission to reproduce copyright material before the book went to press. If any proper acknowledgement has not been made, we would invite copyright holders to inform us of the oversight.

INTRODUCTION

This is not an historical survey of the female nude. Although such a history might place particular artists and images within a range of social and artistic contexts, ultimately it would still leave the category of the female nude intact, perpetuating its existence as a discrete area of art historical study, its boundaries defined by its subject matter and medium. The reader who comes to this book expecting a survey of art will therefore be surprised by certain exclusions and inclusions. A number of artists who are conventionally associated with the female nude are passed over in silence, whereas other work is considered which is undoubtedly less familiar within the canon of art history. The book is rather an attempt to examine the female nude as a means of gaining access to a much wider (and, I would argue, far more significant) range of issues concerning the female body and cultural value, representation, feminism and cultural politics, and the definition and regulation of the obscene.

Anyone who examines the history of western art must be struck by the prevalence of images of the female body. More than any other subject, the female nude connotes 'Art'. The framed image of a female body, hung on the wall of an art gallery, is shorthand for art more generally; it is an icon of western culture, a symbol of civilization and accomplishment. But how and why did the female nude acquire this status? And how does the image of the female body displayed in the gallery relate to other images of the female body produced within mass culture? These are the types of questions that are addressed in the following pages.

During the time that I have worked on this project, I have frequently been overwhelmed by the vastness of the subject and have longed for a topic with clear and limited historical parameters. The material covered in this book ranges from Plato to postmodernism, but in spite of the difficulties implicit in dealing with such a broad historical scope, I have always felt committed to addressing the more general philosophical issues raised by the female nude, as well as to introducing, at various points in the text, specific historical case-studies. Part of this commitment to more general and theoretical argument lies in the fact that, up to this time, feminist art

1

history has not yet produced a wide-ranging examination of the meanings, values and assumptions that have been and continue to be propagated by the female nude within patriarchal culture. Although there has recently been a number of fascinating feminist studies of particular artists or works,[1] these studies are relatively atomized and it is still possible to work within a period in the absence of any critical framework for discussing visual representations of the female body. As a result, a book such as Kenneth Clark's *The Nude* has managed to attain an astonishingly extended life, without meeting any serious or sustained challenge to its critical premises. To formulate a feminist history of the female nude has thus been to rely on isolated historical studies, or texts that are produced from within the same patriarchal culture from which the images themselves may emanate. The aims of this book are thus twofold: to set up a general theoretical framework for further historical study of the female nude and to elaborate and specify this argument through the discussion of specific historical cases.

There is a theme that runs throughout this book; at various points it becomes more explicit, but it is always present as an underlying structure. The theme is frames and framing. The text is divided into three main parts which offer different frameworks for examining the visual representation of the female body. Part I is called 'Theorizing the Female Nude' and is an attempt to establish a general theoretical framework. The claim of this book is that the female nude is not simply one subject among a whole range of subjects that artists have chosen to depict within the history of art; rather, it should be recognized as a particularly significant motif within western art and aesthetics. The representation of the female body within the forms and frames of high art is a metaphor for the value and significance of art generally. It symbolizes the transformation of the base matter of nature into the elevated forms of culture and the spirit. The female nude can thus be understood as a means of containing femininity and female sexuality. If, as will be argued in Part I, the female body has been regarded as unformed, undifferentiated matter, then the procedures and conventions of high art are one way of controlling this unruly body and placing it within the securing boundaries of aesthetic discourse.

The female nude not only proposes particular definitions of the female body, but also sets in place specific norms of viewing and viewers. The Enlightenment ideal of the contemplative viewing of an art object works to reinforce the unity and integrity of the viewing subject and sets up an opposition between the perfection of art and the disruption and incompletion of non-art, or obscenity. The obscene body is the body without borders or containment and obscenity is representation that moves and arouses the viewer rather than bringing about stillness and wholeness. The representation of the female body can therefore be seen as a discourse on the subject and is at the core of the history of western aesthetics.

Part II, 'Redrawing the Lines', examines in more detail the discursive formation of the female nude, through art education and the significance of the life class, and in relation to art criticism and the role of sexual metaphor in the critical appraisal of the female nude. Part II also addresses the relationship of feminism and the representation of the female body. By looking at a selection of work produced by women from the 1970s to the 1990s, it shows how developments within the women's movement have been articulated in terms of a politics of identity and the body and through the formulation of new cultural strategies and interventions.

Part III is titled 'Cultural Distinctions' and looks at the ways in which lines are drawn around different types of representation of the female body, moving through high art, glamour photography, newspaper 'pin-ups' and various forms of soft- and hard-core pornography. These categories present a series of cultural distinctions that not only differentiate types of images, but also classify the consumers of those images. The high-art female nude cannot be studied in isolation, but needs to be looked at in the broader context of its relationship with various forms of mass culture. Part III examines the legal framing of representations of the female body by focusing on the definition of pornography and the regulation of the obscene. The category of the obscene is therefore raised in a theoretical and philosophical context in Part I, and then in the context of specific legislative history in Part III. In 'Cultural Distinctions', it is argued that the policing of the boundaries of pornography is not simply a question of controlling the sexual content of images, but amounts to a regulation of audiences of images. Historically, the sexual has been seen to constitute dangerous knowledge which, in the wrong hands, can lead to a dangerous society; the regulation of obscenity is thus shown to be a procedure for the regulation of populations.

From the beginning of this project, it has always seemed to me that the discussion of the female nude inevitably raises the issue of pornography and I have approached this subject with some trepidation. Current debates on pornography, within the women's movement alone, are both extensive and entrenched. Arguments have polarized into pro- and anti-censorship platforms and, partly as a result of this, have failed to yield fruitful new directions in recent years. The attempt to recast these debates has been one of the most challenging aspects of the production of this book. I have attempted a selective engagement with aspects of these debates, in order to show the complex interrelationships between the domains of art and pornography through the representation of the female body. That said, however, the book is no more exclusively a study of pornography than it is a survey of art; rather it exists in the interstices of these discourses and seeks to uncover how the lines are drawn around these categories and by whom.

I hope that it will be clear from the following pages that in spite of the

dominance of patriarchal culture, more spaces are being made by feminism, both in high and popular culture, for representations of the female body that express women's identities, desires and needs. This project of self-definition is a critical aspect of the politics of the women's movement, and the slogan of the 1970s, 'our bodies our selves', needs to be continuously re-examined and pursued.

Having reached the end of this particular piece of work, I am still impressed by the immensity of the subject and the diverse areas of contemporary and historical culture that are opened out by study of the female nude. So, although it is a conventional qualification, I feel compelled to say that I view this book as a contribution to a much larger and ongoing debate, rather than as a final or conclusive statement about the subjects raised here.

As with most academics in the current political climate, I have found the most difficult aspect of work on this book to be finding the time to spend on it. I am therefore extremely grateful to the Leverhulme Trust who awarded me a grant in order to work on the book for six months in 1990. My thanks also go to all my colleagues in the Department of History of Art at Birkbeck College who continue to create a supportive environment for research which respects the diversity of approaches now represented within the discipline. Laura Marcus and Tag Gronberg have offered really helpful criticism and comments, and I am grateful to them for reading various parts of this text. But above all, my thanks go to Steve Connor, without whom . . . without whom this book could not possibly have been finished; thank you for endless patience, intellectual and emotional support and childcare!

Part I

THEORIZING THE FEMALE NUDE

1 FRAMING THE FEMALE BODY

At no point is there a plane or an outline where the eye may wander undirected. The arms surround the body like a sheath, and by their movement help to emphasise its basic rhythm. The head, left arm and weight-bearing leg form a line as firm as the shaft of a temple.

(Kenneth Clark, *The Nude*, 1956)[1]

Any structure of ideas is vulnerable at its margins. We should expect the orifices of the body to symbolise its specially vulnerable points. Matter issuing from them is marginal stuff of the most obvious kind. Spittle, blood, milk, urine, faeces or tears by simply issuing forth have traversed the boundary of the body . . . The mistake is to treat bodily margins in isolation from all other margins. There is no reason to assume any primacy for the individual's attitude to his own bodily and emotional experience, any more than for his cultural and social experience.

(Mary Douglas, *Purity and Danger*, 1966)[2]

This permanent requirement – to distinguish between the internal or proper sense and the circumstance of the object being talked about – organizes all philosophical discourses on art, the meaning of art and meaning as such . . . This requirement presupposes a discourse on the limit between the inside and outside of the art object, here a *discourse on the frame*.

(Jacques Derrida, *The Truth in Painting*, 1987)[3]

These three statements have been taken from works published over a period of three decades and from three distinct academic disciplines (art history, anthropology and philosophy), but here they are placed side by side because, in their diverse ways, they seem to unravel an aesthetic that has structured the representation of the female body in western art since

5

antiquity. They speak of outlines, margins and frames – procedures and forms that regulate both the ways in which the female body is shown and the proper conduct of the prospective viewer. Kenneth Clark describes the achievement of the Capitoline Venus in terms of containment. The arms 'surround' and enfold the body, and the planes and surfaces of the marble itself seem to emphasize this act of enclosure. Clark's range of images is significant. The pose is likened to a 'sheath'; it has become a covering for the body and is as regular and structured as the column of a temple. It is almost unnecessary to point out the phallic connotations of this language. For Clark, the female body has been shorn of its formal excesses and, as Venus, has been turned into an image of the phallus. The transformation of the female body into the female nude is thus an act of regulation: of the female body and of the potentially wayward viewer whose wandering eye is disciplined by the conventions and protocols of art.

With the quotation from Mary Douglas, the move is from the particularities of the female nude, that is, a cultural commodity, highly formalized and conventionalized, to the more general issue of the body and its boundaries. Douglas examines the cultural links between dirt and disorder or formlessness and analyses the rituals of cleansing and purification that control this threat. Hygiene and dirt imply two conditions: a set of ordered relations and a transgression of that order. All transitional states therefore pose a threat; anything that resists classification or refuses to belong to one category or another emanates danger. And once again it is the margins, the very edges of categories, that are most critical in the construction of symbolic meaning.

From this position, it is not so far to Jacques Derrida's 'discourse on the frame'. In a radical dismantling of Kantian aesthetics, Derrida problematizes the philosophical concept of the disinterested aesthetic experience by focusing our attention not on the object of contemplation but on its boundary. The frame is the site of meaning, where vital distinctions between inside and outside, between proper and improper concerns, are made. If the aesthetic experience is one that transcends individual inclination and takes on a universal relevance, then without the frame there can be no unified art object and no coherent viewing subject.

In this section I will draw on the work of writers such as Douglas and Derrida in order to make sense of the female nude and its symbolic importance within the western tradition of high art. I will argue that one of the principal goals of the female nude has been the containment and regulation of the female sexual body. The forms, conventions and poses of art have worked metaphorically to shore up the female body – to seal orifices and to prevent marginal matter from transgressing the boundary dividing the inside of the body and the outside, the self from the space of the other. Clearly, the relevance of this analytical model goes far beyond the examination of art. For if, as Douglas suggests, the body's boundaries

cannot be separated from the operation of other social and cultural boundaries, then bodily transgression is also an image of social deviation. The general movement, then, is from the specifics of representing the female body to more general structures of values and beliefs. To take up Derrida's point: the definition of limits and frames determines not simply the meaning of art, but meaning as such.

'The chief forms of beauty are order and symmetry and definiteness.'[4] In statements such as this, Aristotle set out the classical ideal of unity and integrity of form which has had a lasting and powerful influence on western culture. It can be traced in the language of aesthetics and art criticism; it lies at the heart of much art education and it structures legal and ethical discourses on art and obscenity. What seems to be at stake in all these discourses, and what all these areas have in common, is the production of a rational, coherent subject. In other words, the notion of unified form is integrally bound up with the perception of self, and the construction of individual identity. Psychoanalysis proposes a number of relations between psychical structures and the perception and representation of the body. Here too, subjectivity is articulated in terms of spaces and boundaries, of a fixing of the limits of corporeality. Freud relates the structure of the child's ego to the psychical projection of the erotogenic surface of the body. In a footnote to the 1927 English translation of 'The Ego and the Id', Freud states that:

> The ego is ultimately derived from bodily sensations, chiefly those springing from the surface of the body. It may thus be regarded as a mental projection of the surface of the body, besides . . . representing the superficies of the mental apparatus.[5]

The female nude can almost be seen as a metaphor for these processes of separation and ordering, for the formation of self and the spaces of the other. If the female body is defined as lacking containment and issuing filth and pollution from its faltering outlines and broken surface, then the classical forms of art perform a kind of magical regulation of the female body, containing it and momentarily repairing the orifices and tears. This can, however, only be a fleeting success; the margins are dangerous and will need to be subjected to the discipline of art again . . . and again. The western tradition of the female nude is thus a kind of discourse on the subject, echoing structures of thinking across many areas of the human sciences.

The general points that are being made here can be specified and pinned down through a more detailed discussion of individual texts and images. Three further examples illustrate how the relationship between boundaries and the female body is given representation. In a painting of the virtue *Chastity* by the sixteenth-century Italian painter, Giovanni Battista Moroni, the allegorical figure holds a sieve on her lap, the symbol of her

7

purity and inviolability (Plate 1).[6] The sieve is filled with water and yet no liquid runs out, for chastity is watertight; it is impenetrable and allows no leakage. The miraculous water-filled sieve is a metaphor for the ideal, hermetically sealed female body. The boundary of the body has been made absolutely inviolate; it has become a kind of layer of armour between the inside of the body and the outside. Of course, there is something worrying and incomplete about the impermeable sieve as a figure for the virtuous woman. If nothing is allowed in or out, then the female body remains a disturbing container for both the ideal and the polluted. Although the impermeable boundary may go some way towards answering fears concerning the female body, the problem does not go away, but is simply contained, staunched, for a while.

Woman is able to stand as an allegory of Chastity by displacing the worrying connotations of yielding and porous skin or oozing gaps and orifices on to the clear outline and metallic surface of the sieve. There are other ways in which this desire for clear boundaries and definitions can be satisfied. The female body can be re-formed, its surfaces reinforced and hardened, by bodybuilding. Lisa Lyon won the first World Women's Bodybuilding Championship in 1979. About a year later she met the photographer Robert Mapplethorpe and posed for a series of pictures which were published as a book called *Lady: Lisa Lyon* in 1983.[7] Now, bodybuilding is a mixed blessing for feminism. On the one hand, it seems to offer a certain kind of liberation, a way for women to develop their muscularity and physical strength. It produces a different kind of female body-image which could be seen to blur the conventional definitions of gendered identity. But on the other hand, this revised femininity seems simply to exchange one stereotype for another – one body beautiful for another, possibly racier, image of woman which can easily be absorbed within the patriarchal repertoire of feminine stereotypes. What is interesting in the present context, however, is the way in which both Lyon's bodybuilding and Mapplethorpe's photographic techniques are articulated in terms of bringing the female body under control. In a foreword to the book Samuel Wagstaff describes the compatibility between the photographer and the model:

> Of course, Mapplethorpe always makes it more difficult for himself by deliberately framing everything and everybody in the same strait-jacket style – the world reinvented as logic, precision, sculpture in obvious light and shadow.
>
> I don't suppose he would ever have taken a second exposure of Lisa if her classicism and ideals of order had not been a match for his.[8]

The images of Lyon are presented in terms of 'logic', 'precision' and 'order', pointing, quite knowingly, to the act of regulation that has been

undertaken in this work. In his search for a language to convey the effect of the images, Wagstaff hits upon 'straitjacket style', that is, a style that is concerned with holding down, with control and containment – an allusion not at all unlike Kenneth Clark's reference to the body as 'sheath'.

In many ways, the visual appearance of Mapplethorpe's monumental black-and-white photographs accentuates this aesthetic control of the female body (Plate 2). The hard edges and stark chiaroscuro of the images transform the body into sculpture – an effect that is intensified by the use of graphite on the body which subordinates modulations and details of the body surface to matt articulations of form and volume. Both model and photographer are seen to collaborate in this ordering of the female body. Both are referred to as classical sculptors in their search for a physical and aesthetic ideal: 'his eye for a body [is] that of a classical sculptor in search of an "ideal" ', and she is 'a sculptor whose raw material was her own body'.[9] The sculpture metaphor is one that emphasizes the projection of surfaces, the building and moulding of form. Together, Lyon and Mapplethorpe turn the raw material of the female body into art. And it is a double metamorphosis. Lyon describes herself as a performance artist; through bodybuilding she turns herself into a living art object and the process is then repeated as Lyon's body is captured in Mapplethorpe's photographic album.

Lisa Lyon has been 'framed'. By contouring her own body she turns its surfaces into a kind of carapace, a metaphorical suit of armour. But what may start out to be a parody of ideals of masculinity and a claim to a progressive image of femininity is easily reappropriated. Rather than transgressing sexual categories, Lyon simply re-fixes the boundaries of femininity. The surface of her body has become a 'frame', controlling the potential waywardness of the unformalized female body and defining the limits of femininity.

The 'framing' also occurs at the level of the formal constraints of the medium. Lyon is contained in the frame of Mapplethorpe's photographs – the disposition of light and shade, the surface and edges of the images. In other words, the act of representation is itself an act of regulation. And finally, Lyon is framed in the sense of being 'set up', offered as an image of liberation and revised femininity, whilst actually reinforcing the place where femininity begins and ends. Her power is contained by convention, form and technique; she poses no threat to patriarchal systems of order.

Paradoxically, Lyon's body is seen to have been both built up and honed down, added to but also reduced to its bare essentials. In his introductory essay to the collection, Bruce Chatwin comments: 'it was obvious that her body was superlative – small, supple, svelte, without an ounce of surplus fat.'[10] Her body has apparently reached the highest or utmost degree of contained form. How strange that a body that has been built up through exercise and weight training is praised for being 'small'. Strange, that is,

until we recognize that what Chatwin is admiring is the transformation of the female body into a symbol of containment. The aesthetic that is represented by Lyon's body is the now familiar one of boundaries and formal integrity.

Within this aesthetic, 'fat' is excess, surplus matter. It is a false boundary, something that is additional to the true frame of the body and needs to be stripped away. The categories 'fat' and 'thin' are not innate and do not have intrinsic meanings; rather, they are socially constituted, along with definitions of perfection and beauty.[11] Social and cultural representations are central in forming these definitions and in giving meaning to the configurations of the body. Over the last decade, for a woman to be in 'great shape' is to be firm, trim, fit and healthy. This in turn is seen as a quest for freedom, a way of realizing her true self and potential. As Michel Foucault has shown, in the modern period the body has become a highly political object, a crucial site for the exercise and regulation of power.[12] In this context, power is constituted both through the production of knowledge concerning the body and through self-regulation, through the individual exercising control over the self. The operations of power are thus not simply coercive, exercised from elsewhere over the individual, but are also self-regulatory and organized from within the subject. The complex relationship of the body and power is clearly demonstrated in the configuration of the female body produced by the workout ethic and aesthetic. Here, the female body, trimmed to its essential outline, promises new freedom and a healthy sexuality. The rigours of the workout signal both the need to conform to social ideals and the force of self-regulation, the exercise of power over oneself. 'I like to be close to the bone.'[13] Jane Fonda's declaration can come as no surprise; being 'close to the bone' means being closer to a bounded, structured form that is devoid of excess, that represents the true, integral self. This ideal of closeness to the bone also means that two dimensions of the idea of the bodily frame converge; the epidermal surface that is the body's *outside* frame tightening around the skeletal frame that forms the body's *inside*. Again, form and identity, visual representation and psychical structures overlap precisely on the issue of spaces and boundaries.

The common factor in all of these matters is the female body as representation, with woman playing out the roles of both viewed object and viewing subject, forming and judging her image against cultural ideals and exercising a fearsome self-regulation. My third example of the primacy of boundaries in social configurations of the female body is anorexia nervosa.[14] Here again, the body is seen as image, according to a set of conventions, and woman acts both as judge and executioner. But rather than anorexia being seen as a distortion of physical needs, it can be posed instead as a confusion of psychical perceptions and, more exactly, as a confusion of form and its boundaries. For the anorectic, there is always

excess matter deposited over the surface, the form of the body. The goal is to get rid of that surplus and to reveal the essential, core self – to get back to the original boundaries.

Woman looks at herself in the mirror; her identity is framed by the abundance of images that define femininity. She is framed – experiences herself as image or representation – by the edges of the mirror and then judges the boundaries of her own form and carries out any necessary self-regulation. The watertight sieve of the allegorical figure of Chastity; the sculpted body of the female bodybuilder; and the struggle over the body's boundaries conducted by the anorectic – all these cases illustrate the ways in which the female body is imaged in western society. The formless matter of the female body has to be contained within boundaries, conventions and poses.

This point is given a striking visual form in Albrecht Dürer's *Draughtsman Drawing a Nude*, 1538 (Plate 3). Here a partially draped female model lies on a table opposite the draughtsman. They are separated by a framed screen which is divided into square sections. The artist gazes through the screen at the female body and then transposes the view on to his squared paper. Geometry and perspective impose a controlling order on the female body. The opposition between male culture and female nature is starkly drawn in this image; the two confront each other. The woman lies in a prone position; the pose is difficult to determine, but her hand is clearly poised in a masturbatory manner over the genitals. In contrast to the curves and undulating lines of the female section, the male compartment is scattered with sharp, vertical forms; the draughtsman himself sits up and is alert and absorbed. Woman offers herself to the controlling discipline of illusionistic art. With her bent legs closest to the screen, the image recalls not simply the life class but also the gynaecological examination. Art and medicine are both foregrounded here, the two discourses in which the female body is most subjected to scrutiny and assessed according to historically specific norms. Through the procedures of art, woman can become culture; seen through the screen, she is framed, she becomes image and the wanton matter of the female body and female sexuality may be regulated and contained.

The distinctions between inside and outside, between finite form and form without limit, need to be continuously drawn. This requirement applies to representations of the female body in high and mass culture. It extends to the way in which the categories of art and pornography are defined and maintained. In nearly every case, however, there is a point where the systems break down, where an object seems to defy classification and where the values themselves are exposed and questioned. If you know the terms of the debate then they can be played with, disrupted and this opens up the possibility for challenging and progressive representations of the female body. These are all issues that will be examined in the following

11

pages. But firstly, what are the terms of the discourse of high culture and who sets them?

2 A DISCOURSE ON THE NAKED AND THE NUDE

To return to a text that is located securely within art historical discourse: Kenneth Clark's *The Nude* was first published in 1956 and is currently sold in its eighth edition in paperback. The subtitle of Clark's book is *A Study of Ideal Art*, which adds an important qualification to the main title and also points to a fundamental tension in Clark's treatment of his material. On the one hand, this is a highly selective survey. Clark is concerned with a specific classical and idealizing tradition of representation; but within the book this particularity gains the force of a general cultural norm against which all other modes of representation of the nude (Gothic, Baroque, non-European) are categorized as transgressive, as a cultural 'other'. Clark's text now stands as a monument to official culture; it is regarded as the classic survey of the subject and there have been curiously few scholarly attempts to revise or rework it.[15]

In his lifetime Lord Clark held almost every influential public position within British culture: Director of the National Gallery, Surveyor of the Royal Collection, Chairman of the Arts Council, Chairman of the Independent Television Authority and so on. Publicly, his reputation was largely established by his television series *Civilisation* which was broadcast in Britain in 1969–70 and sold throughout Europe and North America. Although his contribution to art history may now seem to have been overtaken by more recent developments in the discipline, the continuing healthy sales of his books should prevent us from dismissing his work too precipitately.[16] The significance of *The Nude* now lies partly in the fact that it has remained one of the only serious major surveys of the most central subject within the visual arts.

The Nude traces the history of the male and female nude from Greek antiquity to European modernism. Throughout this narrative Clark wrestles with the competing drives of sensory and contemplative pleasures, trying to hold them together in a balanced combination, without allowing either impulse to dominate judgement. He puts it this way:

> The desire to grasp and be united with another human body is so fundamental a part of our nature, that our judgement of what is known as 'pure form' is inevitably influenced by it; and one of the difficulties of the nude as a subject for art is that these instincts cannot lie hidden, as they do for example in our enjoyment of a piece of pottery, thereby gaining the force of sublimation, but are dragged

into the foreground, where they risk upsetting the unity of responses from which a work of art derives its independent life. Even so, the amount of erotic content which a work of art can hold in solution is very high.[17]

Clark's words illustrate the difficulties that the nude presents to connoisseurship. Although loosely based on a Kantian aesthetic of 'pure' form and disinterested appreciation, this critical framework appears inadequate when considering the visual representation of the body. Clark evokes the process, postulated by Freud, of sublimation.[18] Freud drew upon this notion to account for human activity that is apparently unconnected to sexuality but is assumed to be motivated by the force of sexual drives. These drives are sublimated in that they are turned towards a new non-sexual aim, such as artistic creativity. According to Clark, however, sexual instincts cannot (and possibly should not) be displaced in the creation and contemplation of the nude. The process of sublimation in this case is incomplete, for the originating sexual drives remain apparent and are part of the viewer's responses to the image. Nevertheless, Clark seems unhappy with the responses that are stimulated by the nude; they are 'dragged' into the open and 'risk upsetting' the kinds of reactions that may be more appropriate to a work of art. In the end, Clark leaves us with a kind of chemical compound, in which the 'erotic' (a carefully selected term that designates a kind of sexual content that is free of any connotations of the pornographic) is left bubbling away but in constant danger of boiling over. The pure and independent aesthetic experience is thus seriously compromised by the nude. If the transmutation of sexual drives into artistic creation is impossible then the nude also presents the risk of too much sex – too much, that is, for art. The triumph of a 'successful' representation of the nude is the control of this potential risk.

So far, I have been using the ungendered category of 'the nude'; this is to follow Clark's form, but it soon becomes obvious that in his general comments on 'the nude', Clark is frequently assuming a female nude and a male viewer. At a critical point in Clark's conceptualization of the subject, the category of the female nude loses its specificity and takes on the symbolic importance of the high-art tradition of 'the nude'. It is in the process of dropping the gendered prefix – the moment when the female nude becomes simply 'the nude' – that the male identity of artist and connoisseur, creator and consumer of the female body, is fully installed.[19] Thus, in his discussion of the sexual feelings evoked in the appreciation of 'the nude', Clark refers to the work of Rubens and Renoir, two artists renowned in art history for their female nudes. More than this, Rubens and Renoir stand for a particular kind of depiction and treatment of the female body – painterly, gestural, specialists in female flesh. The universal sexual 'instincts' to which Clark alludes are evidently based on those of the male,

13

heterosexual connoisseur. Again and again, when assessing a female nude, Clark expresses the need to balance the appreciation of pure artistic form and the response to the content concerned – the female body. It is this combination of abstraction and figuration that, according to Clark, makes the subject unique. Although Clark discusses both the male and the female nude, their cultural and symbolic meanings are crucially different and it is the representation of the female body that articulates fully the alchemic powers of art.

Perhaps the best known and most frequently cited passage of the book is where Clark differentiates the naked and the nude. It is a distinction between bodies deprived of clothes, 'huddled and defenceless', and the body 'clothed' in art: the nude is the body re-formed rather than de-formed, 'balanced, prosperous and confident'.[20] The transformation from the naked to the nude is thus the shift from the actual to the ideal – the move from a perception of unformed, corporeal matter to the recognition of unity and constraint, the regulated economy of art. It is this process of transfiguration that renders the nude the perfect subject for the work of art. As Clark states early on in the book, 'The nude remains the most complete example of the transformation of matter into form' (p. 23).

When Clark discusses the aesthetic achievements of the nude, the spectre of its negative 'other', the naked, is always present. If the nude, according to Clark's formulation, is the body 'clothed' in art, the body in representation, as it were, then the naked must represent the body in advance of its aesthetic transformation. The category of the naked describes the body outside of cultural representation; it is the denotative term to the connotation of the nude. In setting up this opposition of the naked and the nude, Clark is tapping into the passion for binary oppositions that dominates western philosophical history. More specifically, he extends the binarized model of classification based on the mind/body opposition. According to this model, the two terms in any pairing are isolated and mutually exclusive; if the mind represents the domain of the conceptual and is capable of abstraction and reason, then the body is reduced to a physical object, defined only in terms of its extension through or occupation of space. This basic dualism is associated with a number of other oppositional pairings such as culture and nature, reason and passion, subject and object, with the mind related to culture, reason and the subject and the body associated with nature, passion and objecthood. Furthermore, the positive values of the mind are associated with masculine attributes, whereas the negative values of the body are related to femininity. Clark's category of the naked belongs to the inferior, female set of the body, whereas the nude is an extension of the elevated male attributes associated with the mind.

For Clark, the category of the nude always holds within it a theory of representation. The nude is precisely the body in representation, the body

produced by culture. But this formulation is achieved by positing, at the same time, the notion of a naked body that is somehow outside of representation and an unmediated residuum of anatomy and physiology. The dualistic construction of the naked and the nude is therefore problematic not only because of the evaluative judgements that it promotes, but also because it sets in place the possibility of an unmediated physical body.

Nevertheless, the structural device of this opposition has proved a highly influential and resilient one. Paradoxically, even John Berger's challenge to Clark's account of the nude only succeeds in inverting the naked/nude opposition. In *Ways of Seeing* (first published in 1972) Berger takes up Clark's opposition but re-evaluates the terms. Whereas the nude is always subjected to pictorial conventions, 'To be naked', he writes, 'is to be oneself'.[21] To be naked is thus to be without disguise, to be free of the patriarchal conventions of western society. With this framework, Berger juxtaposes European oil paintings with photographs from soft-porn magazines, identifying the same range of poses, gestures and looks in both mediums. The particularity of the medium and cultural form is not important. What matters is the repertoire of conventions that *all* female nudes are believed to deploy, irrespective of historical or cultural specificity. But according to Berger, there are a few valuable exceptions to the voyeurism that is constructed through the European high-art tradition:

> They are no longer nudes – they break the norms of the art form; they are paintings of loved women, more or less naked. Among the hundreds of thousands of nudes which make up the tradition there are perhaps a hundred of these exceptions. In each case the painter's personal vision of the particular woman he is painting is so strong that it makes no allowance for the spectator . . . The spectator can witness their relationship – but he can do no more; he is forced to recognise himself as the outsider he is. He cannot deceive himself into believing that she is naked for him. He cannot turn her into a nude.
>
> (p. 57)

Berger's evocation of the hundred or so exceptions to the tradition of the female nude in European art assumes that the relationship between the male artist and the female model is inherently natural and good. Power, for Berger, is constituted as public. Private relationships lie outside the domain of power; love transforms the *nude* into a *naked woman* and prevents the male spectator, the outsider, from turning the female figure into a voyeuristic spectacle. So, for Berger, the naked is now the positive term and the nude is relegated to the inferior position within the opposition. What is undisturbed, however, is the implication that the naked is somehow freer from mediation, that it is semiotically more open and represents the body liberated from cultural intervention.

15

T.J. Clark's reading of Manet's painting *Olympia* (1865) draws on a more complex reworking of the naked/nude dichotomy.[22] Clark provides a disarmingly straightforward definition of a nude: '[it] is a picture for men to look at, in which Woman is constructed as an object of somebody else's desire'.[23] He then goes on to describe the dominant conventions of the female nude in France in the 1860s and analyses the ways in which Manet plays with and parodies these artistic codes. Clark refers to *Olympia* as a meeting of discourses on art, class and female sexuality. The female body represented in *Olympia* refuses the permissible signs of female sexuality. Manet's treatment of the pictorial conventions of the female nude and his handling of the painted surface transgressed the expectations of Salon critics in the 1860s, who read the image in terms of dirt and disease, of working-class identity and blatantly commodified sex. Clark's analysis is based on a perceived blurring of the naked and the nude in Manet's depiction of the female body. Nakedness, for Clark, is a sign of class (or, more precisely, working-class) identity in *Olympia*:

> By nakedness I mean those signs – that broken, interminable circuit – which say that we are nowhere but in a body, constructed by it, by the way it incorporates the signs of other people. (Nudity, on the other hand, is a set of signs for the belief that the body *is ours*, a great generality which we make our own, or leave in art in the abstract.)
>
> (p. 146)

Nakedness is a mark of material reality; whereas nudity transcends that historical and social existence, and is a kind of cultural disguise. Within the terms of T.J. Clark's value system, nakedness – the inescapable sign of social class – is the better term. Although the naked and the nude are no longer structured within an oppositional pairing, they still represent a greater and a lesser degree of cultural mediation, with nakedness still representing the more transparent signs of class and sexuality.

The discourse on the naked and the nude, so effectively formulated by Kenneth Clark and subsequently reworked, depends upon the theoretical possibility, if not the actuality, of a physical body that is outside of representation and is then given representation, for better or for worse, through art; but even at the most basic levels the body is always produced through representation. Within social, cultural and psychic formations, the body is rendered dense with meaning and significance, and the claim that the body can ever be outside of representation is itself inscribed with symbolic value. There can be no naked 'other' to the nude, for the body is always already in representation. And since there is no recourse to a semiotically innocent and unmediated body, we must be content to investigate the diverse ways in which women's bodies are represented and to promote new bodily images and identities.

3 A STUDY OF IDEAL ART

Kenneth Clark's study is organized into separate chapters on the male and female nude. The connotations of the male nude are very different from those associated with the female; they are also somewhat predictable: 'harmony, clarity and tranquil authority . . . calm, pitiless, and supremely confident'.[24] Needless to say, these are not the qualities that Clark associates with representations of the female figure. There are clearly two distinct sets of criteria at work, depending on whether the body represented is male or female.

Clark begins his survey with classical antiquity and the Greek ideal of the nude based on mathematics, proportion and harmony. He describes the standard schematization of the male torso in antique sculpture, the *cuirasse ésthetique*, which he sees as an expression of huge potential and vitality. The *cuirasse ésthetique* describes a kind of muscle-architecture, a formal and schematic disposition of muscles which was used in antiquity for the design of armour. It symbolizes the heroic male body – powerful and in, as well as under, control. In his analysis of the violent fantasies of the men of the German *Freikorps*, Klaus Theweleit has demonstrated the complex psychic compulsions associated with this image of the hard, insulated male body.[25] Within *Freikorps* ideology, the body of woman is perceived as unstructured. It represents the flood, the human mass; it is soft, fluid and undifferentiated. The warrior male insulates himself from the threat of dissolution into this mass by turning his body into an armoured surface that both repels the femininity on the outside and contains the 'primitive', feminized flesh of his own interior:

> The soldier male is forced to turn the periphery of his body into a cage for the beast within. In so doing, he deprives it of its function as a surface for social contact. His contact surface becomes an insulated shield, and he loses the capacity to perceive the social corpus within which his insulated body moves . . . A man structured in [this] way . . . craves war, because only war allows him to achieve identity with his alien, 'primitive', 'bestial' interior, while at the same time avoiding being devoured by it.

> (p. 22)

The armour-like male body signifies the construction of masculine identity in terms of self-denial, destruction and fear. For the soldier male, warfare enables a repudiation of femininity and his own bodily mass and a legitimate explosive dissolution of the controlling force of the body surface. In the light of Theweleit's work on the *Freikorps*, the *cuirasse ésthetique*, the sign of masculinity so admired by Kenneth Clark, begins to lose its aesthetic innocence. It begins to speak of a deep-seated fear and disgust of the female body and of femininity within patriarchal culture and of a

construction of masculinity around the related fear of the contamination and dissolution of the male ego.

Oddly, then, although there is an absolute contrast between the psychic conceptions of the male and the female body (a contrast between the hardness of male form and the deliquescence of female matter), there is a striking identity between the idealized forms of the male and female body, in both of which the threat of the flesh must be remorselessly disciplined. The fetishistic restoration to the lapsing female body of the erectile definition that it seems to the anxious male (and often female) imagination to lack, makes for a complex interchange between male and female bodies. In this, the characteristically female body is paradoxically subject to a masculinization, in order to make it conform to an ideal of the male body that precisely depends upon a dread that the male body might itself revert to what it is feared may secretly be its own 'female' formlessness. Therefore, at a symbolic level, the question of containment and boundaries is far more critical in accounts of the female nude than it is for the male nude. The boundaries of the female form control that mass of flesh that is 'woman'; they have to seem inviolate for the image of the female body to offer the possibility of an undisturbing aesthetic experience.

The regulation of sensory and organic perceptions through order and the rules of geometry apparently reaches its apotheosis in Leonardo's 'Vitruvian Man' (Plate 4). Here the matter/form dichotomy is brought to a temporary resolution, with the classicized male body articulated (albeit somewhat imperfectly) through mathematical relations; the male body is fantasized as pure form.

But the resolution of matter and form cannot easily be accomplished in the representation of the female body. Historically, woman has occupied a secondary or supplementary role in western philosophy and religion. As Eve, formed from one of Adam's ribs, woman was created to fill Adam's own insufficiency. The Adam and Eve (man/woman) pairing is the founding opposition within western metaphysics. The two terms share a structural link (that is, Adam's rib) but they are not equal. The primary subject is Adam; Eve has a supplementary function, secondary but threatening since her existence always testifies to the original lack in Adam, the primary term. As we have already seen, many other value oppositions map on to this man/woman pairing, including culture/nature. If the male signifies culture, order, geometry (given visual form in Vitruvian Man), then the female stands for nature and physicality. Woman is both *mater* (mother) and *materia* (matter), biologically determined and potentially wayward. Now, if art is defined as the conversion of matter into form, imagine how much greater the triumph for art if it is the *female* body that is thus transformed – pure nature transmuted, through the forms of art, into pure culture. The female nude, then, is not simply one subject among others, one form among many, it is *the* subject, *the* form.

These sets of value oppositions can be seen working in Clark's chapters on the female nude. Initially, he attempts to keep the domains of the sensual and the spiritual apart by dividing the female nude into distinct types: Venus (1) and Venus (2) or the Celestial Venus and the Earthly Venus (Venus Vulgaris). Here again, Clark draws on a classical tradition and its later humanist derivatives.[26] Celestial Venus is the daughter of Uranus and has no mother. She belongs to an entirely immaterial sphere, for she is without mother and matter. She dwells in the highest supercelestial zone of the universe and the beauty that she symbolizes is divine. The other Venus, Earthly Venus, is the daughter of Jupiter and Juno. She occupies a baser dwelling-place and the beauty symbolized by her is particularized and realizable in the corporeal world. While Celestial Venus represents a contemplative form of love that rises from the visible and the particular to the intelligible and universal, Earthly Venus represents an active form of love that finds satisfaction in the visual sphere. According to the same theory, no value whatever can be attached to mere lust, which sinks from the sphere of vision to that of touch.

In the Platonic model the Venuses are seen to be co-existent but quite distinct; Clark shifts this view by suggesting that artists have transformed vulgar or earthly objects into celestial ones through the controlling discipline of artistic form. He compares two early examples of the female nude: a prehistoric figure of a woman (Plate 5) and a Cycladic doll (Plate 6) which he designates respectively Vegetable and Crystalline Venus. In the first example, the body is lumpy and protruding but in the second image 'the unruly human body has undergone a geometrical discipline' (p. 64). This is the important point – the female body has undergone a process of containment, of holding in and keeping out. It is commonly recognized that prehistoric statuettes such as the Willendorf Venus were images of fertility; they represented the maternal body, the female body in parturition. Clark alludes to this image of the female body as undisciplined, out of control; it is excluded from the proper concerns of art in favour of the smooth, uninterrupted lines of the Cycladic figure. In so far as geometry is the science of space and its boundaries, then in the Cycladic figure the contour, the frame of the body has been sharpened, thus hardening the distinction between inside and outside, between figure and ground, between the subject and the space it is not. The female body has become art by containing and controlling the limits of the form – precisely by framing it. And by giving a frame to the female body, the female nude symbolizes the transforming effects of art generally. It is complete; it is its own picture, with inside, outside and frame. The female nude encapsulates art's transformation of unformed matter into integral form.

Clark attempts to make the relationship of the female nude and artistic form a natural one, arguing that the conventions of art are particularly suited to the natural lines of the female body. For example, he takes the

classical pose of the the weight resting on the right leg with the left leg bent as if to move (Plate 7). The pose, he writes, was invented for the male figure but had a greater and more lasting impact on the representation of the female body (Plate 8). He explains:

> This disposition of balance has automatically created a contrast between the arc of one hip, sweeping up till it approaches the sphere of the breast, and the long, gentle undulation of the side which is relaxed; and it is to this beautiful balance of form that the female nude owes its plastic authority to the present day.
>
> (p. 71)

According to this rationalization, the female body is naturally predisposed to the contours of art; it seems simply to await the act of artistic regulation.

Things, however, are not quite as under control as might first appear, and signs of the physical, sensory world regularly interrupt the smooth contours of the female nude. The most significant causes of these breaks appear to be the personal desires of individual artists. Clark reads brush marks and lines as though they are part of a symbolic language of sensual impulses, telling traces of sexual desire. For example, his connoisseurial eye detects that:

> behind the severe economy of Botticelli's drawing we can feel how his hand quickens or hesitates with his eye those inflections of the body which awaken desire.
>
> (p. 99)

But although desire may be awakened it needs to be kept under control; the armour of artistic form can be relaxed but it cannot easily be removed entirely. Clark goes to considerable lengths to try to specify the degree of physicality that can be integrated within the female nude without upsetting the unity and integrity of art. Thus Correggio's figure of Antiope in *Jupiter and Antiope* (Plate 9) is described as being 'as seductive as possible' but 'the reverse of obscene' (p. 127). Seductive but *not* obscene. Now we might ask *why* Clark needs to make this point – why he needs to make this careful manœuvre between a seductiveness that is permissible within the limits of art and a category of obscenity that goes beyond art, that is outside of art. Art is being defined in terms of the containing of form within limits; obscenity, on the other hand, is defined in terms of excess, as form beyond limit, beyond the frame and representation.

As might be anticipated, Rubens provides Clark with a particularly demanding case for appraisal but the critic again invokes the form/matter opposition to confirm the artist's status (Plate 10):

> [Rubens] learnt what a severe formal discipline the naked body must undergo if it is to survive as art. Rubens' nudes seem at first sight to

have been tumbled out of a cornucopia of abundance; the more we study them the more we discover them to be under control.

(p. 133)

So all is well: form triumphs over matter and style is privileged over substance. There is an interesting economic dimension to Clark's language too. If, as we have already seen in his general definition of the nude, the ideal is balanced and prosperous, then this model of artistic practice as a kind of controlled economy is developed in his assessment of Rubens. The image of excess, presented by a 'cornucopia of abundance', is brought under control; the female bodies are not tumbling out of and beyond the procedures of art and parsimony but are regulated through the discipline of form and thus are able to survive as art.

We can begin to see the sets of values with which Clark is working: a category of *art* which is concerned with stylistic procedure and form and a category of *obscenity* which has to do with excess and lack of boundaries. Furthermore, the two categories are not held apart, away from each other, but are abutting, touching, exerting a pressure at their defining edges. Too close for comfort.

Clark's procedure can be fully exposed by looking at the examples that he selects to demonstrate failure to assert control – where the image goes beyond the bounds of art and decency. The first is the work of Jan Gossart (Plate 11) which, for reasons that will become clear, Clark does not illustrate in his book. Clark describes Gossart's style as an undigested mixture of Italian composition and Flemish realism; he continues:

This unresolved mixture of conventions has the result of making Gossart's nudes curiously indecent. They seem to push their way forward till they are embarrassingly near to us, and we recognise how necessary it is for the naked body to be clothed by a consistent style.

(p. 320)

Here the artistic process seems to be working in the opposite direction. Form has devolved back into matter, has been turned into something impure that threatens to break out of the picture surface. The figures have become lifelike, physical, they 'push their way forward', so that faced with this violation of artistic procedure the spectator is embarrassed rather than elevated. Artistic style also has its defining frame and it is the overlapping, the unstructured blend of conventions in Gossart's art that produces this disorder; coherent style is necessary to encase and enclose the female body.

Another example of failure to assert formal control over the matter of the female body is provided by Georges Rouault. Considering Rouault's series of prostitutes (Plate 12), Clark states:

All those delicate feelings which flow together in our joy at the sight

of an idealised human body . . . are shattered and profaned . . . from the point of view of form, all that was realised in the nude in its first creation, the sense of healthy structure, the clear geometric shapes and their harmonious disposition has been rejected in favour of lumps of matter, swollen and inert.

(p. 333)

What exactly has happened here? The ideals of the nude – structure, geometry, harmony – have given way to unhealthy, unformed lumps of matter. The female nude is meant to transcend the marks of individualized corporeality by means of a unified formal language; when this fails, both the image of the body and the feelings of the viewer are profaned, that is, desecrated or violated. Profane means literally 'outside the temple' and once again we have an image of the body that connotes an inside and an outside, a distinction here between the sacred and the defiled. We can now begin to see that the fundamental relationship is not that of mind and body, or form and matter, but the critical distinction of interior and exterior and the consequent mapping of the body's boundaries. Rouault's female nude has broken out of its framing contours; the body is swollen, it is in excess of art. But Clark goes on to say that the image was conceived in a spirit of religion and that it inspires us with awe and fear; it is apparently sublime.[27] If the ideal female nude, the beautiful, is conceived of in terms of unity and harmonious completeness, then the image created by Rouault belongs to a different category altogether, a category that invokes awe and fear through the recognition of something beyond human limitation and control.

4 AESTHETICS AND THE FEMALE NUDE

So far, I have identified a set of value oppositions (mind/body, form/ matter, art/obscenity) that form the basis of Clark's critical language and judgement. To this set of pairings I have just added the beautiful and the sublime. In using these categories Clark is not inventing a new set of aesthetic criteria; he is simply adopting and working within a system that has dominated the philosophy of art before and since Kant. So in order to understand what may be at stake in this system, it is necessary to go beyond the particularities of Clark's text and to consider, more generally, the history of aesthetics and its implications for critical responses to the female nude. Indeed, if it is true, as Terry Eagleton has recently suggested, that 'aesthetics is born as a discourse of the body',[28] then (since, as we will shortly see, the female body has so often been identified with the body as such) the female nude must be considered as more than one topic among others for aesthetics. It is therefore not just a matter of looking to aesthetics to illuminate the history of attitudes towards the female nude, but also

of grasping the ways in which the concern with the female body conditions the nature and possibility of aesthetic thought itself.

Modern European aesthetics is generally held to have its origins in the eighteenth century and the attempt by writers such as Winckelmann, Lessing, Burke and Baumgarten to provide universal principles for the classification, judgement and experience of beauty and especially of works of art. But the question of taste and aesthetic judgement can be traced back much further to the roots of the western philosophical tradition and the Platonic concept of ideal forms. Plato argues that objects that we encounter in sensory experience are mere tokens or echoes of absolute forms which lie beyond the reach of our senses and beyond physical experience. The basic set of distinctions that is established through the Platonic system – between the ideal and the actual, between mind and body, between form and matter – also forms the framework of Enlightenment thought.

In the writings of Descartes reason is the only true basis of judgement and the body is the source of all obscurity and confusion in our thinking.[29] As body we are unable to make basic distinctions between self and world, between the orders of the human and the natural. The goal of Cartesian thought is the creation of distinct boundaries to one's sense of self, the creation of an absolute distinction between the spiritual and the corporeal with the complete transcendence of mind over body. Knowledge is something that can be acquired in an objective and detached manner, on the assumption of the separation of knower and known. For Plato and Aristotle and throughout the Middle Ages, the natural world had been conceptualized as female, as 'mother'. With his celebration of the scientific mind, Descartes effectively recasts knowledge and reason as masculine attributes. In the *Meditations* a series of binary oppositions runs through the argument as 'metaphors of contrast' that assert the primacy of the masculine over the feminine.[30] The term 'male' is associated with the higher faculties of creativity and rational mental processes, while the 'female' is demoted to the role of passive nature and associated with the biological mechanisms of reproduction. Thus in western metaphysics, form (the male) is preferred over matter (the female); mind and spirit are privileged over body and substance and the only way to give meaning and order to the body in nature is through the imposition of technique and style – to give it a defining frame. The implications of a system of thought that defines both scientific inquiry and artistic creativity as masculine are considerable and are certainly still at work in contemporary society.[31] This powerful tradition has been systematically adopted within modern aesthetics and Kenneth Clark is simply one agent in its trajectory.

Immanuel Kant's *Critique of Aesthetic Judgement* (1790) is fundamental in the formation of European aesthetics and its influence is still easily discernible in art history and criticism today, although usually in a somewhat diluted or popularized way. The form/matter opposition governs the

whole of the *Critique*.[32] Kant sought to distinguish sensory from contemplative pleasures. According to Kant, although the pleasure experienced in the beautiful is immediate, it involves a reflection on the object and this sets it apart from the merely sensuous pleasures that may be derived, for example, from eating and drinking. Aesthetic pleasure is thus more refined than physical forms of pleasure since it necessarily involves the 'higher' faculty of contemplation. Perhaps one of the most influential of Kant's ideas was the axiom that the individual object is detached in aesthetic judgement and considered simply for 'its own sake'. The art object should serve no ulterior purpose, and aesthetic judgement itself should be disinterested; the observer's desires and ambitions should be held in abeyance in the act of pure contemplation. Kant also distinguished 'free' from 'dependent' beauty, the first derived without the aid of conceptualization, the second requiring an interest in the material existence of the object. For Kant the judgement of 'dependent' beauty is necessarily less pure or open to abstraction than the contemplation of 'free' beauty. Whereas examples of 'free' beauty are found in nature, they are rarely seen in art; art usually requires some conceptualization of the subject expressed. This system establishes a hierarchy of aesthetic experience. As far as possible, judgement should be free of interest in relation to both the material condition of the individual object and the aims and desires of the viewer, for it is only through this act of liberation from individual preference that a judgement may be claimed as universally valid for all rational beings.

This set of distinctions may seem unexceptionable enough but it has been devastatingly analysed and dismantled by Jacques Derrida in his essay entitled 'Parergon', included in the collection *The Truth in Painting* and quoted at the beginning of Part I. Derrida makes an apparently simple observation: in order to make a 'pure' judgement you have to be able to judge what is intrinsic to the object and thus the proper concern of aesthetic judgement and what is extrinsic to the object and thus irrelevant. This permanent requirement, Derrida writes, structures all philosophical discourses on art and most importantly:

> [It] presupposes a discourse on the limit between the inside and the outside of the art object, here a discourse on the frame.
>
> (p. 45)

So Kant's whole analytic of aesthetic judgement presupposes that you *can* distinguish rigorously between the intrinsic and the extrinsic. Judgement should properly bear upon intrinsic beauty (which is within the proper limits of art) and not upon mere decoration or sensuous appeal (which are outside the limits). According to Kant (and we have seen these values operating in Clark's book) what is bad, what is outside of or goes beyond aesthetic taste and judgement, is matter – that which is motivated, which

seduces, embarrasses, or leads the viewer astray, away from the proper consideration of intrinsic form.

But how, or where, are these distinctions between form and matter, between intrinsic and extrinsic, made? Derrida suggests that the critical place of judgement is not at the centre of the category where differences are most emphatic, but at the very limit, at the framing edge of the category, where the surplus or secondary term most nearly belongs to the main subject. It is at these crucial edges where the distinction between inside and outside, inclusion and exclusion, acceptability and unacceptability, is most exquisite.

I have been taking this immense detour via western metaphysics, Kant and Derrida because I believe that together they offer a way of understanding the critical importance of the female nude in the tradition of western art. The female nude strains the value oppositions of western metaphysics to their limits and forces to the point of compromise the Kantian aesthetic of universal judgement. If we go back to the basic opposition of art and obscenity that I discussed earlier, we can now begin to place the female nude not only at the centre of the definition of art but also on the edge of the category, pushing against the limit, brushing against obscenity. The female nude is the border, the *parergon* as Derrida also calls it, between art and obscenity. The female body – natural, *un*structured – represents something that is outside the proper field of art and aesthetic judgement; but artistic style, pictorial form, contains and regulates the body and renders it an object of beauty, suitable for art and aesthetic judgement.

5 OBSCENITY AND THE SUBLIME

The frame, then, is a metaphor for the 'staging' of art, both in terms of surrounding the body with style and of marking the limit between art and non-art, that is, obscenity. Here, etymology seems to confirm the metaphor. The etymology of 'obscene' is disputed but it may be a modification of the Latin 'scena', so meaning literally what is off, or to one side of the stage, beyond presentation. Within this context, the art/obscenity pairing represents the distinction between that which can be seen and that which is just beyond representation. The female nude marks both the internal limit of art and the external limit of obscenity. This is the symbolic importance of the female nude. It is the internal structural link that holds art and obscenity and an entire system of meaning together. And whilst the female nude can behave well, it involves a risk and threatens to destabilize the very foundations of our sense of order.

There is just one more relationship that can be introduced into this system. The art/obscenity opposition can also be mapped on to Kant's distinction between the beautiful and the sublime. Following Edmund

Burke, Kant differentiated between the experience of the beautiful and the experience of the sublime. He wrote in the *Critique*:

> The beautiful in nature is a question of the form of the object, and this consists in limitation, whereas the sublime, is to be found in an object even devoid of form, so far as it immediately involves, or else by its presence provokes, a representation of limitlessness.[33]

So whereas the form of the beautiful is seen to lie in limitation (for example, in the contemplation of a framed picture), the sublime challenges this act of judgement by suggesting the possibility of form beyond limit. Whereas the sentiment of beauty is predicated on a sense of the harmony between man and nature and the rationality and intelligibility of the world, the sublime is conceived of as a mixture of pleasure, pain and terror that forces us to recognize the limits of reason. Kant specifies this relationship in terms of framing: the beautiful is characterized by the finitude of its formal contours, as a unity contained, limited, by its borders. The sublime, on the contrary, is presented in terms of excess, of the infinite; it cannot be framed and is therefore almost beyond presentation (in a quite literal sense, then, *ob*scene). For Kant the sublime is encountered more readily in raw nature than in art. If art is defined as the limiting or framing of formed matter, then the sublime must necessarily be beyond or outside the parameters of art.[34]

There is a profound ambivalence about the sublime. Kant argues that it is through a perception of the sublime that we gain an intimation of divinity, of transcendence. But this apprehension is won through the renunciation of our comprehension and control of the world. There can be no boundary of the sublime, and in this knowledge we recognize the transient nature of all boundaries, including the boundary between the self and the other. The sublime is thus a disturbing category, for in its promise of form without limit it shatters the form/matter duality and reminds us of the social nature of all categories and boundaries.

It is significant that Kant expresses the distinction between the beautiful and the sublime in relation to the viewer's experience of the object. Whereas the pleasure provoked by the beautiful is one of life enhancement which may be united with the play of the imagination, the pleasure (*Lüst*) that is excited by the sublime is of a different and negative order. According to Kant, the feeling of the sublime arises indirectly; it is characterized by an inhibition of the vital forces, and as a result of this momentary retention, is followed by a 'discharge all the more powerful' (p. 11).[35] It is a violent, explosive experience. Serious rather than playful, it goes beyond simple charms and attraction and is caught up in an alternating rhythm of attraction and repulsion.

The experience of the sublime is thus seen to be kinetic, in contrast to the experience of the beautiful which is always contemplative. Kant writes:

The mind feels itself *set in motion* in the representation of the sublime in nature; whereas in the aesthetic judgement upon what is beautiful therein it is in restful contemplation.

(p. 107)

This opposition of a quiet, contemplative pleasure and a form of excited arousal can be related back to the art/obscenity opposition. The axiom that the experience of high art should be static and reflective and that this differentiates it from the experience of non-artistic forms such as pornography recurs again and again in nineteenth-century and twentieth-century European aesthetics. As an expert witness to Lord Longford's committee on pornography in 1972, Kenneth Clark stated:

> To my mind art exists in the realm of contemplation, and is bound by some sort of imaginative transposition. The moment art becomes an incentive to action it loses its true character. This is my objection to painting with a communist programme, and it would also apply to pornography. In a picture like Correggio's *Danaë* the sexual feelings have been transformed, and although we undoubtedly enjoy it all the more because of its sensuality, we are still in the realm of contemplation. The pornographic wall-paintings in Pompeii are documentaries and have nothing to do with art. There are one or two doubtful cases – a small picture of copulation by Géricault and a Rodin bronze of the same subject. Although each of these is a true work of art, I personally feel that the subject comes between me and complete aesthetic enjoyment. It is like too strong a flavour added to a dish. There remains the extraordinary example of Rembrandt's etching of a couple on a bed, where I do not find the subject at all disturbing because it is seen entirely in human terms and is not intended to promote action. But it is, I believe, unique, and only Rembrandt could have done it.[36]

This statement is worth quoting at length in order to see how Clark establishes an impressively nuanced system for the differentiation of art and pornography. As soon as an image becomes 'an incentive to action' it is expelled from the realm of art and creativity and enters the inferior and corrupted domain of documentary, propaganda and pornography. In this domain there is no imaginative escape from the real, and the viewer becomes motivated and disturbed rather than lifted into aesthetic contemplation. Between the two poles of art and pornography Clark is able to register a complex range of differentiated responses that distinguish acceptable and unacceptable forms of representation. Here the term 'sensuality' plays a critical role as a form of sexual content that is permissible and can be accommodated within the category of art, since sexual desire is present but transformed or momentarily arrested.

The differentiation of art and pornography has been grounded, to a

significant extent, in terms of the effects of the image or object on the viewer. When I discuss 'pornography' in this very general context, it should be clear that I am not using the term in its common, contemporary sense as a self-evident or given category of sexually explicit imagery. The way in which pornography is defined historically through legal definitions, social opinions, moral and sexual discourses will be examined in Part III. Here, I am concerned with the way in which pornography is constructed within philosophy and aesthetics as the 'other' of art. If, as I have suggested above, art is seen to represent the sublimation or transformation of sexual drives, then pornography conveys the sexual unmediated; it incites and moves the viewer to action. The pure aesthetic experience is posed as a consolidation of individual subjectivity; it can be seen in terms of the framing of the subject. In contrast, the experience of pornography is described as a kind of disturbance; it presents the possibility of an undoing of identity.

In this series of relationships, visual perception is placed on the side of art and in opposition to the information yielded through tactile perception. Through visual perception we may achieve the illusion of a coherent and unified self; the gaze of the draughtsman in Dürer's print symbolizes the aesthetic distance and control invested in the visual image (see Plate 3).[37] But the information presented through tactile perception lacks this critical distance; it is partial, fragmented and necessarily involves the viewer in motivated action. The pornographic image is clearly absorbed by the viewer through visual perception, but at a symbolic or psychic level, pornography, as the 'other' of art, signifies the hectic and disordered experiences yielded through tactile perception. In Joyce's *A Portrait of the Artist as a Young Man* the invalid aesthetic response is symbolized by graffiti scribbled on the bottom of the *Venus* of Praxiteles; the arrested gaze of the connoisseur is contravened by the physical gesture, the touch of the culture lout (see note 36).

This set of associations is also activated in the Kantian opposition of the beautiful and the sublime. Whereas the form of the beautiful is adapted to our faculty of perception and judgement and conveys a finality of form, the idea of the sublime is a disturbance of these faculties and is an 'outrage on the imagination'.[38] Here again, it is important to specify that I am referring to the sublime in its more precise Kantian sense rather than to the more popularized, nineteenth-century notion of the sublime as something awesome or uplifting. For Kant, the greater the 'outrage' on the imagination, the greater the sublimity of the experience. In its focus on the viewing subject, the discourse of the sublime can be seen, more generally, as a discourse on the subject and what is at stake in the sublime is precisely the 'loss of power of human agency'.[39] The sublime acts as a reminder that identity is socially and psychically constructed and that the subject's grasp of its own identity is both precarious and provisional.

It is in this reminder of the provisional nature of individual identity that the sublime may be seen to offer a radical possibility for any politics concerned with questioning the social construction of identity and putting in place alternative sets of social identities. In the final part of this section, I want to consider the gendering of the sublime and ways in which characteristics of the sublime have been reworked in feminist aesthetic theories. I have argued that the female nude is a symbol of the transforming effects of high culture. It stands as a paradigm of the aesthetic of the beautiful, a testimony to wholeness and integrity of form. The female nude is precisely matter contained, the female body given form and framed by the conventions of art. But when these conventions fail to contain the connotations of the female sexual body, then, as we have seen with Kenneth Clark's analyses, the image is judged to have gone beyond the bounds of art; it is unpresentable. So what possibilities are there for the construction of a progressive aesthetic around the notion of form beyond the procedures and protocols of western high art? Does the sublime suggest new ways of representing the female body and female subjectivities from a feminist position?

Traditionally, the sublime has been characterized as a masculine category. For Kant and other eighteenth-century writers on aesthetics, the sublime and the beautiful are clearly gendered. Whereas the beautiful is associated with feminine characteristics, the sublime is seen to be characterized by masculine traits. In his *Philosophical Enquiry into the Origin of Our Ideas of the Sublime and Beautiful* (1757), Edmund Burke observed:

> The beauty of women is considerably owing to their weakness, or delicacy, and is even enhanced by their timidity, a quality of mind analogous to it.[40]

For Kant, while neither sex is entirely without the character of either the sublime or the beautiful, the 'merits of a woman should unite solely to enhance the character of the beautiful which is the proper reference point; and on the other hand, among the masculine qualities the sublime clearly stands as the criterion of his kind'.[41] But in the light of the relationship between the sublime and the unbounded female body, we arrive at a more subtly nuanced understanding of the gendering of aesthetics. The sublime is not simply a site for the definition of masculinity but is also where a certain deviant or transgressive form of femininity is played out. It is where woman goes beyond her proper boundaries and gets out of place.

In the 1980s the category of the sublime was the subject of an enthusiastic revival. Indeed, the present discussion is itself a product of the revival of interest in the ambiguities and uncertainties raised by speculations on the sublime. The sublime is now a buzzword of postmodernity.[42] It has been presented as the only viable aesthetic for the contemporary age, while the harmony and wholeness of the beautiful is dismissed as the outmoded

dream of an earlier utopian moment. Jean-François Lyotard's interpretation of the sublime is based on a close reading of Kant. Lyotard presents the sublime in terms of the gap between the subject's faculties of presentation and judgement, and the idea or object of knowledge; the sublime is the apperception of the unpresentable. Lyotard defines the concerns of postmodernity based on this aesthetic:

> The postmodern would be that which, in the modern, puts forward the unpresentable in presentation itself, that which denies itself the solace of good forms, the consensus of a taste which would make it possible to share collectively the nostalgia for the unattainable; that which searches for new presentations, not in order to enjoy them but in order to impart a stronger sense of the unpresentable.[43]

The paradox of an art practice that mundanely adopts this position, that is, an art that sets out to present the unpresentable has been discussed elsewhere.[44] The postmodern sublime can be easily appropriated by museums, curators and critics as the next in line in the tradition of the new. But this is not the only possible understanding of the possibilities of the sublime; what remains suggestive about the category is its uncertainty, its questioning of categories of judgement and experience. Rather than modish and outlandish speculation on the possible content of an art of the unpresentable, the sublime can be used as a way of drawing attention to the problems involved in 'presentation'. More specifically, the sublime provides a suggestive starting-point for theorizing the gap between knowledges of the female body produced through such discourses as medicine and advertising, art and religion. Rather than seeking to maintain the pure autonomy of art or suggesting a happy (or unhappy) diversity of 'images of women', a critical art practice would draw attention to the incommensurability of these regimes.

Within feminist literary criticism there has been an attempt to reinvent the sublime as a female mode. Recognizing the destabilizing potential of the sublime, some Anglo-American feminist critics have argued for a new 'vocabulary of ecstasy and empowerment, a new way of reading feminine experience'.[45] The major impetus for this project has been the writing of the French feminists Luce Irigaray and Hélène Cixous. In their prose, the feminine text has an exhilarating and unbounded energy that shatters masculine institutions and values as it explores the multiplicity of new positions opened up by the realization of feminine power:

> Because we are always open, the horizon will never be circumscribed. Stretching out, never ceasing to unfold ourselves, we must invent so many different voices to speak all of 'us', including our cracks and faults, that forever won't be enough time. We will never travel all the way round our periphery: we have so many dimensions.[46]

Irigaray develops an idea of the sublime in terms of an unbounded horizon or endless periphery; the female sublime occupies different dimensions to the vertical and hierarchical sublime of patriarchy. Although one does not question the urgency and exaltation of this writing, it is worth remembering Rita Felski's caveat that the subversion of internal textual structures does not necessarily lead to social critique, let alone social change.[47] Moreover, in the celebration of the feminine text, the diversity of standpoints within feminism is erased by the heady utopia of a single, comprehensive feminist poetic.

An alternative approach, which allows for the multiplicity of feminist positions and not only addresses the production of meaning within visual representation but also considers broader ideological constructs, is to think again in terms of boundaries and the framing of meanings and representations. If one draws attention to processes of containment – social, artistic, philosophical – it is possible to see the ways in which the female body is given meaning, and how its containment within the protocols of the high-art tradition is then linked to definitions of correct aesthetic experience and socially valid forms of cultural consumption. At the beginning of Part I, I quoted from Mary Douglas's brilliant analysis of purity and pollution. Within her account danger does not lie in any given category but in transitional states; it is the process of belonging to neither one state nor another that is most threatening. Douglas illustrates her argument with the prohibitions on food set out in Leviticus on which the Judaic notion of *kosher* is based.[48] Basically the animals that are considered unclean and are therefore prohibited are those that escape clear-cut classification. Each element – water, air and earth – is allotted its proper kind of animal life. Only birds that fly, fish that swim and have fins and gills, and animals that walk on four legs, chew their cud and have cloven hooves may be considered holy and therefore fit for consumption. Any animal that does not have the appropriate form of locomotion for its element (for example, wingless birds or the snake that slithers both on land and in water) is contrary to classification and is thus impure and contrary to dietary rules. Douglas concludes:

> To be holy is to be whole, to be one; holiness is unity, integrity, perfection of the individual and of the kind. The dietary rules merely develop the metaphor of holiness on the same lines.[49]

For Douglas, the ideal of wholeness extends to perceptions of the body and to the social community. Concepts of pollution and rituals of purification are thus an insurance against confusion and it is the boundaries or borderlines that are most critical in the maintenance of order. Objects or individuals that transgress these classifications challenge correct definition and right order.

Douglas's work has been used by Julia Kristeva in her formulation of

abjection in *Powers of Horror*.[50] Kristeva describes abjection in terms of ambiguity and uncertainty:

> [It is] not lack of cleanliness or health that causes abjection but what disturbs identity, system, order. What does not respect borders, positions, rules. The inbetween, the ambiguous, the composite.[51]

For Kristeva, the most significant border is that between the subject and the object, the distinction between the inside and the outside of the body. Subjectivity is organized around an awareness of this distinction and the sense of the body as a unified whole, defining the form and limits of corporeal identity. Kristeva is concerned with the ways in which subjectivity and sociality are based on the expulsion of that which is considered unclean or impure from the clean and proper self. This involves a rejection or disavowal of the subject's corporeal functioning, especially those functions that are defined as filthy or anti-social. However, this process of rejection can never be final or complete but remains always at the border of the subject's identity, threatening to dissolve apparent unities and making identity a continuously provisional state. It is the individual's recognition of the impossibility of a permanently fixed and stable identity that provokes the experience of abjection. Objects that produce abjection are those that traverse the threshold of the inside and outside of the body – tears, urine, faeces and so on. The abject, then, is the space between subject and object; the site of both desire and danger. There are echoes here of the Kantian sublime, for both terms signify an immense power in their generation of attraction and repulsion in the subject.[52] For Kristeva the abject is on the side of the feminine; it stands in opposition to the patriarchal, rule-bound order of the symbolic. The bodily state that Kristeva likens to abjection is pregnancy, for in the condition of parturition the maternal body stands at the borderline of categories and dissolves the socially contructed margins of identity and the distinctions between life and death, self and other.

Even in the highly summarized accounts given here, the links between the arguments of Douglas and Kristeva are clear. For both writers power lies at the margins of socially constructed categories, for it is here that meaning is called into question and challenged. The main distinction between their positions is that whereas for Douglas bodily boundaries are not privileged in any way but are seen as symbols of and responses to social orderings, for Kristeva the body's margins are primary as the site for the subject's struggle for attainment of identity.

The sublime, abjection, the *parergon* – the term itself is not important. If one draws on such a broad range of theoretical positions it may seem that the resulting heterodoxy is too unwieldy or contradictory to be of use. Certainly, aspects of these analyses are not necessarily compatible but they

are not being offered as an agreeable theoretical blend that, once mixed, points the single way forward for a feminist cultural politics of the female body. It is, however, helpful to interrogate these ideas and to reflect on the ground that they share and the tensions between them. This is not simply to be caught up in an undiscriminating ebb and flow of intellectual ideas but is a way of discovering new paradigms for considering the range of issues raised by visual representations of the female body within contemporary western society.

What the discussion in Part I points to is that meaning is organized and regulated at the edges or boundaries of categories. These borderlines are important, they are powerful, for, as Douglas writes, 'all margins are dangerous. If they are pulled this way or that the shape of fundamental experience is altered.'[53] This notion raises possibilities for a feminist critique of patriarchal representations of the female body and may suggest some directions for alternative ways of representing – through art practice and criticism – the female body. The classical, high-art tradition of the female nude plays on the ideal of wholeness and contained form. Its formal integrity then offers to the discerning connoisseur the attractions of an uncompromised aesthetic experience. It may well be, then, that these values can be questioned by highlighting how this category is maintained, through artistic protocols and the construction of viewing positions and critical criteria. It is not possible to dream up a single solution, a formula with which artists and critics may produce a new, 'correct' discourse on the female body, but it is worthwhile re-opening the debate and identifying a set of issues for feminists to discuss and develop.

The patriarchal tradition of the female nude subsumes the complex set of issues and experiences surrounding the representation of the female body within a single and supposedly unproblematic aesthetic category. If one challenges the boundaries of this category, it is at least possible to propose not a single aesthetic register but a range of possibilities and differences – distinctions of race, size, health, age and physical ability which create a variety of female identities and standpoints. In its articulation of differences, an engaged feminist practice necessarily breaks the boundaries of the high-art aesthetic symbolized by the female nude. Unity and wholeness give way to differences and a recognition that the female body is in a continual process of definition and change. And finally, the coy play on eroticism and aesthetic experience is replaced by a direct address to the relationship of desire, visual representation and the female body. Rather than 'being framed', it is a question of who draws the lines, where they are drawn and for whom.

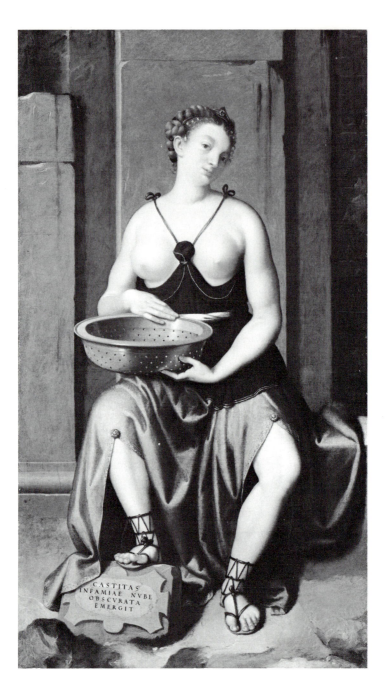

Plate 1 Giovanni Battista Moroni, *Chastity*, mid-to-late 1550s.
(The National Gallery, London.)

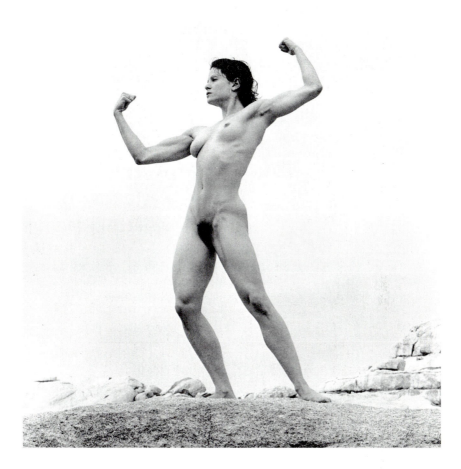

Plate 2 Robert Mapplethorpe, 'Lisa Lyon', 1980.

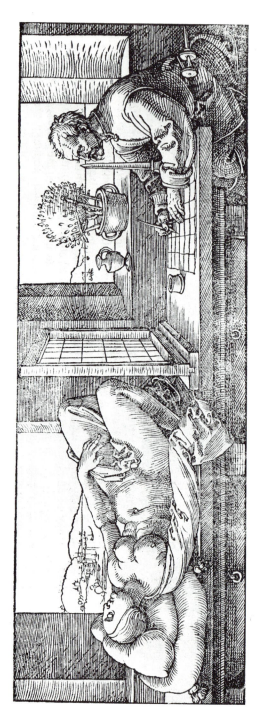

Plate 3 Albrecht Dürer, *Draughtsman Drawing a Nude*, 1538.

Plate 4 Leonardo da Vinci, Human figure illustrating proportions ('Vitruvian Man'), *c*.1485–90.

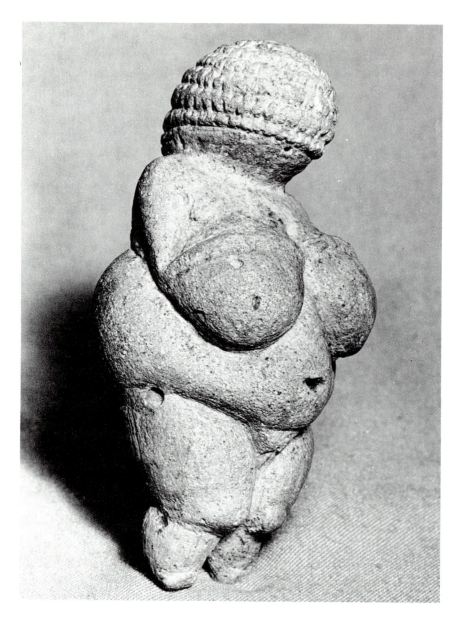

Plate 5 Prehistoric figure of a woman ('The Willendorf Venus'), *c.* 21000 BC.

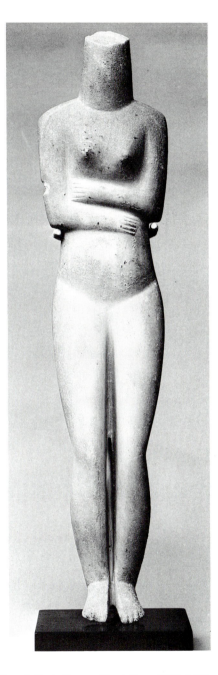

Plate 6 Cycladic marble doll, *c.* 2500–1100 BC.

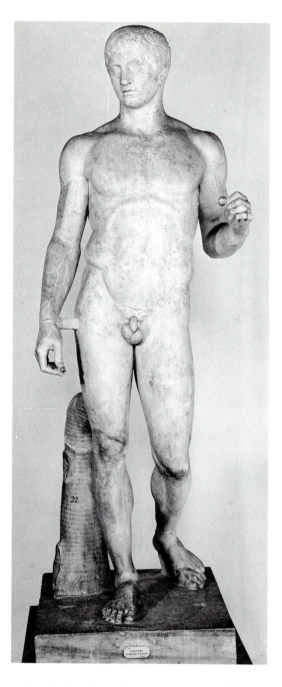

Plate 7 After Polyclitus, *Doryphoros*, *c*.450 BC.

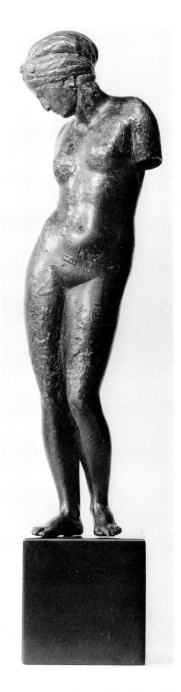

Plate 8 Bronze figure of a girl, *c*.400 BC.

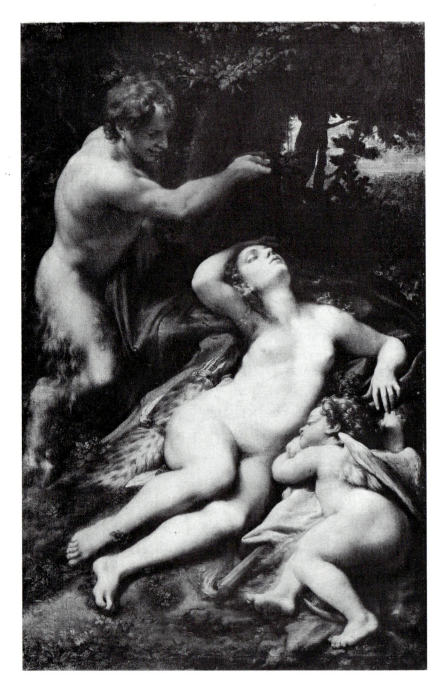

Plate 9 Antonio Correggio, *Jupiter and Antiope*, 1524–5.

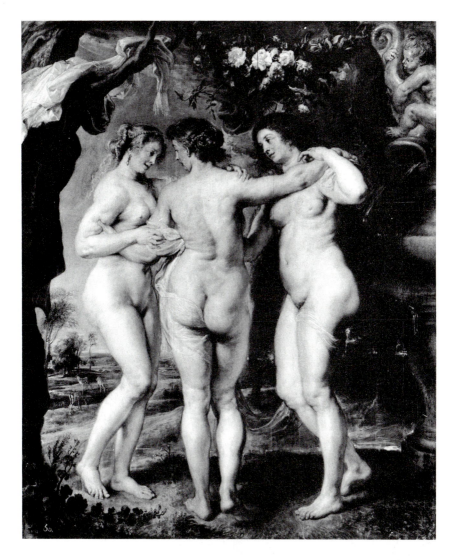

Plate 10 Peter Paul Rubens, *Three Graces*, c.1639.

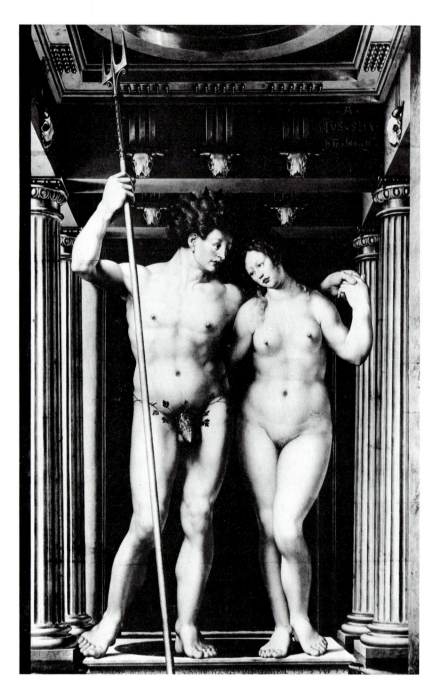

Plate 11 Jan Gossart, *Neptune and Amphitrite*, 1516.

Plate 12 Georges Rouault, *Filles ou Prostituées*, 1906.

Part II

REDRAWING THE LINES

1 'THE DAMAGED VENUS'

On 10 March 1914, shortly after 10.00 a.m., a small woman, neatly dressed in a grey suit, made her way through the imposing entrance of the National Gallery, London. It was a Tuesday and so one of the Gallery's 'free' days, when the entrance fee was waived in order to allow those who could not afford an admission charge an opportunity to enjoy and be instructed by some of the western world's most well-known and valuable works of art. The woman made her way through the Gallery's succession of rooms, pausing now and then to examine a painting more closely or to make a drawing in her sketch-book. Eventually she made her way to a far corner of Room 17, where she stood, apparently in rapt contemplation, before a picture on an easel. By now it was approaching lunch-time and the room was beginning to empty of the crowds who filled the gallery on its 'free' days. Suddenly, the tranquillity of the museum was broken by the sound of smashing glass. The attendant who was on duty in the room immediately looked up towards the skylights; some labourers had been working there earlier and perhaps there had been an accident. But within an instant it became clear that the noise came not from a broken skylight but from the corner of the room where the woman in grey had produced a small axe or chopper and was attacking the picture in front of her. As soon as the attendant realized what was happening he rushed over to stop her but slipped on the recently polished gallery floor, which slowed him down for a few critical seconds. By this time, other visitors in the gallery and two plain-clothes detectives had also joined in the fray. The woman, who put up no resistance, was disarmed and led out of the gallery, followed by attendants and an angry and noisy crowd of visitors and tourists. The woman in grey was Mary Richardson, a well-known and highly active militant suffragist; the painting that she attacked was Velazquez's 'Rokeby Venus'.

The following day Richardson was brought to court, tried and sentenced. In her speech from the dock she explained that the motive for her

attack was to bring to public attention the cruelty and hypocrisy of the Government's treatment of Mrs Emily Pankhurst. The judge passed a sentence of six months' imprisonment, the most severe possible for the damage of a work of art. Ironically, however, the sentence imposed was never specifically served. At the time of her arrest for the National Gallery attack, Richardson was on temporary release from Holloway Prison under what became known as the 'Cat and Mouse' Act, which was used by the authorities to send prisoners out of Holloway when their lives were threatened by prolonged hunger-strikes. On her return to gaol, it was unclear which sentence she was actually serving.

On 11 March and succeeding days every national daily newspaper carried extensive reports of the incident[1] and many reprinted the statement that Richardson had sent to the headquarters of the Women's Social and Political Union (WSPU):

I have tried to destroy the picture of the most beautiful woman in mythological history as a protest against the Government destroying Mrs Pankhurst, who is the most beautiful character in modern history.[2]

Immediately following the attack on the painting, the National Gallery was closed to the public and within a day the Office of Works and the trustees and directors of the Wallace Collection, the Tate Gallery, the National Portrait Gallery, the Guildhall Art Gallery, Hampton Court and Windsor Castle collections had taken the same action. The nation's journalists were incensed. The British public – men *and* women – as well as visitors from around the world were prevented from seeing the country's greatest art treasures because of the 'dastardly' actions of one small woman in grey.[3]

This, roughly, is the sequence of events of Mary Richardson's attack on 'The Rokeby Venus' which has become one of the most notorious acts of iconoclasm in recent history.[4] Although there was a significant number of attacks by militant suffragists on works of arts and public buildings between 1912 and 1914, the 'Rokeby Venus' incident seems to have had the strongest hold on the public imagination whilst other similar attacks are largely forgotten or commemorated only in archives or the minutes of Gallery Board Meetings.[5] The incident has come to symbolize a particular perception of feminist attitudes towards the female nude; in a sense, it has come to represent a specific stereotypical image of feminism more generally. So although the general outline of the attack on 'The Rokeby Venus' is well known, it is worth re-examining some of the less familiar and apparently unimportant details of the story to see how they might alter our understanding of the significance of the event. My aim in doing this is not so much to pass a judgement concerning the morality of the act or its political perspicuity, but rather to see what may be yielded concerning the

meaning of the female nude and its relationship to patriarchy and feminism both in 1914 and today.

To start with, some details about the acquisition of the painting by the National Gallery. It was brought to England by the Duke of Wellington in 1806, having been acquired for Mr Morritt of Rokeby Hall in Yorkshire. The picture remained in the family for 100 years until 1905, when permission was obtained from the Court of Chancery to sell the painting which then came into the hands of the art dealers, Messrs Agnew. After the raising of money by private subscription 'The Rokeby Venus' was purchased from Agnew for £45,000 by the National Art Collections Fund and was presented to the National Gallery in January 1906. Whilst there were those who did not approve of the purchase and who felt, for various reasons, that the painting was not suitable for a national art collection, on the whole, art critics, historians and curators supported its acquisition for the nation. 'The Rokeby Venus', they argued, was an outstanding example of the genre of the female nude and was unique in the *œuvre* of Velazquez. Just before the purchase was completed, an article in *The Times* described it as 'perhaps the finest painting of the nude in the world', an opinion that it endorsed nine years later when it conveyed to its readers the significance of the image that had been damaged in Mary Richardson's attack:

> The picture which is in perfect condition, is neither idealistic nor passionate, but absolutely natural, and absolutely pure. We may indeed echo the words of an eminent critic and say that . . . 'She is . . . the Goddess of Youth and Health, the embodiment of elastic strength and vitality – of the perfection of Womanhood at the moment when it passes from the bud to the flower'.[6]

According to its advocates, 'The Rokeby Venus' could satisfy all tastes. Avoiding aesthetic and moral extremes, the figure seems to have conveyed an image of eugenic perfection – woman in her prime, young, healthy and fertile! But not only was it an image of womanly physical perfection, it was also the nation's. No longer was it in any material sense the 'Rokeby' Venus, it was now the nation's Venus and much of the outrage in 1914 was focused on the fact that Richardson had attacked a work of art that, in principle, belonged to every man and woman in the country.[7] The value of the painting thus far surpassed its financial or artistic worth; its importance was also measured in terms of its representation of a certain kind of femininity and its position in the formation of a national cultural heritage. The object that Mary Richardson targeted for her attack was thus one that could bear a number of meanings for its various audiences.

Between 1912 and 1914 the WSPU embarked on the most militant and violent phase of its campaign. Believing that parliamentary reform would not bring about votes for women, the WSPU organized systematic violence

and widespread destruction of public property. As Lisa Tickner has written:

> No longer interested in converting the public, they set out to astound and appal it . . . The WSPU became focused on daring deeds of furtive guerrilla activity performed by a small number of individuals tasting what Christabel (safely secluded in Paris) referred to as 'the exaltation, the rapture of battle'.[8]

In the context of the WSPU's militant tactics, it was clearly realized by the authorities that public monuments, museums and galleries were likely targets of suffragist attacks. Special precautions were taken to try to prevent such an outrage and in the National Gallery the ordinary staff of attendants had been supplemented by police constables and plain-clothes detectives for at least twelve months before Richardson's attack. But what also begins to emerge from contemporary sources is that especial watch was being kept on 'The Rokeby Venus'.[9] We can only speculate about the reasons why this painting, more than others, was identified by both the authorities and the militants as an 'appropriate' target. But even with our historical distance the choice seems inevitable: 'The Rokeby Venus', hailed as a paragon of female beauty, an exemplar of the female nude, a national treasure and worth a fortune – surely this combination of values and meanings distinguished it from other works in the Gallery, including other female nudes.

In 1914 Richardson herself emphasized that her choice had been motivated by her anger at the Government's treatment of Mrs Pankhurst. Justice and beauty did not simply apply to the treatment of great works of art but had also to be extended to the treatment of political causes and their leaders. It was a case of 'an eye for an eye': if the Government was going to mistreat and abuse Mrs Pankhurst, then Richardson felt justified in her violent attack on a 'figure' of femininity which those same authorities held in esteem. As a lover of art, it had been difficult for her to damage such a beautiful work, but her hand had been forced, she claimed, by the Government's indifference to the suffragist cause. In her statement during her trial, Richardson appears calm and articulate and nothing is said explicitly about any objections that she might have had to a female nude. Indeed, it was not until an interview given in 1952 that Richardson gave an additional reason for choosing the Velazquez: 'I didn't like the way men visitors to the gallery gaped at it all day.'[10] Although this point was never made in 1914, it seems likely that the apprehension of this kind of objection lay behind the additional security measures taken by the Board of Trustees and Scotland Yard. All parties concerned in the incident – the Gallery, Richardson and the press – were willing to represent it in terms of the conflict of two opposed forms of femininity: the patriarchal ideal (the Venus) and the deviant (the militant suffragist).

The construction of Richardson as deviant can be easily traced in contemporary newspaper reports. Descriptions of her behaviour range from the relatively moderate label 'wild woman' to more fantastic accounts of her in 'a wild frenzy', 'hacking furiously' and 'raining blows' upon the picture. These images of uncontrolled wildness seem, at first, to sit uncomfortably with the representation of Richardson as a small, quiet woman of demure appearance which also appeared in the same reports. But what seems to be happening is the presentation of deviant femininity as a kind of demonic possession, in which the calm exterior is simply a dissembling mask for desocialized and violent female drives.[11] This representation of Richardson should also be seen in the wider context of contemporary anti-suffrage imagery which Lisa Tickner has discussed:

> within its rather elastic sense of the 'hysterical' anti-suffrage imagery produces the signs of feminine deviance in the flushed expressions, wild gestures, and cognate lapses from womanly decorum . . . What anti-suffrage imagery does to great effect is to give feminism a sexual pathology which makes it a 'law and order problem', not only for the interests of the Empire and the state, but at the deepest levels of sexual identity.[12]

Richardson's attack on 'The Rokeby Venus' enabled a visualization of this lapse from womanliness in the form of the mad assailant and her decorous victim.

In using the term 'victim', one reaches the central signification of the incident. As we have seen, contemporary reports emphasized the violence of Richardson's attack on the canvas, 'hacking', 'slashing', 'raining blows'. But surely we are more familiar with this language in a different context, applied to a different order of crime? Newspapers represented the attack on 'The Rokeby Venus' in the visual and written language usually reserved for the sensation murder. Reports provided detailed accounts of the attack, the weapon used, and the nature of the damage. In the representation of the attack as a murder, the nude figure of Venus becomes a 'victim' and the cuts in the canvas are described as 'cruel wounds'.[13] Moreover, Mary Richardson was nicknamed 'Slasher Mary', the 'Ripper', the 'Slasher' – the connections are surely obvious.[14] The *Daily Mail* illustrated its coverage of the story with a picture of Richardson's face above a close-up of a hand holding the kind of chopper that was used in the attack. Exactly this kind of juxtaposition of images was commonly found in the *Police Gazette* and in the more sensational coverage of violent murders. *The Times* seems to have 'scooped' the other 'dailies' by carrying a photograph of the damaged picture itself (Plate 13), but other papers were happy to reproduce the undamaged painting with the approximate position of the cuts superimposed. The *Daily Sketch* went one step further for its front page and showed the painting 'Before' and 'After' the attack,

under the headline: 'How the Rokeby "Venus", Bought by the Nation for £45,000, was Slashed with a Chopper by a Suffragette in the National Gallery'.

Journalists were meticulous in their descriptions of the number and extent of the cuts to the canvas; *The Times* referred to a 'cruel wound in the neck' and to cuts across the 'shoulders and back'. In other words, the attack was assessed in terms of the wounds inflicted on a female body rather than in terms of the damage caused to a valuable painted canvas. But perhaps the most interesting example of this substitution of flesh for canvas is in the description of the damage caused where the blunt end of the chopper struck the canvas, causing rough tearing and an indentation rather than a clear cut with the blade. This was apparently more difficult to repair than the places where the blade had cut straight through the canvas and caused the greatest problems for the conservationists.[15] In a press statement, Mr Hawes Turner, the Keeper and Secretary of the National Gallery, described this damage as 'a ragged bruise on the most important part of the work' and most of the papers fixed upon this notion of 'bruising' in their own accounts of the damage to the painting. To bruise is to discolour or contuse but to keep the damaged surface/skin intact; it suggests a soft, three-dimensional form, and one might think of bruising to the flesh of fruit or a human body. To refer to the damage on 'The Rokeby Venus' as a bruise is instantly to confuse the distinctions between hardness (the canvas) and softness (the signified female body). The viewers of the damaged painting could not be confined to descriptions of a flat surface but moved directly to the evocation of a three-dimensional form with surface and volume – in other words, to the account of damage to a woman's body rather than to a picture.

Something further needs to be said about this image of the damaged painting. Shards of glass testify to the first blow from Richardson's weapon and recall suffragist attacks on the windows of famous London department stores such as Liberty's, and Swan and Edgar, during the same period. The female model in the shop window, and the Venus in the painting, both represent an ideal image of femininity and in both cases the plate glass acts 'as both barrier and transparent substance, representing freedom of view joined to suspension of access . . . [and] figures an ambivalent, powerful union of distance and desire'.[16] The broken windows and the smashed glass of 'The Rokeby Venus' powerfully symbolized the suffragist rejection of patriarchal culture both on the street and in the art gallery.

Each subsequent blow is marked by a further cut in the canvas. At one level, any image of a naked female body, cut and torn, covered with the traces of a violent attack, is profoundly horrifying and this is no exception. But the disturbing effects of the photograph of the damaged painting are also produced through the bringing together of particular and highly conflicting codes of representation. What is so uncanny about the damaged

'Rokeby Venus' is the concatenation of the signs of violence on the surface of the canvas and the unperturbed stillness and meditation on female beauty that is represented in the fictive space of the painting. The image is at once familiar and also strange; it is a female nude frozen in the process of a terrifying metamorphosis from high-art icon to murder victim.

In the photograph the span of the figure's back and legs becomes not so much an exercise in the technical mastery of form and colour (as some critics have advocated) as the vehicle for an appalling exhibition of the cuts in the canvas. In this context, the reflection in the mirror held by the complicit Cupid becomes a display of passivity in suffering. The antithesis between the hiatus on the surface of the picture and the calm passivity of the scene represented within the pictorial space is unbearable.

In a recent article Edward Snow discusses the ways in which viewing positions are constructed by 'The Rokeby Venus'.[17] Contesting a tendency which he perceives in recent feminist theorizations to universalize the male gaze as fixed, patriarchal and phallocentric, he identifies the painting as an exception to the genre of the female nude which complicates the gendering of the viewing situation and which exposes the fantasy of the controlling power of the 'male gaze'. Snow's analysis rests on a number of elements in the painting, chief of which is the effect of the reflection in the mirror:

> The face in the painting's mirror has a disconcerting tendency to gaze
> – without the knowledge of the woman from whom it apparently
> derives – directly into the eyes of the viewer, with knowing intimacy.
>
> (p. 36)

If one leaves aside the somewhat puzzling incidental point about whether or not this 'woman' can be usefully said to have knowledge of anything at all, the significance of Snow's observation is that he goes on to claim that this misalignment of gazes in the painting detaches the mirror's image from the figure and allows it to gaze down at the body and assume a priority of desire within the inner dynamics of the painting. For Snow, the Cupid is the attendant of the face in the mirror and together they form a pre-oedipal bond, the infant and the maternal, gazing out together on the 'single self-sufficient female body' which they have nurtured.

A great number of trees must have been expended in the speculations about the face in the mirror of 'The Rokeby Venus'. As early as 1906, in a lyrical celebration of the painting just acquired by the National Gallery, another critic offered a very different interpretation. For Filson Young, there was a perfect match between the back of the head and the reflection in the mirror:

> The mirror's surface does not move here nor flow away, but stays,
> like a thing that holds its breath to preserve a perfect moment . . .
> The two faces of perfection hold each other in still fascination . . .

and within the chamber there are stillness unbroken and contentment profound.[18]

For 'faces', we can read 'sides' or 'aspects' of perfection and here the mirror seems to be fulfilling its conventional purpose of offering the spectator a fully rounded viewing experience. The reflection in the mirror assures us that we are looking at a complete female body, with volume and planes as well as surface.

Perhaps it would surprise Snow to discover that there is a strong similarity between his appreciation of 'The Rokeby Venus' and that of the effusive Filson Young. But both critics evoke their experience of viewing the painting in terms of the pleasures of an uninterrupted 'scanning' of the full length of the figure, and, for both, the beauty of the painting seems to lie in its representation of 'wholeness', of female flesh contained within defining contours. Young describes the outlines of the form which are 'for our imperfect vision the finite terms in which the beauty of her form expresses itself'; and Snow argues that 'the whole horizontal project of the painting . . . [sweeps] our gaze along the lines of the woman's span, transporting us into an experience (aesthetically even more irresistible) of the whole unbroken body' (p. 41).

The point of looking at two such diverse historical and intellectual critical responses to 'The Rokeby Venus' has been to show that, in spite of their differences, both point to the face in the mirror and the perception of a bounded and yet expansive female form as the sources of the painting's power. If they come any way towards being correct, then perhaps they also help us to understand the shocking effects of the photograph of the damaged painting. It is precisely these two features that are most compromised by the results of Richardson's attack. The viewing situation is utterly changed. No longer can the spectator scan the uninterrupted expanse of the back of the figure. Although the formal arrangement of the painting might incline the viewer to do so, this is constantly undermined by the vertical cuts in the canvas. The face in the mirror might lead us to believe that the body has volume, but the cuts and marks insist on its fabrication, that it is a flat, painted canvas. In 1914 the *Daily Telegraph* dismissed the recent controversies concerning the authorship of the painting and despaired: 'Yesterday a female miscreant left her own markings on the work with an axe.'[19] Richardson's attack amounted to a re-authoring of the work that ruptured the aesthetic and cultural codes of the painting and of the female nude more generally. No longer a fantasy object for visual pleasure and speculation, the photograph exposed smashed glass and a torn canvas – a testimony to an image and a viewer who would no longer play the game.

The press reaction in the face of this 'outrage' is, therefore, hardly surprising. Confronted with the breakdown of the genre of the female

41

nude, they placed the incident within a different narrative structure, that of a sensational murder case. The painting was the perfect 'victim' – 'The Nation's Venus' a finished, unflawed beauty. But Mary Richardson was not quite the perfect killer. Although she could be pathologized, represented as deviant or hysteric, the vocabulary of the really sensational crime called for a male murderer. And so we have the appellation 'Slasher Mary'. This nickname was a half-hearted attempt to insert the attack, and the idea of female violence generally, within the more familiar pathology of male violence. In a contemporary cartoon in *Punch*, this re-gendering of the assailant is complete (Plate 14). Here the cartoonist uses the 'Rokeby Venus' incident to bring together the two main pieces of legislation of the day: the Reform Bill and the Home Rule Bill which proposed to allow opting out of a united Ireland on a county basis for six years only.[20] The Richardson figure is replaced by the Unionist MP, Andrew Bonar Law, and the Venus has become an embodiment of both the Bill and a united Ireland. The cartoon thus assumes the traditional symbolism of representing a country, and more especially Ireland, as a woman's body; only here, the contained span of the figure of Venus will fragment into the disunited counties of Ireland. The 'Rokeby' incident works well as a platform for a satire on Home Rule, since both situations are concerned with a conception of an ideal whole and its reduction, through attack, to imperfect parts. And, no doubt unwittingly, the cartoonist also resolves some of the remaining anxieties regarding women's suffrage, as the feminist activist is turned into a man.

In her statement to the nation's press, Mary Richardson presented her action as a symbolic act, only the symbolism of the incident went further than she could possibly have known or controlled. In the press representation of the affair as the frenzied attack of a militant feminist on an image of perfect womanly beauty, it becomes a metaphor for the operation of the female nude discussed in Part I of this book. If the female nude is understood as the transformation of matter into form, as the containment of the wayward female sexual body within the framing outlines of artistic convention, then Richardson can be seen in terms of that pre-formed matter, as the fearful spectre of female sexuality that has to be regulated through male style. And perhaps Richardson is also the frightful embodiment of the capricious male connoisseur, whose behaviour in front of the canvas fails and who exposes art to the kinaesthetic responses of pornography.

But this is all in the realm of speculation. What seems more certain is that the attack on 'The Rokeby Venus' has come to symbolize a particular crude perception of feminism and of feminist views of male-engendered images of the female body. This is surely the explanation of Tom Phillips's assessment of the exhibition *The Nude: A New Perspective* (Victoria and

Albert Museum, 24 May–3 September 1989) which attempted to introduce feminist approaches to the nude into the art gallery. According to Phillips: 'You only have to be a bit more barmy than this before it's hatchet time at the National Gallery.'[21] So we have come full circle; the spectre of the axe-wielding Mary Richardson stands behind every feminist pronouncement on the representation of the female body. The aim of Part II is partly to exorcize this ghostly presence. It seeks to examine just how 'The Rokeby Venus' could come to represent such a complex multiplicity of meanings to its audiences by looking at the dissemination of the patriarchal ideal of the female nude through the institutions of art education and art criticism. The most substantial section will consider some recent feminist art that has drawn on the female body for its subject matter. It is hoped that this discussion will offer a more sensitive understanding of feminist approaches to the power of the image.

2 THE FRAMEWORK OF TRADITION

In his introduction to a National Gallery booklet on Velazquez's 'Rokeby Venus', Neil Maclaren opens with the following words:

> A French writer, Paul Valéry, has written that the nude is for the artist what love is for the poet. The human body does, indeed, present the painter or sculptor with extraordinary possibilities for the exhibition of his talents. In particular the humanist artists of the Renaissance and Baroque periods, for whom the sculpture of Greek and Roman antiquity represented the most complete and perfect expression of art, made the nude one of the principal vehicles of artistic expression . . . Velazquez's *Toilet of Venus* is one of the world's greatest and most famous pictures; it is also one whose subject is universally pleasing, and whose manner of painting is wholly congenial to modern taste.[22]

From almost every point of view this is an entirely unexceptional piece of writing; the observations which it makes about the nude are made in nearly every study of the subject. Firstly, the nude is presented as the fountain-head of artistic expression; it is unlike any other subject matter and is the source of a unique and intense inspiration. Secondly, the nude has a flawless historical pedigree and is the subject of a long and authoritative tradition within western culture. At the same time, its appeal is said to be timeless and masterpieces of the genre transcend the historical specificities of their making. Finally, implicit within this kind of criticism is the assumption that the artist is male and that the human body in question is a woman's. The slippage from the ungendered category of 'the nude' to the

highly significant particularities of the 'female nude' is almost inescapable in writings produced from within patriarchal culture this century.

So far, I have been discussing the female nude in terms of its identity as a 'genre', but the concept of 'tradition' might be a more helpful and accurate way of understanding the significance of this group of images.[23] As Raymond Williams has shown, 'tradition' has a dual meaning; it describes both a handing down of knowledge, or passing on of doctrine, and a surrender or betrayal. Its ambiguity lies in this combination of an active process of transmission and a passive reception of something that is believed to deserve necessary respect and duty.[24] In the transmission and acceptance of statements, beliefs, rules and customs that constitute a tradition, there is also always a relinquishing or surrendering of alternatives. Tradition sets in place a history, a narrative that carries with it the authority of cultural continuity whilst also allowing (in fact, requiring) the possibilities of innovation.

If the female nude is understood discursively, that is, not only as a set of images, but also in terms of its formation through institutions such as art schools, galleries and publishing houses and through utterances in the forms of philosophy, art theory and criticism, then the concept of tradition is helpful in understanding the cultural power of this discourse. The projection of the female nude as one of the primary aesthetic traditions within western culture works as an ordering device. It implies that what are actually highly diverse ranges of images have a virtually uninterrupted and progressive history of representation, stretching, in this case, from classical antiquity to the Renaissance and on to the heroic achievements of modernism. This historical sequence is punctuated with the names of the outstanding masters of the form – Giorgione, Titian, Rubens, Boucher, Ingres, Manet, Renoir, Degas, Picasso – with variations to fit the trajectory of particular artistic tendencies.

In a number of articles written over the last fifteen years, Carol Duncan has done much to expose the mutually reinforcing relationship between modernist innovation and the female nude. On the one hand, the stylistic experimentation of modernism works to revitalize and extend the tradition of the female nude and, on the other hand, the representation of the female body in these images functions as a critical sign of male sexuality and artistic avantgardism. In one of the earliest and best known of these pieces, entitled 'Virility and Domination in Early Twentieth-Century Vanguard Painting', Duncan argues that, both in terms of style and imagery, the female nude in European modernism asserts a particular ideal of artistic identity as male, virile and sexually uninhibited: 'The assertion of that presence – the assertion of the artist's sexual domination – is in large part what these paintings are about.'[25] Duncan sees the stylistic distortions and abstractions of the female body in modernist art as a form of cultural subjugation of women by men. Women are portrayed as powerless and

vulnerable, given meaning only through the creative force and potency of the male avantgardist. She states:

> More than any other theme, the nude could demonstrate that art originates in and is sustained by male erotic energy. This is why many 'seminal' works of the period are nudes. When an artist had some new or major artistic statement to make, when he wanted to authenticate to himself or others his identity as an artist, or when he wanted to get back to 'basics' he turned to the nude.
>
> (p. 306)

Although much of the analysis is framed in the language and by the concerns of the Women's Movement in the early 1970s, its importance lies chiefly in the way it opens out and extends our understanding of the social meanings of the female nude. Duncan helps to create a different kind of framework for analysing modernism and its place within the tradition of the female nude.

In a more recent article, Duncan develops some of these themes in relation to the installation at the Museum of Modern Art, New York (MoMA).[26] Identifying MoMA's central role in the promotion of mainstream modernism, she points to the particular pride of place given to modernist versions of the female nude. In the light of the modernist narrative of the progressive refusal of representational elements, Duncan suggests that the conspicuous placing of these images of the female body within the gallery's installation works to 'masculinize the museum as a social environment' (p. 173). In the broader historical context of male anxieties concerning the sexualized female body, the modernist trajectory is defined by Duncan as an attempt to transcend the earthly domain of woman/nature/representation in order to discover the higher masculine plane of pure abstraction. The tradition of the female nude works here to identify the spiritual quest for abstraction as an exclusively male endeavour. Duncan gives as an example the placing of Willem de Kooning's *Woman I* (Plate 15) on the threshold to the rooms containing the great Abstract Expressionist breakthroughs by Pollock, Rothko, Still and so on. The interpretation that is suggested through this installation is that the female body, woman, must be confronted and transcended on the way to spiritual and artistic enlightenment (abstraction). The reference to the tradition of the female nude at this point lends abstraction a cultural authority whilst marking its radical extension of that history. Finally, Duncan makes a suggestive but perhaps rather forced connection between the experience of soft-porn street displays and the exhibition of the female body in the galleries of MoMA. Although subject to different conventions of representation and viewing protocols, both spaces affirm male domination and remind women that:

their status as members of the community, their right to its public space, their share in the common, culturally defined identity, is not quite the same – is somehow less equal – than men's. But these signals must be covert, hidden under the myth of the transcendent artist-hero.

(p. 178)

Duncan's work demonstrates some of the ways in which feminist theory breaks open the otherwise hermetically sealed tradition of the female nude. She begins to show the ways in which the female nude has been used to transmit rules and standards and how the passive reception of those ideas necessarily involves a kind of surrendering or relinquishing of power for women. As we have seen, the notion of tradition works to contain dissent and to create a particular kind of public for images of the female body through the assertion of an ideal of aesthetic transcendence and timeless appeal. Social difference and political contestation are held in abeyance through these structures as we are incited to celebrate an historical continuum of male mastery over the female body. In order to counter this tradition feminist theory needs to engage in a redefinition of aesthetic and intellectual knowledge. It needs to focus on the question of women's self-representation and self-definition and to highlight those aspects of the relationship of the body and female subjectivities that have been consistently obscured by and omitted from the western tradition. This is not to stay within the framework but to identify its interests and limits and to create different structures of understanding.

3 THE LESSONS OF THE LIFE CLASS

The study of the female figure is indispensable to the education and experience of the artist.
(Douglas Graves, *Figure Painting in Oil*, 1979)[27]

From the Renaissance onwards the standard training for art students was organized around three main principles: the antique, the life class and the study of anatomy.[28] Although other subjects such as perspective, ornament and history were also taught, these were nearly always subordinated to the principal area of study which was the human figure. Study from the figure was taught in academies, studios and workshops and from the early seventeenth century it was also disseminated through engravings in printed drawing books.

Art in the early modern and modern periods was a central factor in the formation of national identities. European nations competing for trade markets also competed for mastery in the cultural domain and a thriving

national school of painting was regarded as an index of a nation's power and prosperity. Drawing on classically inspired theories of art and Renaissance categories of rhetoric, the first academies of art classified painting into a hierarchy of genres or subject types. At the bottom of the hierarchy was still-life, those subjects drawn from the inanimate world and for which the signs of painterly virtuosity were paramount. Further up the hierarchy came landscape which could, by ridding itself of local particularities and assuming the impedimenta of classical mythology, be promoted to near the top of the scale. Portraiture also enjoyed a relatively elevated position, but the most important place was reserved for history painting – art that improved upon the flawed nature of individual subjects and represented men and women at their most perfect. History painting was conceived of as a moral endeavour; the subjects it represented (derived from the Bible, ancient history and classical mythology) were intended to instruct and improve. It was a monumental art – large-scale and filled with references to classical antiquity and, in the case of the subsequent academies, the art of the Italian Renaissance. History painting not only described a certain kind of subject matter, but also defined protocols for viewing. Audiences were to be raised above the mere sensual appreciation of paint on canvas and were to be instructed and elevated by the moral lessons displayed before them. For the ambitious imperialist nations of Europe, it was not enough to have a school of art based on the painting of animals or still-lifes. Their aim was to produce a school of history painters that would properly reflect their position and authority.

The education of history painters and the entire curriculum of the academies thus revolved around the grand triumvirate of the antique, the life class and anatomy, with one or more of these categories assuming priority according to the vicissitudes of academic theory. The use of male and female models in the life class varied in different European countries. In England, the use of female models seems to have been a fairly frequent occurrence from the late seventeenth century onwards; whereas in France, in the Académie Royale de Peinture et du Sculpture, naked female models were forbidden throughout the seventeenth and eighteenth centuries and their use was prohibitively expensive for the privately run studios. In very general terms, it can be said that the unclothed male model dominated the life class in European academies and studios up until the late eighteenth century, but that around this time there was a perceivable shift in emphasis to the study of the unclothed female model and that by the middle of the nineteenth century the female nude had become the dominant form in European figurative art. Although one does not wish to rush headlong into historical explanations of the 'rise of the bourgeoisie' kind, there can surely be no doubt that the proliferation of the female nude in nineteenth-century European art is related to complementary shifts in the definition of femininity and female sexuality during the period.[29] The construction of an ideal

of femininity based on economic dependence and passivity can be traced through on a cultural register, in attitudes towards the female model and in the historical development of the nude. Marcia Pointon has noted the relationship between the examination of the female body in nineteenth-century medical and artistic training:

> The lecture room in the medical school was constructed in ways similar to the Life Class in the academy and art students received lectures on anatomy as did medical students. The same kinds of exclusions founded on gender operated in both institutions; women were excluded from the Life Class (and thus from the higher echelons of professionalism) and were debarred from becoming doctors.[30]

Examining the female body internally and externally, medicine and art, anatomy and the life class, offered a thorough surveillance of femininity, regulating the female body through the definition of norms of health and beauty. The collaborative effects of medicine and art have continued unabated throughout the twentieth century and it is only in recent feminist art and performance work that the power and ideological function of these two discourses have begun to be challenged (see Section 6 'Redrawing the Lines').

For a number of traditional art critics the historical shift from the male to the female nude has seemed an inevitable and fully justifiable phenomenon. For these writers, the female body is inherently of greater formal and aesthetic interest and offers more of a technical challenge to artists at every stage of their careers. In *The Nude* Kenneth Clark dates the predominance of the female nude over the male as early as the seventeenth century:

> No doubt this is connected with a declining interest in anatomy (for the écorché figure is always male) and so is part of that prolonged episode in the history of art in which the intellectual analysis of parts dissolves before a sensuous perception of totalities . . . no doubt in the eventual establishment of the female body the tug of normal sensuality must have a place. But it is also arguable that the female body is plastically more rewarding on what, at their first submission, seem to be purely abstract grounds . . . [Artists] have found it easier to compose harmoniously the larger units of a woman's torso; they have been grateful for its smoother transitions, and above all they have discovered analogies with satisfying geometrical forms, the oval, the ellipsoid and the sphere.
>
> (pp. 343–4)

There are a number of points to be drawn from this passage. Firstly, Clark describes the study of the female body as a less intellectual practice than the study of the male body. More interestingly perhaps, he then reinscribes

this perception of the female body within an aesthetic of whole or complete forms which, as we have already seen, is a dominant theme in the aesthetic regulation of female sexuality. Clark goes on to outline a number of inherent reasons for the ascendancy of the female nude: its formal composition, its expression of elementary notions of design and the force of male heterosexual desire. The assumptions of this text regarding physical, psychic, sexual and aesthetic norms are astounding but they are repeated with striking regularity in most mainstream texts on the subject. Take, for example, the following extract from a publication directed at the wider art-book market:

> It is undeniable that, in drawing and painting, the female body is much more frequently dealt with than the male. This is not only to be explained by the obvious fact that the unclothed woman is usually far more attractive to the artist . . . It is also true that the female body offers a greater variety of forms and contours to draw, and light and shadow have more differentiated forms and surfaces to define.[31]

The details vary slightly, but otherwise the basic dual justification of formal integrity and sexual appeal is once again delivered.

What is clear from all of this is the way in which the scenario of the life class has become a staple part of the definition of masculinity and artistic identity. One has only to look at the series of artists' portraits by the photographer Brassaï to see how the naked female model functions as a sign of the artist's authority and stature (Plate 16). The aged Matisse, sketch-book in hand, is depicted next to the posing female model. In what seems to be rather uncomfortable proximity, Matisse peers at the woman's body, his white coat lending him the appearance of the physician as much as the artist. On an easel in the foreground, a canvas reminds us of the great master's style – part of a room, boldly painted, with a roughly notated nude on the wall. The female nude in the painting has clearly moved on far from the concerns of naturalism, so the representation of Matisse with a naked female model in his studio reaffirms that such study is the basis of all artistic creation and that the male artist–alchemist will effect the transmutation of the female body's base matter into the 'gold' of great modernist art.[32]

But the lessons of the life class are not confined today to those who are fortunate enough to attend art schools and specialist courses. In an inevitable historical extension of the seventeenth-century engraved drawing books, advanced printing technologies have created a new mass genre publication: the widely circulated, cheap, 'do-it-yourself' life-class manual. These step-by-step guides and instruction books give a good idea of how the female nude and art itself is packaged to a broader cultural market.

The manuals frequently try to humanize the more impersonal aspects of 'distance learning' by addressing readers individually and by evoking the

ambience of an actual life class. The reader/student who, more often than not, is working alone and from the examples and illustrations in the book, is nevertheless constantly advised of the precedents, procedures and rewards of working with a real model. The detail into which these authors go to create for their readers the experience of the life class suggests nothing so much as the careful construction of a fantasy *mise-en-scène*:

> It has occurred to me that you might never have attended a life class. If you have, you've probably noticed that every student has a different problem or bunch of problems. I'd like you to follow me on a tour of my class; maybe some of the questions that bother you will be answered here. I've worked with some of these students before; some of the others are new . . .[33]

The text's voice is that of the master standing over the shoulder of the reader and offering individual guidance and advice: 'Because each student has a different view of the pose, I never teach the class *en masse*. I walk around and talk to each student individually about his particular view.'[34] The manuals thus offer the lessons of the life class to a mass audience, but projected as a fantasy of direct study of a living model and individual attention from the master.

Most of these publications enthusiastically reproduce the sexual myth of the artist/model relationship and in this way the reader is always positioned as a male whilst the bodies that he is invited to study are female. According to the mythology, the artist's female model is also his mistress and the intensity of the artistic process is mirrored only by the intensity of their sexual relationship. This sexual fantasy has been so prevalent in the narrativization of the lives of male artists that its traces are now indissolubly attached to the image of the life class. It is this potential, as much as any technical training, that is being sold to the purchasers of the manuals and handbooks. A photograph of the artist's studio in *Painting the Nude* (1976) shows the artist/author, Francesc Serra, seated with a model (Plate 17). The juxtaposition of the naked model and the clothed artist is a usefully blatant visualization of the power relations that are traditionally embodied in the life class. Behind the artist, part of a canvas is revealed showing a woman's head and shoulders thrown back in an abandoned pose and recalling the mythology of sexual congress. The caption to the image reads: 'The ideal model for the artist, Francesc Serra, should have a well-proportioned body, normal breasts, not large ones, but preferably small, and powerful hips and thighs.'[35] The art manual becomes the vehicle for a male-centred standardization of the female body, and the roles of artist, lover and judge are superimposed and mutually reinforced in its pages.

In this form of popular presentation, the life class is thus specifically gendered and sexualized. These meanings are both reflected and intensi-

fied by the frequently made assertion that studies of the female nude are a peculiarly intimate form of art, that they tell us more about the private nature of the artist than any other kind of image. In her study of twentieth-century painters of the female nude, Janet Hobhouse describes the images as autobiographical, as confessions in paint.[36] And the artists included in Jain Kelly's anthology, *Nude: Theory*, take this metaphor one stage further, presenting the depiction of the female body as a kind of sexual therapy, a way of working through unresolved childhood relationships and anxieties concerning women.[37] In all these texts and images, study from the living model is framed by the construction of male heterosexuality and this entire sector of the publishing industry tells us less about the practice of making images than it does about the coding of the female body as a sign of masculinity. The books provide their readers with sexual fantasies wrapped up in cultural capital, and artistic authority suffused with sexual possibilities – the two aspects are completely inseparable. And in the final instance, the pictures, style itself, carry this enormous connotative load: 'I get the keenest pleasure from drawings which are essentially spontaneous, in which there is the smallest time lag between the feeling – the desire – the ache to draw, and its expression.'[38]

There are, then, at least two contradictory forces at work in this genre of books. On the one hand, the presentation of public and objective artistic criteria for the conduct of the life class; and, on the other hand, the projection of the life class as the 'art of the bedroom', the record of an intimate relationship and personal sexual dynamics.

The ambiguous cultural status of these publications can be gauged to some extent through the cataloguers at the British Library. Although some of the books can be obtained from the general stacks, others are seen to belong to the category of the 'indecent' and have been sent to the special locked cases. The special cases are reserved for books that are prone to theft or damage and include commercial or titillating representations of sex – in other words, books that are regarded as an incitement to masturbatory action rather than contemplative reading. Within these general guidelines, the life-class manuals have a very uncertain status. For example, Patricia Monahan's *How to Draw and Paint the Nude* (1986), one in a series of step-by-step artist's guides, published by Macdonald, is included in the locked cases. Originally, the magazine was marketed in high-street bookstores for the audiences of respectable leisure literature and yet it seems to have been unable to maintain the necessary distance from the soft porn on the top shelves of the magazine racks. Unlike other examples of this genre which have already been discussed, this particular publication seems to take some trouble to emphasize the impersonal aesthetic gaze of the life class (Plate 18). In a double spread on 'Posing the Model', all background details are eliminated, as if in an attempt to expel any possible narrativization beyond that of the respectable protocols of pure artistic endeavour. And yet the

book failed to stay on the right side of the border between art and pornography.

It is tempting to suggest that the photographic medium alone is enough to connote the pornographic. Photography is conventionally imbued with an ideology of realism; the photographic image is believed to represent reality in a particularly direct and unmediated way. This 'commonsense' notion also finds its way into legal definitions of pornography in which photographic images of the female body are assumed to be more arousing than comparable images in other, 'artistic' media. Thus in 1970 the liberally inclined Commission on Obscenity and Pornography in the United States reported its findings on the affectivity of different kinds of visual representations of the female body:

> Another experiment used silhouettes of women, analysing preference for size of legs, breasts and buttocks. Actually the silhouettes were probably too abstract and devoid of detail to elicit measurable sexual arousal, and photographs would have produced more useful results.[39]

The assumed immediacy and accuracy of the photographic image is invested with a pornographic intent; whereas the abstraction and mediation of artistic methods such as painting and drawing are believed to be contrary to the relentless realism of the pornographic project. So it is possible that the photographic images in Monahan's guide, stripped as they are of supplementary narrative elements, could not escape the connotations of pornographic realism. But this is to impose a logic and consistency on the practices of British Library cataloguers that empirical evidence suggests is not the case. Like the British Constitution, the British Library guidelines for the classification of 'special case' literature are not written down and in the absence of published criteria it is impossible to recreate the standards used for the categorization of this group of art-manual publications. The point of this discussion is not to suggest that all representations of the female body produced within patriarchal culture are pornographic and should be relegated to a cultural scrap-heap; rather, it is to demonstrate just how unstable the edges of these categories are. Art manuals are on the borderline – 'about' art and yet unable to acquire a stable art identity.

Because of this cultural instability this genre of texts is often more explicit about how images can be 'encoded' with the connotations of art than are other more culturally secure publications. To start with, there are the appeals to the neutrality of scientific knowledge (the twentieth-century distance-learner's last point of contact with the anatomy class, no doubt). Diagrams are frequently used to emphasize the objectivity and scientific validity of the images from the life class. In a section on 'Proportions' in Dunkelberg's *Drawing the Nude* (1984), the author compares male and

female anatomy (Plate 19). The male figure is indicated in a continuous black outline, whereas the female figure is shown in dotted areas of varying density. The difference between the two forms is most clearly marked where the female shading spills over the male outline; to put it another way, femininity is defined where it is in excess of masculinity. Here is a neat visual demonstration of Derrida's concept of 'supplementarity'.[40] Although the first term within this image, the male, may seem self-contained and undetermined by any other element, the presence of the supplementary shading exposes the fact that the identity and meaning of the first term is dependent on relationships of difference. The primary sign – masculinity – is shown to be not a self-sufficient entity but a product of differences. In this case, the 'logic of the supplement' enables us to read the image against the grain.

Diagrams of a visually far more offensive kind are used in Douglas Graves's *Figure Painting in Oil* (1979). In an image illustrating the anatomical structure of the breast, Graves again reproduces the notion that the female body is simply that which is added to the male body (Plate 20). But the resulting diagrammatic painting is a really shocking image of a truncated torso in which the left breast is indicated only through the rough notation of a black line. This pictorial removal of the breast inevitably recalls, for women viewers at least, radical surgical treatments of breast cancer. What is offensive about this image is not the connotation of the post-operative body, but the careless way in which these signs are evoked and ignored. The caption tells the viewer: 'underneath [!], a female chest is structured like a male's, the mammary glands of the female grow out from the lower part of the pectoral muscles. It looks as though the chest muscle disappears *into* the gland.'[41] This 'pop' anatomy should be seen in the context of other images in the book, such as a series showing the progressive stages in the development of an oil painting (Plate 21). Here the model is laid out on a bed in a pose that belongs generally to the 'reclining female nude' tradition; only the details of the brass bedstead and table lamp set the figure in the more specific context of a modern bedroom. Again, it is not the question of whether this image is more or less pornographic that is at issue; the irresponsibility of the publication lies in its promiscuous use of the female body and its juxtaposition of images regardless of their potential sensitivity for certain readers.

Diagrams are used as the main pedagogic form in the manuals. Often ludicrous simplifications of the images they accompany (Plates 22 and 23), they declare the didactic purposes of the book and are key signs of its cultural respectability. The authors themselves are keen to inform their readers how to produce images of the female body that will convey the meanings of high art rather than the more vulgar connotations of mass culture – their own cultural status seems to depend on that of the images their putative students might produce. So Wendon Blake advises:

Avoid 'glamor' poses that exaggerate the model's charms like a publicity photograph of a star. Such paintings tend to look like caricatures. For the same reason, don't exaggerate details like eye lashes, ruby lips, pink cheeks, painted fingernails or toenails. In fact, it's usually best for the models to wear a minimum of makeup. In general, avoid *all* kinds of exaggeration. A nude figure in a natural, relaxed, harmonious purpose is *inherently* beautiful.[42]

In this list of signifiers to avoid when painting from the model, Blake shows himself surprisingly sensitive to semiotic function. All signs of vulgar, mass culture must be rejected, along with any indications of deliberate or artificial sexual appeal. The aesthetic high-art nude must be clearly differentiated from the sexy glamour photo. Similar advice is offered by Jan De Ruth, the author of *Painting the Nude* (1976). After fairly straightforward technical details about the handling of colour and brushwork, he comments on the difficulties of painting blonde hair: 'This holds true especially when you paint some sort of bleached blonde, a subject which immediately brings the painting into the realm of bad taste.'[43] What is interesting is how explicit these writers are able to be about the encoding of 'art' and 'pornography'. It is their position on the borderline of these categories that necessitates their detailed instructions; one slip of the brush and the image can tumble into the mire of soft porn. In his section on 'Painting Nipples', De Ruth warns: 'Don't paint them in some sweet pink and avoid detail. This would attract attention, suggesting the kind of cheap erotic quality that is least desirable' (p. 125).

An obvious conclusion to be drawn from the preceding discussion is that the lessons of the life class basically amount to an aesthetic endorsement of patriarchal power. To some extent, of course, this is true; but the extension of an acceptance of this situation would be to 'ban' the life class, to prohibit its use in art education. But, as will be shown in the following section, some of the most exciting and radical women's art in recent years has drawn on the representation of the female body and has explored subjectivity in relation to a politics of the body. Many of these artists work with their own bodies rather than using models but there are also ways in which the ethical premises of the life class can be shifted and used to explore different and progressive sets of issues. Already feminist teachers (usually part-timers in the art-school system) have been working to introduce feminist concerns into the life-class situation.[44] Theoretical sessions are run alongside the practical classes so that at every stage the students are aware of the meanings of the images that they are producing. Rather than the question of power being ignored, the relationships between teacher, student and model and the power of the image are constantly addressed. Basic theoretical tools such as semiotics, introduced to the life class, show how the images are encoded, how the body is gendered and sexualized through

particular poses, gestures and settings. The female nude is a very powerful cultural tradition and the life class plays a central role in its formation; students who are aware of this tradition and the values that it propagates are enabled to work with images in an informed and critical way. So there is a place for teaching the life class and sexual politics but there are limitations to how effective these strategies can be. At a time when art-school budgets have been savagely cut and the contracts of many part-time staff discontinued, it will be harder for these ideas to be developed within the system. And let us never forget that we are dealing with a very pervasive cultural myth. If, as I have argued, the life-class situation has been used to propagate a particular definition of virile masculinity, then there is a great deal at stake. It will take a lot of work to erase the traces of this mythology at all levels of cultural production.

4 ART CRITICISM AND SEXUAL METAPHOR

In the discursive formation of the female nude, art criticism functions as an important site for the production of meanings and values. In the main it has worked to legitimize patriarchal views of femininity whilst claiming to be set apart from the daily political concerns of society. In *The World, the Text, and the Critic*, Edward Said attacks literary criticism within the dominant culture for being concerned only with its particular discrete area of professional specialization and for having become detached from its explicit links with politics and society. Literary criticism in its various forms – academic history, journalism, appreciation, theory – has, according to Said, tended to endorse the central authority of society, making connections between the spheres of politics, culture and society invisible, if not impossible. In calling for the end of these professionalized critical activities, he proposes instead 'a politics of interpretation', formulated from the answers to the following questions: 'Who writes? For whom is the writing being done? In what circumstances?'[45] This is a useful starting-point for a re-examination of the function of art criticism; only to Said's questions I would add 'What kind of writing is it?' How is language being used and for what purposes?

In the texts of the life-class manuals, discussed in the previous section, it was seen that sex and sexuality could not be allowed to dominate the representation of the female body; sex has to be implicit rather than explicit in order to keep the art/contemplation coupling intact and to maintain the conventional polarity of art and pornography. So too, within traditional art criticism, the language of connoisseurship has developed as an expression of aesthetic judgement, taste and value. The way language is used in accounts of the female nude allows us to assess the role of sexual metaphor in recent art criticism.

As cultural commodities, oil paintings have been relished by critics and art historians and the practice of applying paint to canvas has been charged with sexual connotations. Light caresses form, shapes become voluptuous, colour is sensuous, and the paint itself is luxuriously physical.[46] This representation of artistic production supports the dominant stereotype of the male artist as productive, active, controlling, a man whose sexuality is channelled through his brush; who finds expression and satisfaction through the act of painting. Perhaps the most famous articulation of the metaphor of penis-as-paintbrush comes from Renoir. What is less well-known but equally significant is the way in which Renoir's statement is contextualized by his son; it is worth recalling in full. When asked how he painted with hands crippled by arthritis, Renoir replied 'With my prick', a remark that his son and biographer describes as 'one of those rare testimonies, so seldom expressed in the history of the world, to the miracle of the transformation of matter into spirit'.[47] This is an interesting variation on the matter/form dichotomy; here it is male sexuality rather than the female body that is transmuted into the forms of high art. Within this metaphorical structure, the canvas is the empty but receptive surface; empty of meaning – naked – until it is inscribed and given meaning by the artist. Kandinsky's statement of 1913 is a particularly vivid example of this feminization of the canvas/surface:

> Thus I learned to battle with the canvas, to come to know it as a being resisting my wish (dream), and to bend it forcibly to this wish. At first it stands there like a pure chaste virgin . . . And then comes the willful brush which first here, then there, gradually conquers it with all the energy peculiar to it, like a European colonist.[48]

In this astonishing combination of contemporary sexual and colonial ideologies, Kandinsky evokes the practice of painting as a rape scene, a violation of the female body/canvas which he then compares to the forceful subordination of a colonized subject by the colonizing power. Kandinsky may have been aware of the currency of the images that he was invoking but he cannot have realized the deeper structural links between gender and style into which he was tapping.

In *Spurs: Nietzsche's Styles* Derrida examines the concept of style in philosophical and critical writing and the metaphors that embody the concept. Starting from the buried reference to the 'stylus', Derrida argues that style is usually conceived of as a pointed, sharp, spurred projective. This idea is part of an opposition between the pointed, the punctual and the hostile material that surrounds it and that it resists or perforates:

> In the question of style there is always the weight or *examen* of some pointed object. At times this object might be only a quill or a stylus. But it could just as easily be a stiletto, or even a rapier. Such objects

might be used in a vicious attack against what philosophy appeals to in the name of matter or matrix, an attack whose thrust could not but leave its mark, could not but inscribe there some imprint or form . . . it seems, style also uses its spur (épéron) as a means of protection against the terrifying, blinding mortal threat (of that) which *presents* itself into view.[49]

Obviously style is masculinized, phallic power and the medium that it resists, which may be imaged as paper or canvas, is woman. Derrida's essay goes much further with the analysis of Nietzsche's notion of philosophical truth, but for the present examination of the critical construction of the female nude it is useful simply to take Derrida's formulation of the gendering of styles. There are two main elements in his analysis: the phallic, marking instrument of style and the awaiting surface which is both receptive but also a terrifying and unknown force. Both of these figures are played out with surprising insistence in critical writing about the female nude. Describing the advantages of pencil for drawing the female body, Georg Eisler writes:

It obeys every movement of the hand, responds to the lightest pressure. The lines may be softened and blurred by the fingers. There is practically no limit to the ways it can be moved over the paper: long flowing strokes as well as spontaneous jabs . . . It is in many ways the ideal medium for drawing the nude.[50]

What Derrida can alert us to here is both the phallic, sexualized representations of artistic technique and the constituting relationship between woman and the paper/surface; both of these figures are particularly intense and focused in the production of the female nude. Metaphorical language constitutes the receptive surface as bare, resistant, without meaning until it is inscribed with the signs of style. But this structure is then repeated; for woman's body is itself a metaphorical blank surface which is given meaning through the values of the dominant culture. In Derridean terms, the female nude marks a double inscription – it is a kind of surface within a surface. In an article on her experiences of professional art modelling, Elizabeth Hollander provides a concrete example of these ideas. She writes: '[The model] has rather more in common with the canvas than with the painter in this sense, that . . . both she and it must be subordinated to the painter's will in the studio.'[51] Although she does not endorse this power relationship, Hollander's comment recalls the metaphorical linking of the female body and the canvas, as surfaces that are to be subordinated/given meaning through the artist's will/style. Within critical language woman is figured as the resistant, unnameable 'otherness' of paper/canvas, the sign of absolute non-signification. The female nude within patriarchy thus signifies that the woman/surface has come under the government of male style. Within this

framework Mary Richardson's attack on 'The Rokeby Venus' can be seen as a literal realization of the phallic figuration of style. Richardson, 'the female miscreant', leaves her 'own markings on the work', enacting the violent attack of the spur/style on the surface of the canvas/body. Richardson's iconoclasm can be seen as an unwitting revelation of the unconscious hostility embodied in the contemplative, spectatorial relationship to the female nude and the desire to violate that lies within the adoring gaze of the connoisseur.

Surface texture is thus charged with significance; the marks on the canvas are essential traces of agency, evidence of art and also signs of masculine virility. Mary Kelly has described this function of the painterly signifier in relation to modernist aesthetics: the surface gesture works 'to give evidence of an essentially human action, to mark the subjectivity of the artist in the image itself'.[52] But, more precisely, the artistic subjectivity that is registered by the brushwork and surface is sexualized. Art criticism writes sex into descriptions of paint, surface and forms. The category of art does not permit a sexuality that is an obvious and provocative element, but a certain kind of phallocentric textuality can be articulated in the discussion of a painting's handling and style. The sexual, then, is distanced from the subject represented on the canvas and is reinscribed through the metaphorical language of connoisseurship. Lawrence Gowing, for example, describes a small female figure in a Matisse interior as 'abandon[ing] herself to the colour'. In *Nude Painting* Michael Jacobs refers to Titian's *Nymph and Shepherd*, in which 'the dynamics of flesh and blood are revealed in their rawest state, all distracting movement and meaning are stripped away by the rigorous harshness of the artist's late style'. And Malcolm Cormack describes a Veronese in which 'the whole is a riot of the senses where the sensuous mode of expression emphasizes the theme'.[53]

The tradition of the female nude is not simply a question of the male artist or viewer imposing order on and controlling the canvas or the female body. There is another relationship at stake. The mythology of artistic genius proposes a model of masculinity and male sexuality that is free-ranging, unbounded, needing to be contained within forms. Woman and femininity provide that cultural frame; woman controls and regulates the impetuous and individualistic brush. In a review of an exhibition of Impressionist drawings at the Ashmolean in Oxford, the art critic William Feaver considered the examples of the female nude: 'A Renoir drawing "Nude Woman Seen from the Back", . . . [illustrates] the Impressionist concept of untrammelled instinct: Renoir's caress, Monet's spontaneity. But drawing was the basis. Without it Renoir would have been incoherent.'[54] What are we to make of 'Renoir's caress' and 'Monet's spontaneity'? Artists and lovers, paintings and sex are collapsed into each other. Masculinity is now seen as a matter of unregulated instinct, potentially anarchic and incoherent; but the discipline of drawing and the contained form of the female

nude – high culture and femininity – give order to this incoherence; together they civilize and tame the wild expressiveness of male sexuality.

In all these cases sexual metaphor works to maintain a hold on sexual difference, to contain both the female body that is imaged and the body of the viewer/critic. Sight is also often constituted in phallic terms, such that the punctuality of the line of vision is opposed to the depth, surface and space of the object viewed. This construction of vision defines the aesthetic gaze as cerebral rather than bodily whilst also, of course, asserting the power of that gaze. So, the critic's eye is free to wander over the forms of the female body in the image, exacting judgements that play out a sexualized narrative without disturbing corporeal integrity. But what happens when the gaze turns into a stare, when the desire to see becomes the need to touch? The sexual economy established in the language of art criticism also produces the terms of its own collapse. John Barrell has described the attempt to distinguish the aesthetic gaze from the scopophilic stare in responses to the Venus de Medici in early eighteenth-century Britain. He traces the most intense point of this aesthetic gaze, when sight invokes touch.[55] The detection of a critical blurring of the senses can be seen as a mark of instability in the relationship between the connoisseur and the image, a point at which the controlling force of metaphor and aesthetic vision breaks down. Perhaps there is just such a moment for Kenneth Clark in front of the female nudes of the Fontainebleau School. The line of vision is not enough; sight invokes smell and Clark informs us that around these paintings there 'hangs a smell of stylish eroticism, impossible, like all smells, to describe, but strong as ambergris or musk'.[56] Clark's nose twitches, his hand reaches out and the aesthetic moment is undone by the return of the connoisseur's body.

The female nude is both a cultural and a sexual category; it is part of a cultural industry whose institutions and languages propose specific definitions of gender and sexuality and particular forms of knowledge and pleasure. Obviously, we cannot and would not wish to abandon metaphorical language altogether, but it is also clear that the sexualized metaphorization of the female nude within art criticism has systematically reinforced the attitudes towards the female body and aesthetics that dominate patriarchy. But a shift in figurative register is not enough; this must be accompanied by a redefinition of the role of the art critic, with the functions of judge and connoisseur giving way to politically vigilant forms of interpretation. Edward Said has written about the social responsibility of the critic who, aware of the values that are created through acts of interpretation, is also 'responsible to a degree for articulating those voices dominated, displaced, or silenced by the textuality of texts'. This is as good a model for the definition of the function of feminist criticism as any, and it is worth ending this section with Said's evocation of the intervention of the true critic within the dominant culture:

Texts are a system of forces institutionalized by the reigning culture at some human cost to its various components . . . The critic's attitude . . . should . . . be frankly inventive . . . which means finding and exposing things that otherwise may be hidden beneath piety, heedlessness, or routine.[57]

5 BREAKING OPEN THE BOUNDARIES

The history of the female nude can be seen as a relentless and ever-increasing attempt to put the female body on show. John Berger describes the female nude in the nineteenth century as 'the ever-recurring subject', and in *Old Mistresses*, Rozsika Parker and Griselda Pollock refer to the same period as one in which 'woman was ever more present as the object of . . . painting'.[58] Although there is undoubtedly a degree of truth in this formulation, it can be altered slightly to produce a rather different and possibly more accurate understanding of the European tradition. Rather than the female nude being seen as a progressive display of the body of woman, it can be understood instead as a kind of tyranny of *in*visibility, as a tradition of *ex*clusions as much as it is a tradition of *in*clusions.

As we have seen, the female nude has been the focus of a certain idealist aesthetic of wholeness and containment and whilst the female body has indeed been the object of relentless display within this framework, it has at the same time rendered certain bodies invisible within the defining boundaries of art. Women whose bodies do not conform to the ideal are beyond the field of vision, and the right to self-definition in these cases may mean an insistence on the right to make and be visible. Here, art may be taken as a reasonable gauge of social visibility in general and the images of the female body that have been omitted from the visual arts echo the lived experiences of women within the dominant society and its culture of physical perfection. The project of feminist art practice and theory has, therefore, never been and is not currently a simple question of changing the terms of a unified regime of representation; on the contrary, feminist strategies have had to engage with and represent a diverse range of subject positions. In this and the following section I will examine some of the changing engagements of feminist art and theory with the representation of the female body over a period of approximately two decades, from the 1970s to the 1990s. This is not intended as a comprehensive survey of feminist art during the period, but is deliberately selective in order to develop particular issues and themes that have already been introduced in other contexts elsewhere in the book. Starting from the assumption that the tradition of the female nude has been organized around the principle of the integrity of the body and its physical boundaries, these sections will

examine the ways in which recent feminist art has attempted to break down these artistic and bodily protocols. Dichotomies such as whole/fragment and surface/interiority have been reworked and reassessed in feminist representations of the female body and these themes will be highlighted in the following pages. Historically, there has been a powerful alliance between the discourses of art and medicine in the definition of femininity which has continued to exercise power within contemporary society. The collaborative links between these two discourses and the definitions of health and beauty that they produce have been explored in some recent feminist art which will also be focused upon in the following sections. In general terms, feminist art and theory have been involved in the politics of self-definition. If the history of the female nude is defined as the representation of women in patriarchy, then feminist art has tried to wrest back this power, claiming the right to self-representation. The results of this work have been not only to expose the omissions and absences perpetrated within the dominant tradition, but also to make visible new female subjectivities through the media of the visual arts.

The category of 'feminist art' does not imply a stylistic label; it does not describe a unified stylistic tendency. The term is used here in relation to the production of certain meanings through visual images, the effects of these images/works and their conditions of reception. To speak of feminist art is to speak of visual representation that engages with and challenges historically constituted audiences and ideologies. In *Framing Feminism* Griselda Pollock differentiates a notion of feminist art that rests solely on the gender and intentions of the artist and an understanding that is based upon the effectivity of the image. She reformulates the useful, if rather vague, label of 'feminist art' in terms of an art work that produces political effects as a feminist intervention within the dominant, patriarchal culture. A work can be defined as feminist:

> according to the way [it] acts upon, makes demands of, and produces positions for its viewers. It is feminist because of the way it works as a text within a specific social space in relation to dominant codes and conventions of art and to dominant ideologies of femininity. It is feminist when it subverts the normal ways in which we view art and are usually seduced into a complicity with the meanings of the dominant and oppressive culture.[59]

There are a number of helpful indicators in this passage concerning the category of feminist art. Firstly, the image itself is seen as part of a process that constructs possible viewing positions for its audience. Of course, interpretation cannot be guaranteed and feminist art that draws on the female body is open to a range of interpretative possibilities, including reappropriation into the voyeuristic structures of the tradition of the female nude. But this very risk may be seen as productive and some of the

most stimulating debates within feminist arts have been concerned with the problems and ambiguities involved in the representation of the female body. The second main point that is raised by Pollock and can be elaborated is that images are not received as discrete entities but in relation to institutional frameworks and discourses. The work can be defined as 'feminist' at the moment it enters into the arena of these debates and intervenes in the dominant codes of artistic practice and definitions of gender and sexual difference. Again, this has particular implications for visual images of the female body; in this case, the intervention will be in the structures of male sexuality and pleasure that are conventionally set in place by the female nude.

Feminist art is, therefore, necessarily deconstructive in that it works to question the basis of existing aesthetic norms and values whilst also extending the possibilities of those codes and offering alternative and progressive representations of female identity. This idea of the politicization of art both at the point of production and reception also raises the question of the place of feminist art practices within the public domain of culture. Given the complex interrelations of the state and society in late capitalism, it is no longer possible to postulate a pure feminist cultural sphere that is totally distinct from the rest of society. There can be no 'safe place', outside of institutional frameworks and untouched by mainstream cultural discourses, that feminist art can occupy. This point is put well by Rita Felski in her discussion of feminist literature in *Beyond Feminist Aesthetics*. Felski uses the concept of a feminist counter-cultural practice as a way of describing a set of practices that is both representative of the diversity of the contemporary women's movement and influential (a basic aim of any political endeavour). The term does not imply a utopian space that functions outside of commercial and state institutions but allows for the creation of a public forum for oppositional debate and practices. Felski defines this feminist public sphere in terms of 'a series of cultural strategies which can be effective across a range of levels both outside and inside existing institutional structures'.[60]

The following discussion of feminist art is based on this understanding of counter-cultural practice and a feminist public sphere. To some extent the examples have been chosen to represent the diversity of the women's movement over the last twenty years and to avoid the suggestion of any fixed or final criteria for determining what constitutes a feminist image of the body. What most of the work does have in common, though, is a dual function as a critique of existing values and in the construction of new and progressive meanings for the female body. The examples chosen cover a long and complex period within the recent history of the women's movement. During this time there have been very substantial shifts and changes within feminist theory and cultural practice. Although these developments have not followed an even historical path and whilst it would be inaccurate

to posit a consistent historical trajectory for feminism from the 1970s to the 1990s, it is possible to identify a particularly significant shift in feminist cultural practice and the representation of the female body that does approximate to an earlier and a later period. For this reason, and partly in the interests of clarity, the following discussion is divided into two sections which also roughly describe historical periods. This section covers the earlier period and discusses the ways in which feminist artists worked through the sexual and body politics of the contemporary women's movement to challenge the images of woman propagated through the tradition of the female nude. Although the female body was on show within high culture, this display denied women's experiences of their bodies and sexual desires. In general terms, the objective of the art of this period was to transform woman from the passive object of representation to the speaking subject. Feminist art articulated the right of women to represent their own bodies and sexual identities through vaginal imagery, performance work and the body, the representation of previously taboo subjects such as menstruation and so on. But on the whole much of this work was organized around the celebration of the universal category of 'woman'. Feminist theory invoked the shared and common aspects of women's physical and psychic lives which, it was claimed, could form the basis for a female aesthetic. Although this tendency has been criticized for expressing an essentialist view of femininity, this was not always the case and there were those who constructed an aesthetic around the concepts of woman and the body, whilst also recognizing that femininity was socially and historically constructed. The work that is covered in this section challenged the aestheticization and sanitization of the female body within patriarchal culture and broke open the boundaries of this regime of representation to reveal woman's body as matter and process, as opposed to form and stasis. The images and performances frequently shattered the accepted conventions of art and propriety and made visible aspects of the female body that could not easily be accommodated within the existing protocols of connoisseurship.

The work discussed in the following section, 'Redrawing the Lines', represents the shift from the implied singularity and inclusiveness of the category 'woman' towards a situating of the multiplicity and plurality of subject positions that constitute the women's movement. It marks the move away from the invocation of 'woman' towards the recognition of the diversity of standpoints among women, formed by other aspects of identity such as class, race, sexual preference and so on. This shift has meant not only acknowledging the differences between women and 'woman' but also the differences among women themselves. This may not be such a comfortable position for those women who feel themselves identified within the category of 'woman', but this theoretical shift has enabled a more critical awareness of the exercise of power in society and the multiple subject

63

positions that women occupy. As Teresa de Lauretis has written: 'there are, after all, different histories of women. There are women who masquerade and women who wear the veil; women invisible to men in their society, but also women who are invisible to other women, in our society.'[61] The discussion in 'Redrawing the Lines' will focus on the different positions from which feminist artists engage in the representation of the female body and the diverse identities that are being claimed in this work. Feminism has increasingly recognized that there is no monolithic category of 'the body'; there are different types of bodies but many of these have been defined as deviant and rendered invisible by a dominant aesthetic that posits the white, healthy, middle-class and youthful body as the ideal of femininity. The art that is included in 'Redrawing the Lines' represents the defiant assertion of the autonomy of those other kinds of bodies and subjectivities.

The feminist claim of the 1970s to 'our bodies, our selves' put the issues of control and identity at the centre of the movement's political agenda. For women to reclaim power over their bodies meant to reclaim both control over the medical care and regulation of the female body and over the ways in which the body is imaged and represented within culture. Again, as we have seen, the coupling of art and medicine is no accident; both were seen as repressive mechanisms that worked to regulate and contain women's power and rights to self-definition. Women's body art, that is, art that focuses on images and aspects of the female body, was one attempt within the sphere of culture to create a different kind of visibility for women and to raise issues that had hitherto been ignored in the visual arts. In 1978 Lisa Tickner wrote an article entitled 'The Body Politic: Female Sexuality and Women Artists since 1970' which reviewed and analysed recent women's body art. The article was published in the second issue of *Art History*, the newly created journal for the Association of Art Historians, the official professional organization for British art historians. In this context, the article was an emphatic feminist intervention within official public culture. Its publication provoked widespread protest from senior male art critics and academics and, since its original publication, both the article itself and the subsequent correspondence have been reprinted in feminist anthologies.[62] The article is, therefore, an interesting case of the formation of feminist public spheres, beginning as a strategic intervention within a mainstream institutional structure and then subsequently adopted to consolidate the developing feminist space within the education system. Tickner situates women's body art within the context of the social and historical construction of female sexuality. The work, she argues, is to a large extent a reaction against the representations of the female body produced by the 'Old Master/*Playboy* tradition'. Tickner differentiates images of the female body that can be produced by a woman from those that can be made by men: 'Living *in* a female body is different from looking *at* it,

as a man. Even the Venus of Urbino menstruated, as women know and men forget.'[63] The article critiques the patriarchal basis of most images of women and sets the context for a de-colonization of the female body by women artists and an exploration of female sexuality and eroticism from the perspective of woman. Tickner divides the work into four categories: 'the male as motif; "vaginal iconology"; transformations and processes; parody'; but it was largely the illustration of this work, drawing on the forms of female genitalia, that provoked the derision and anger of some of *Art History*'s readers. Such images on those pages not only declared the existence of women's representations of female sexuality and the body, but also forced a recognition of the dominant codes at work in the female nude. Tickner's article reconstituted the audience for both the work discussed and the journal itself, forcing a confrontation between the feminist counter-culture and the existing official cultural framework. On its own terms, the article referred to the ambiguities concerning the use of vaginal iconology in the work of artists such as Judy Chicago. If these artists were claiming that vaginal and vulvic forms were an innate and natural language for female artistic expression, as opposed to a political claim to visibility where traditionally it was denied, then the work could reproduce the patriarchal definition of woman, as biologically determined, which was being contested elsewhere in the women's movement. This accusation of biological determinism or essentialism has continued in feminist responses to Chicago's work such as *The Dinner Party*. The central conception of *The Dinner Party* is a triangular banquet table with thirty-nine place-settings representing various mythological and historical women. Each of the figures has a runner, cutlery, goblet and plate whose different designs symbolize her particular achievements and character (Plate 24). It is a monumental form of herstory and a celebration (although undeniably selective) of women's achievements. But what is the effect of using vaginal imagery for this celebration? Amongst the many justified anxieties that Michèle Barrett expressed about the project in 1982 was a sense of betrayal about the reduction of women to the sign of genital sculpture:

> I was in fact horrified to see a 'Virginia Woolf' whose image to me represented a reading of her life and work which contradicted all she had ever stood for. There she sits: a genital sculpture in deep relief . . . resting on a runner of pale lemon gauze with the odd blue wave embroidered on it.[64]

In Chicago's terms this horror might be seen to reproduce the shame with which women have been made to view their bodies. But be this as it may, there can be no doubt that female identity in *The Dinner Party* is reduced to the single sign of the female genitalia which in turn posits a universal notion of 'woman' whilst masking the real differences that lie within that category.

It seems a little too easy now, with the advantages of hindsight, to dispatch women's art based on female sexual imagery, but the problems of essentialism should not obscure the radical intervention that this work made in the 1970s. At times, it was able to unmask in quite unprecedented ways the contradictions within the dominant codes of aesthetic permissibility and the representation of the female body. Suzanne Santoro's *Towards a New Expression* (published in Rome, 1974) presents just such a case. Santoro's book included photographs that explored the structural links between vulvic images and forms such as shells and flowers and had been part of an Arts Council travelling exhibition of 'Artists' Books'. The book was removed from the exhibition on the grounds of obscenity; the Arts Council stated: 'We are willing to defend obscenity on the grounds of artistic excellence but considered that in this case the avowed intention of the book was primarily a plea for sexual self expression.'[65] In this statement the ideological terms of official culture are momentarily revealed. 'Artistic excellence' and 'sexual self expression' are, in this case, apparently antithetical; and yet, conventionally, some of the greatest masterpieces have been seen to be the result of the bringing together of artistic genius and sexual self-expression (Picasso's female nudes are a good case in point). The problem, it seems, is not so much sexual self-expression but female sexual self-expression and it is this that, in 1976, is defined as obscene, as unsuitable for an Arts Council exhibition and thus placed beyond the boundaries of art.

The insistence, in women's art of the 1970s, on representing images and aspects of the female body that are normally hidden from mainstream culture demonstrates the precarious nature of cultural definitions of art and obscenity and of the permissible and the forbidden. Works such as Chicago's *Red Flag* (1971, Plate 25), showing the removal of a bloody tampon, deliberately push the boundaries of artistic propriety to their limits by challenging the aesthetic ideal of the sealed and finished female body (recalling here the symbolic sieve of Chastity). If the tradition of the female nude emphasizes the exterior of the body and the completion of its surfaces, then women's body art reveals the interior, the terrifying secret that is hidden within this idealized exterior. In a recent article on the work of Cindy Sherman, Laura Mulvey maps out a topography of the female body that is just as apposite to women's body art.[66] She describes the female body as a spatial metaphor for the structural division between surface allure and concealed decay. The cosmetically finished surface of the body must conceal the abject matter of the interior of the female body; and in psychoanalytic terms, this cosmetic surface 'conceals the wound or void left in the male psyche when it perceives sexual difference' (p. 146). For Mulvey, then, the topography of the cosmetic surface and concealed interior is an echo of the topography of the fetish.

This analysis offers a useful model for understanding the impact of

vaginal imagery and women's body art on mainstream culture in the 1970s. Although the female nude holds the surface/secret structure in abeyance, these images begin to reveal and invoke that anxiety-provoking interior or void. The male viewer is confronted with the fact of sexual difference as the fetishized surface of the body is dissolved to reveal the traces and bodily fluids of the interior.

In the 1970s and early 1980s women artists drew on a wide range of media in order to explore the relationships between representation and the body. In an influential article originally published in *Art in America* in 1976, Lucy Lippard discussed recent European and American mixed-media performances by women. Frequently these performance works involved the artist's own naked body as well as those of other women and occasionally men. Lippard warned about the risk that was always present in women's body art:

> A woman using her own face and body has a right to do what she will with them, but it is a subtle abyss that separates men's use of women for sexual titillation from women's use of women to expose that insult.[67]

Women who used their bodies in performance art could easily be reappropriated for the purposes of male sexual arousal, and Lippard identified the work of Carolee Schneemann as a good case in point. In her claim to sexual freedom, her celebration of all aspects of the female body and her construction of a female tradition of performance from the mythological past to the present, Schneemann typifies many tendencies within the women's movement in the mid-1970s. She states:

> In some sense I made a gift of my body to other women: giving our bodies back to ourselves. The haunting images of the Cretan bull dancer – joyful, free, bare-breasted, skilled women leaping precisely from danger to ascendancy, guided my imagination.[68]

Schneemann's *Interior Scroll* was performed twice (1975 and 1977) and brings together her ideas concerning sexual liberation and the body, vaginal imagery, and the position of the woman artist within patriarchal society. In the performance Schneemann undresses, paints herself in large strokes defining the contours of her body and face and then reads from an earlier text as she adopts a series of life-model 'action poses'. Towards the end, she drops the book and begins to read the script from a scroll which she unravels from her vagina (Plate 26). The life-class poses and daubs of paint recall the emphasis on the surface and boundaries of the body in the traditional representation of woman as object of art; this is then undermined, however, by the removal of the vaginal scroll which represents the female body as a source of interior knowledge and matriarchal power. At the second performance of the work, at a film festival in Colorado,

Schneemann was to introduce a section of films by women entitled 'The Erotic Woman'. Her response was to alter the film presentations, by putting her objections to this designation in an introductory statement and then applying strips of mud to her naked body before reading from the scroll. In a subsequent account of the event she compared the 'passive viewing' of filmic images with live body action which diminishes 'the distancing of audience perception and fixity of projection'. As a film-maker, she felt compelled to break with the tradition of passive viewing and to 'move' the audience by 'stepping out of [her] frame'.[69]

The context of the 1977 performance of *Interior Scroll* neatly encapsulates some of the debates concerning the use of the body in feminist performance work. On the one hand, the categorization of the work in a section called 'The Erotic Woman' demonstrates that interpretation is not entirely in the hands of the performer and that the female body can be reappropriated for meanings quite other than those originally intended. But on the other hand, the claim that performance breaks with conventional viewing structures and disrupts the aesthetic and voyeuristic containment of the female body constructed in other media such as film and painting is one that is still made by its advocates.

The debates within feminism concerning the representation of the body by women performers have focused on this split between those who fear the inevitable recuperation of the female body to the patriarchal spectacle of woman and those who see its potential as a way of building a new cultural presence for the female body by reversing the gaze and enabling women to become the speaking subjects of discourse.[70] This view that women's body performance is the discourse of the objectified 'other' has been expressed most recently by Jeannie Forte who describes women's performance art as a 'deconstructive strategy'.[71] Forte argues that patriarchal discourse depends upon the construction of woman as object, as that term within language that is always spoken about, but never achieves the status of full speaking subject. This means that actual women are rendered invisible, an absence, within the dominant culture and can only speak by assuming the mask of falsity and simulation: 'Women's performance art operates to unmask this function of "Woman", responding to the weight of representation by creating an acute awareness of all that signifies Woman, or femininity' (p. 218). Drawing on the theories of Hélène Cixous and Luce Irigaray, Forte describes the use of the female body in performance as a form of 'writing the body' that reclaims it from its patriarchal textualization.

Another claim that is made for women's body performances is that they subvert the male gaze and prevent the fetishization of the female body. Whereas with painting or sculpture the viewer is able to relish the object at his chosen speed, to carry out repeated examinations and to select viewing positions, the mobility of the performance artist prevents this colonization

of the female body. She, it is argued, determines the way she is experienced by her audience and, in this way, takes control of her own image. Because the performer and spectator occupy the same physical and temporal space, the (male) spectator is also exposed to the proximity of the performer and the implications of his desires. As Catherine Elwes has written: 'His cloak of invisibility has been stripped away and his spectatorship becomes an issue within the work.'[72]

It is undeniable that the use of the female body by women in performance art since the 1970s has been conceived as a political and socially subversive enterprise. Perhaps this politics of subversion has become even more emphatic in performances created by a number of women in the 1980s. In these works, the celebratory notion of the female body that was created in the 1970s is replaced by an exploration of the obscene body and of transgressive aspects of female sexuality. Karen Finley's performances take the form of discontinuous, first-person narratives that describe sexual fantasies and fragments of putative actual events about rape, incest, death, abortion and so on. In some early performances she violates her own body, smearing herself with garbage and, on one occasion, applying a can of yams over her naked buttocks. In a discussion of works by performers such as Finley, Elinor Fuchs describes their dissolution of moral categories such as the obscene and the pornographic, as a realization of Bataille's theories of erotic transgression.[73] For Bataille, the erotic excess of pornography shatters the illusory unity of the viewing subject and thus forces a critical crack in the system of bourgeois values. It is also through this experience of transgression that the subject comes to recognize the presence and function of prohibition. According to Fuchs, 'the staging of the obscene body' in women's performance art creates such a moment of erotic transgression. This violation also occurs at a cultural level, as the protocols of both the 'legitimate' and the 'experimental' theatre are pushed to their limits and seem to dissolve into the realm of burlesque, peepshow and porn.

Since the 1970s, large claims have been made for women's performance art. It has been seen to project a space for a speaking female subject; to shatter the structures of voyeurism and fetishization; and to create a politics of erotic transgression. In many ways it would be impossible for any performance to exemplify these claims and, indeed, many seem to fall far short of their theoretical elaboration. An aesthetic that is based on the principle of transgression, of 'breaking open the boundaries' of the dominant discourse, can only have a limited viability for a feminist politics of the body. The performances that have been discussed in this section can only be seen to have initiated an awareness of some of the issues surrounding representation, sexuality and the female body. Feminist art that seeks to counter the disavowal of sexual difference within patriarchal culture by asserting the female body as pure matter (in the terms of Chicago, Schneemann or Finley) does not deconstruct the gendered terms of the

mind/body dichotomy; it simply inverts them. In this sense, women's performance body art fails as a 'deconstructive strategy'. The representation of the female body need not imply an exclusive commitment to the 'Nature' or the 'Reason' side of the binary opposition. As recent feminist writing has shown,[74] the body is always physically *and* psychically conceived and, as such, it crosses the threshold of nature and culture and blurs the boundaries of the mind/body opposition.

6 REDRAWING THE LINES

I imitated the artist at Croton, who, when making the likeness of a goddess, chose all remarkable and elegant beauties of form from several of the most handsome maidens and translated them into his work. So we too chose many bodies, considered to be the most beautiful by those who know, and took from each and all their *dimensiones*, which we then compared one with another, and leaving out of account the extremes on both sides, we took the mean figures validated by the majority of *exempeda* [ruled measurements].
(Leon Battista Alberti, *De Statua*, c.1464)[75]

Alberti's well-known formula for the representation of the human figure is based on classical mythology. There are variations of the myth, but, according to one version, the artist Zeuxis wished to make a painting of the goddess Venus. Since no single woman was beautiful enough to model for the painting, Zeuxis brought all the women of Croton together and, choosing the best parts from all of them, compiled an image of perfect femininity. On their own, none of these parts or fragments had any significance; their meaning lay in their relationship to an ideal: the complete, finished form of woman.

Alberti's theory is a reformulation of this myth and is based on the principles of measurement and the judgement of perfect beauty. The *exempedum* is a thin wooden ruler, the length of the body, which is then divided and further subdivided for the purposes of measurement and classification. Once taken, the measurements are put together to form the entire figure in perfect proportion. From the start, only the most beautiful bodies are taken for measurement and all examples of excess are omitted from the calculations. The classical ideal of perfect beauty is thus based on the body of woman and is a compilation of meticulous measurement and appraisal. Beauty is an ideal which is arrived at through the definition of norms and deviations.

In a forty-minute video, made in 1977, *Vital Statistics of a Citizen Simply Obtained*, Martha Rosler examines the ways in which women internalize the normative judgements of patriarchal culture. Rosler is systematically

measured by two men in white coats, who record their findings on a chart behind her. Rosler's statistics are then compared to a set of 'normal' measurements. These activities are contextualized by a spoken commentary:

> [Her mind] learns to think, perhaps without awareness, of her body as having 'parts'. These parts are to be judged. The self had already learned to attach value to itself. To see itself as a whole entity with an external vision . . . [to] remanufacture the look of the external self to simulate the idealized version of the natural.[76]

This work is a celebration neither of the biological body of woman nor of bodily transgression; rather, its aim is to explore how women continue to be regulated through the scientific and cultural classification of their bodies. The video does not propose an alternative, feminist ideal of the body but begins to show how women's bodies are defined and lived within patriarchy. From Zeuxis and Alberti, to the anonymous white-coated men in Rosler's video, women have been regulated by men who draw the lines around the category of 'woman', lines that divide the normal from the deviant and the desirable from the loathsome. But if we accept the view that is exemplified by Rosler's work, that the female body is a socio-historical subject, then it is also possible to see the spaces for oppositional definitions of women's bodies. Within this context the representation of the body becomes, for feminism, a highly political project.

In an article entitled 'Corporeal Feminism', Elizabeth Grosz draws on sociological and psychoanalytic theories in order to propose the framework for a feminist politics of the body.[77] Grosz detects a certain ideological suspicion of and theoretical aversion to the body within current feminism, which can be partly attributed to the biologism and essentialism of feminist theories in the 1970s and early 1980s. She argues instead for a theorization of the body that accounts for both its social and its psychic formation, for both the inscription of its external surface and the production of its internal, psychical operations. The body is, therefore, central in the formation of individual identity and is the site of the subject's desires and fantasies, actions and behaviour. Once one rejects the perception of the body as a biologically determined and pre-cultural given and moves towards the conception of 'embodied' subjects, the way is opened for feminist interventions within the definition of the female body. As Grosz states near the beginning of her article:

> [The body's] form, capacities, behaviour, gestures, movements, potential are primary objects of political contestation. As a *political* object, the body is not inert or fixed. It is pliable and plastic material, which is capable of being formed and organized in other, quite different ways or according to different classificatory schema than our

binarised models. If it is a social object, the body can be redefined, its forms and functions can be contested and its place in culture re-evaluated or transformed.

(p. 3)

The following discussion takes as its starting-point this notion of the redefinition of the body as a political endeavour. But in an examination of these attempts to redraw the lines, it will be clear that feminism no longer advocates a final or monolithic category of the female body. The project of feminist art is not the projection of a perfect type that represents the interests of all women; rather, it is the exploration of women's diverse social, cultural and economic identities. The work that is discussed below represents a series of cultural strategies that modify and extend the range of existing cultural categories, adapting them to the particular political and aesthetic interests of women. What also emerges is that there are inevitable risks involved in the representation of the female body but these risks have to be taken. As we have already seen, the female body is dense with meaning in patriarchal culture and these connotations cannot be shaken off entirely. There is no possibility of recovering the female body as a neutral sign for feminist meanings, but signs and values can be transformed and different identities can be set in place.

There is undoubtedly a high degree of risk involved in Chila Kumari Burman's 'body prints'. The images are made by the artist covering her body with acrylics or Indian ink mixture and then pressing it against a blank sheet of paper. At times Burman has simply exhibited the resulting image without adornment; on other occasions, she has worked up the image, adding glitter and paint to emphasize the body and heighten the visual impact (Plate 27). If one leaves aside, for the moment, the contexts within which this work is made and exhibited, there is a disturbing pre-cedent for these images that may seem, at first, seriously to undermine the feminist potential of Burman's body prints. In 1960 Yves Klein orches-trated a number of performance works that were enactments of his concept of the *femme pinceau* (living or female paintbrush). The most celebrated of these works was entitled *Performance anthropométrie de l'époque bleue* and was carried out at the Galérie Internationale d'Art Contemporain, in Paris, on 9 March 1960 (Plate 28). Under the direction of Klein and to the sound of the 'Symphonie monoton' played by an orchestra of twenty musicians, three naked models were covered with blue paint and imprinted their bodies on white paper, hung on the walls and on the floor of the gallery. In another version of the method, paper was placed over a large cylindrical support on the floor which the painted model then 'straddled' in order to achieve a variation of the body-print image. Klein called the prints that were made from the models' bodies *anthropométries*, a term that reintroduces the questions of measurement and appraisal into the visual

representation of the female body. The photographic documentation of the *femme pinceau* method and related performances was clearly as important as the images and events themselves. Photographs record every stage in the making of the anthropometric image, detailing Klein's directorial control of the women. One well-known image from this collection shows a female model, with the front of her body covered in paint, standing near to a print which we must assume she has made from her body (Plate 29). Two details are significant here: firstly, the woman's passivity and lack of expression, which are a general feature of these photographs; and secondly, the blurred image of a man's (Klein's) hand in the bottom left-hand corner, holding on to the model's wrist. The hand is a critical sign of Klein's authorship of the anthropometric images. The women may be the instruments or tools for the production of the prints, but their actions are determined and controlled by Klein. As we have seen in the section (4) on sexual metaphor, the paintbrush and the act of painting are commonly described in terms that evoke the penis; in Yves Klein's works this mechanism is taken one stage further. For Klein, the limbs of the figure are irrelevant and it is the torso of the female body that most concerns him and to which he ascribes an almost transcendent significance. He states:

> Very quickly I saw that it was the 'block' of the body itself, that is to say the trunk and also a portion of the thighs, that fascinated me. The hands, the arms, the head, the legs were unimportant. Only the body lives, all-powerful, and does not think.[78]

In the substitution of the woman's body (and specifically the torso) for the phallic brush, the represented figure is turned into a fetish, so that it becomes a reassuring image rather than one that evokes unpleasure through the threat of sexual difference and castration.

So the female body print in Yves Klein's hands is an extremely problematic method and image, and it might be felt that, in the light of this precedent, it is best left alone by feminist artists. The question is, however, does Burman manage to create different meanings with the body print; does she manage to set up the image in ways that modify the associations created by Yves Klein's work? Chila Kumari Burman has described the strict/traditional Indian family in which she was brought up.[79] The blanket term of 'feminism' does not, therefore, adequately account for Burman's position within patriarchy. Born of Indian parents who migrated to England in the 1950s, Burman is situated between cultures, positioned and identifying herself as an Asian feminist in the context of a Liverpudlian–Punjabi upbringing. To understand the significance of Burman's body prints it is important to place them against this historical and cultural background and in relation to attitudes towards women and the female body within contemporary Hindu culture. For Burman to use her own body as a source of artistic imagery is a claim to a complex identity. Of

course, one of the most obvious distinctions between the prints produced by Klein and those by Burman is that in the latter there is no other authorial presence. Burman paints and prints her own body and is not the mediated 'living' brush of a great male artist. But this distinction cannot be secured by the image alone. Burman has sought to control and contextualize the image of the body print by working it up in various ways. The addition of paint, glitter and tinsel to the form of the body recalls the decoration and colour of some Indian art that Burman has reworked elsewhere in her graphic art. Also the emphasis, or exaggeration, of the breasts and genital area prevents any illusion of aesthetic coyness. The image insists that the viewer engages with the artist's display of her body. It is a snipe at the European tradition of the female nude and also a statement about physical and sexual identity by a black woman artist working in Britain. In the installation of the body prints at *The Thin Black Line*, an exhibition of work by black women artists, held at the Institute of Contemporary Arts in 1985, Burman anchored the meaning of the images even further (Plate 30). In this case, a compilation of body prints in varying colours and densities is overlaid with graffitied slogans such as 'Women Reclaim Our Bodies' and handprints, which create an explicit feminist context for the display. The female body is on show, but through the filter of the history of the women's movement and the politics of black feminism. Yves Klein's *femmes pinceaux* fetishize the female body: the anthropometric images reduce women to the sign of the painted torso, apparently transcendent but always under the controlling agency of the artist. For Chila Kumari Burman, identity never resides in a metaphysics of the body but is always placed in the historical and cultural discourses of race, class and gender. It remains, however, a risky business.

In his statement of 1913, Kandinsky evoked the image of the conquering, colonizing brush of European modernism. The colonialism of modern art is embodied in the discourses of 'primitivism', which validate the appropriation of non-western cultures as a creative aid and stimulus to the European avant-garde.[80] But the ideologies of primitivism are also highly gendered, a fact that is exemplified in Kandinsky's perception of his canvas as both a virgin awaiting violation and as a colonial subject. Black women's cultural practice has always had to engage with the construction of both racial and sexual difference within dominant culture and these two discourses come together in a particularly volatile way, around the representation of black women's bodies. In his study of stereotypes of sexuality in nineteenth-century and early twentieth-century European culture, Sander Gilman has shown that black women were the subject of a particularly insistent form of sexual pathologization.[81] Conceived within the terms of racial degeneration, black women's bodies were reduced to signs of sexual abnormality and, as Gilman shows, the obsession with the appearance of the buttocks and genitalia transformed the body of the

black woman into a heightened sign of sexual difference. Black female sexuality, as conceived by white society through the signs of the body, has been the object of both a profound attraction and fear. It could be said, therefore, that the political issues involved in the representation of the female body by black women artists are even more complex than those that have faced white women. As Claudette Johnson has written:

> As [black] women, our sexuality has been the focus of grotesque myths and imaginings. We have been attributed a bestial sexuality as in the Bond film character played by Grace Jones, or the seductress in Carmen Jones. Whilst some painters have used us to explore their strange fantasies of purity versus impurity, as in one well known work [Manet's *Olympia*] where the strategic positioning and obscure rendering of the servant woman serves to highlight the whiteness . . . of the reclining woman.[82]

Black cultural politics thus demands both a critical interrogation of the past and the affirmation of black, Asian and Oriental women's identities within their own cultural traditions and experiences. Racial difference is an extremely complex set of constructs, and women need to reaffirm their particular and diverse identities through the visual arts. Lesley Sanderson's self-portrait entitled *Time for a Change* combines these strategies of critique and affirmative transformation (Plate 31). In the juxtaposition of the two female figures – one clothed, the other naked – the artist explores the stereotyping of the 'Oriental' woman and claims an identity that lies outside of this racist construction. Painted in a realist style, the picture allows an immediate and easily accessible reading. The clothed figure in the background represents the 'National Geographic-type media representation of "ethnic" women being exotic and submissive'.[83] The image gazes down, out of the painted frame, at the figure seated in front of her, which is Sanderson's self-portrait. The seated naked figure thus represents the refusal to occupy the containing frame of Orientalism which is represented by the appearance of the figure behind her. The seated figure gazes out of the picture space and confronts the viewer with the questions of identity and power that are raised by the painting. Curiously enough, what we have here, partly, is a return to one of the traditional functions of the female nude, as an allegorical image of Truth. But this return is no simple repetition, for the female body is now explicitly inscribed with the signs of self-determination and the politics of cultural identity.

What has been emerging again and again in this discussion of feminist art practices is the issue of the control of identity through the control of the image. The image of the female body may never be free of contradiction but patriarchal traditions of representation can be sufficiently disturbed to create new and different associations and values. Since the 1970s, there have been voices from within the women's movement that have suggested

that under patriarchy the female body cannot be represented – that it cannot be shown without being appropriated for the dominant ideologies of gender and sexual difference. Peter Gidal has stated: 'I do not see how . . . there is any possibility of using the image of a naked woman . . . other than in an absolutely sexist and politically repressive patriarchal way in this conjuncture.' What this statement amounts to is an assertion that within patriarchy the female body is beyond representation; that it is, in the sense outlined in Part I of this book, 'obscene'. More recently, Mary Kelly has modified the position represented by Gidal and has stated: 'To use the body of the woman, her image or person, is not impossible but problematic for feminism.'[84] In Kelly's work *Interim*, she has addressed this problem by using articles of clothing to represent the body. The section of the piece called *Corpus* is made up of a number of triptychs, each of which is organized around a woman's garment such as a black leather jacket, or a white silk dress. By drawing on these traces of the body, Kelly explores the imaginary construction of female corporeality through the fantasies of romantic fiction, melodrama and advertising, but disengages the female body from those specular regimes that have constituted 'woman' as object of the voyeuristic gaze. In a review of this work, Laura Mulvey stated:

> *Corpus* achieves a very fine balance between the iconoclastic repression of the body during the 1970s which led to woman becoming unrepresentable and a recognition that such a reaction against the exploitation of women in images could lead to a repression of the discourse of the body and sexuality altogether.[85]

Leaving aside the question of the accuracy of this characterization of feminist body politics in the 1970s, the point that is being made here is that by shifting the representation of the female body on to emblematic objects, Kelly is able to explore desire and identity without colluding in the objectification of women. In *Corpus* the female body is a constant referent but is free of the patriarchal structuring of voyeurism and exhibitionism.

In their perception of the female body as always on display and endlessly visible, both Gidal and Kelly assume a bodily norm that is both valued and exhibited within patriarchal culture. But this rather lumpen classification of social power risks creating feminist alternatives that are as repressive to certain groups of women as their patriarchal precedents. As this section has shown, the female body is not a unified category and as a result women are not positioned identically within the specular regimes of patriarchy. If the mode and degree of visibility imposed upon different types of female bodies vary, then it follows that the cultural strategies adopted by individuals and groups of women will be equally diverse. Denying visibility to 'the female body' as a universal category perpetuates the invisibility of women whose bodies do not conform to the ideals of the dominant culture and who may be struggling for the right to physical and public visibility.

Many of these issues around visibility, representation and the body are most clearly focused by those campaigning for the rights of disabled people. Across the many struggles in which disabled people are involved, the fight for self-representation has become one of the most significant. Within the mass media, people with disabilities are either largely invisible or marginalized through a limited range of social and cultural stereotypes.[86] Disabled women are not only subjected to the generalized stereotypes that define people with disabilities as helpless victims and inadequate individuals, but are also defined in gendered terms, as deviations from particular sets of feminine norms. In the last two decades there has been a particular intensification of the associations between 'good' femininity and physical health. Desirable femininity has been constructed specifically in terms of both health and beauty – to be fit for life is to be fit for art. As health has become increasingly commodified, so we have been enticed to consume by the prospect of the perfectibility of the body and have been surrounded by advertising images displaying young, able and beautiful female bodies.

In this context of what might be called 'body fascism', the image of the female body that does not conform to these ideals is both transgressive and disruptive. The image of the 'imperfect' or incomplete female body can only be managed within consumer culture by rendering it invisible, or by subjecting it to the stereotypical narratives referred to above. The disability arts movement has provided an important and significant forum for disabled women artists to challenge the stereotypes and omissions of non-disabled culture and to make visible new definitions of physical identity. Intervention here does not take the form of a disengagement of the female body from the visual economy; rather, it involves the insertion of different women's bodies that call into question prevailing norms and expectations.

In her writing, tape-slide and performance works, Mary Duffy has used her naked body to confront the issues of gender, representation and disability in a particularly powerful way. She has stated:

> Through my work I try and find a balance in relation to my feelings towards my body . . . It is not a comfortable or definitive statement about images of women or images of disability . . . I have been surrounded all my life by images of a culture which values highly physical beauty and wholeness, a culture which denies difference. My identity as a woman with a disability is one that is strong, sensual, sexual, fluid, flexible and political.[87]

Cutting the Ties that Bind is an eight-panel photographic piece with accompanying text (Plates 32–34). Commissioned by the Arts Council of Ireland in 1987, it was part of an exhibition that travelled to schools throughout Ireland. The first photograph in the series shows a standing figure, wrapped from head to foot in lengths of white material. It is an

enigmatic image, reminiscent of a statue in protective coverings, or the bandaged figure of a mummy. As the sequence progresses, the figure begins to shake itself free of the wrappings which fall, discarded, to the floor. In the final images, the woman's body is revealed, standing amongst and then striding away from the pile of material. The images are dramatically set in a darkened space, with strong side-lighting, and the viewer's attention is thus drawn exclusively to the progressive revelation of the figure. What is unexpected about the sequence is that the woman's body, when shown, has no arms and, in this context, the powerful image of the figure striding away from the restraining, disguising wrappings takes on the additional metaphorical force of the rejection of the cultural, social and economic constraints that face disabled women.

Duffy has written very clearly about the tactical use of her body in her art work.

> By confronting people with my naked body, with its softness, its roundness and its threat I wanted to take control, redress the balance in which media representations of disabled woman is usually tragic, always pathetic. I wanted to hold up a mirror to all those people who had stripped me bare previously . . . the general public with their naked stares, and more especially, the medical profession.[88]

Duffy's redefinition of her body is couched in ambiguous terms. On the one hand, it is soft and round (suggesting pliability); on the other hand, it is also threatening. Duffy draws on the modulations of femininity posed by her body to create a different and empowered self-identity and to question the structure of voyeuristic pleasure. Refusing the role of object of the scrutinizing gaze, she uses her art to present her body in the public domain on her own terms.

In a more recent live art performance, commissioned for Rochdale Art Gallery, Duffy delivered a text standing naked in front of the audience (Plate 35). The work, entitled *Stories of a Body*, includes the projection of abstract, linear forms on to Duffy's body which creates a vibrant and containing exterior surface. In an accompanying text Duffy describes building a wall around her 'self' as a means of protection against the scrutiny and judgements of the medical profession. In this instance, therefore, the notion of the containment of the female body and the enforcement of its surfaces is used defensively by a woman artist, in order to claim the finished wholeness of a body that is otherwise conventionally regarded as incomplete and unfinished.

The aesthetic relationship of the whole and the part or fragment is redefined in Duffy's visual construction of her body. In the classical tradition inherited from the Renaissance, female beauty is frequently typified by Roman statues which are partial and incomplete. These damaged forms have been seen as condensed statements of classical prin-

ciples of ideal beauty and their fascination seems to lie, partly at least, in their allowing imaginary reconstructions of the once-complete figure. Peter Fuller exemplifies one tendency within this aestheticization of the fragment. In his essay 'The Venus and "Internal Objects" ' Fuller attempts to analyse the apparently transhistorical fascination of western audiences with the broken image of the female form in the Venus de Milo.[89] He sees the history of the Venus de Milo, the resurrections and attempts at its reconstitution, as a paradigm of Melanie Klein's psychoanalytic theories. To simplify a complex set of ideas which Fuller summarizes in his essay, Klein focuses on the earliest months of infant life and the ways in which the infant copes with its overbearing instinctual drives in relation to the mother and her breast. The infant's desires in relation to the mother's body are bound up with frustration, envy, hatred and destructiveness as the child learns to separate itself from the body of its mother as it gains subjectivity. Klein describes fantasies, dating back from the earliest months of life, involving violent, sadistic attacks on the mother's body. The position set out in these destructive fantasies is then replaced, according to Klein's developmental model, by the acceptance of ambivalence, as the child learns to acknowledge both its love and its hate of the mother and begins to split from and separate its own subjectivity from that of its mother. According to Klein – and this is crucial to Fuller's argument – this phase is also characterized by overwhelming reparative impulses, desires to regain or repair that which has been destroyed in the earlier paranoid-schizoid position. The power of the Venus de Milo lies in its gratification of this fantasy of reparation. The statue in its damaged state 'evokes in its receptive viewers the affects attaching to their most primitive phantasies about savaging the mother's body, *and* the consequent reparative processes' (p. 124).

Fuller provides one rationalization of the view that the power of the fragment – as focused on the image of the female body – derives from the spectator's need to repair and complete the form. The significance of the fragment lies in the degree of its difference from an imagined whole. It is precisely this aesthetic account that is challenged and resisted in Mary Duffy's work. She rejects the conceptualization of her body as incomplete; in her art, her body is itself whole, complete and self-bounded. It is an entire presence rather than the sign of some mutilated whole. Duffy's images of the female body force her audiences to confront these cultural and aesthetic norms and the values and judgements that they imply.

The feminist project of 'redrawing the lines' has been, to a large extent, a question of challenging the monolithic and normative category of 'the female body' proposed by patriarchal and certain feminist art forms. It has meant opening up visual culture to different kinds of images of femininity and the female body, and has politicized the role of visibility itself. All these aspects are brought together in the work of Jo Spence who, as well as

using the camera to explore her own physical identity, has also advocated the use of photography in a therapeutic context, for women to analyse body images and identity. The issue of control is also at the centre of Spence's art. It is concerned with reclaiming control of the female body and formulating a pictorial language to represent difference. It is also about the politics of healthcare and how the individual can retain power when categorized as passive patient or victim. And above all, Spence's work is about taking control of identity and of drawing attention to the complexities and fractured nature of our sense of self.

Spence's photographs – both individually and juxtaposed in series – are narrative fragments; they are points of entry into stories about gender, class and age. Collectively, they do not tell the same story or come up with a single authoritative version of the truth; instead, they tell different stories which testify to struggles over identity and the tensions between the ways in which women are represented and how they come to understand themselves within contemporary British society.

Identity for Spence is always psychic *and* social and the relationship between these two levels is brought out for her through psychotherapy. Therapy offers another kind of story-telling and many of Spence's photographic images make visible the processes of telling the story of the self. But in case this begins to seem excessively individualistic, it should be made clear from the beginning that Spence's work addresses broader categories than that of the individual. The identities put in place by Spence concern a working-class woman, ageing and with a scarred body. This is not a set of positions that is endowed with any power in dominant culture, but Spence explores these identities in relation to a political agenda. She places this self within history (the class mobility enabled by state education); within patriarchy (the construction of motherhood and female desire); and within dominant aesthetics (the norms of female beauty prescribed through visual representation).

In a recent collaborative work, entitled *Narratives of Dis-ease*, Spence makes visible in public the taboo subject – the unhealthy and ageing female body. The series re-enacts some of Spence's feelings and experiences since being diagnosed with and treated for breast cancer.[90] The politics of the medical treatment of breast cancer are only just being publicly discussed, but what is still invisible in this debate is the image of the post-operative body. Women who have undergone radical surgery for the removal of a breast are offered a prosthesis to disguise, to hide from the public gaze the damaged female body; the female body defined as ugly, undesirable, aesthetically offensive. By reassuring others, it seems, the cancer patient has herself to be reassured. This 'cover up' is exposed by Spence in five images that explore the shifting subject positions that she, as a post-surgery patient, occupies. They include weeping child ('Included', Plate 36) and monster ('Exiled', Plate 37); they express shame, fear and defiance and use

humour and punning to articulate the social and psychic construction of these identities. In 'Exiled', Spence's torso is cut off from the rest of her body in order to represent her experiences as a cancer patient, terrifying and monstrous to other people. A hospital gown is held open to reveal the scarred body. 'Monster' has been written in large letters over the breasts, and part of the lower half of the face is covered by a *Phantom of the Opera* mask. This image is about the experience of exclusion but, in the context of the other images in the series, it is also about the confusion of subject positions that are lived out as cancer patient.

Narratives of Dis-ease does not simply present alternative 'positive' images of the female body to counter the silences of mainstream medicine and culture and, as a result, it does not offer a happy ending to the narrative of disease and treatment. It is impossible to read the series as a progressive development with resolution at the climax, but to see the fragmented forms of identity being worked through is, nevertheless, enabling.

The female body is constantly subjected to the judgemental gaze. Whether it be the gaze of the medic who defines the body as healthy or diseased, or the connoisseur who defines it as beautiful or ugly, the female body is caught in a perpetual cycle of judgement and categorization. So how are we, the viewers of this series, positioned? Can we escape from this structure of looking and judging? The answer is probably 'not entirely'; but in viewing the shifting subjectivity of Spence in the images, our own subjectivity is surely also disturbed and called into question. Shock, identification, rejection, admiration, sympathy – all these are possible responses to the images. But ultimately, the power of the images lies in the fact that we are not made to witness a display but are, rather, involved in the processes through which identity is formed.

In *Libido Uprising* Spence examines identity in the context of her economic, social and psychic relations with her mother (Plate 38). The word 'uprising' offers a key to the feelings that are represented here. 'Uprising' means both insurrection and ascent; it also has the more archaic senses of resurrection and the rising of a woman after confinement. In *Libido Uprising* the mother and daughter are represented through a play on the opposition of the erotic and the domestic. A hose from a vacuum curls its way around a leg which is adorned with a red stiletto shoe and black stocking (Plate 39). This clear reference to the serpent in the Garden of Eden is given a comic effect by the banality of the 'homely' and familiar image of the 'Hoover'. It is also an image about the fragmentation of the female body within visual culture ('a good pair of legs') and the desire to separate the sexual and the maternal within femininity. In the sequence across the arms of the crucifix-form of the installation, the head and body of the female figure become smeared and progressively covered in red, blood-like daubs. These marks are the signs of transgression, of the

daughter breaking with the taboos and repressions signified by the madonna/mother figure, cradling her vacuum. Again, there is no unified narrative path through this work; instead, we are offered narrative fragments and reworked memories in which the erotic is domesticated and the domestic is eroticized. By coming to terms with her own bodily and sexual identity, the daughter also begins to come to terms with her projection of her mother and her mother's own complex subject positions.

Jo Spence is therefore another feminist artist who makes images from her own body in order to expose the multiple constructions and identities of femininity within contemporary British society. The artists discussed in this section demonstrate the importance of feminist representations of the female body. The project may be difficult and contradictory but it is an important element in the struggle for self-definition and self-representation. It may be appropriate to end with a Spence self-portrait (Plate 40). A sharply foreshortened figure is completely shrouded in a coarse white cloth and has been deposited on a trestle in a bare room. It is an image of alienation, of an individual detached from the business of the social world. Behind the figure, a roughly written notice has been pinned to the wall; it reads: 'Write or be Written Off'. It is this instruction that offers a way of understanding the work discussed in this section. To write, or more generally to represent, is to take power; it is to tell your own stories and draw your own lines, rather than succumb to the tales and images of others. Of course, there is a risk involved; you might not end up telling a fairy-tale with a happy ending, but at least you are the narrator and are in control of the means of narration.

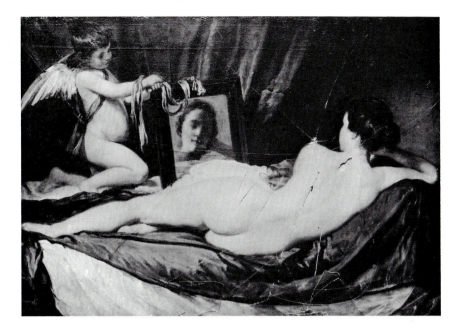

Plate 13 Photograph of damage to Velazquez, 'The Rokeby Venus', 1914.

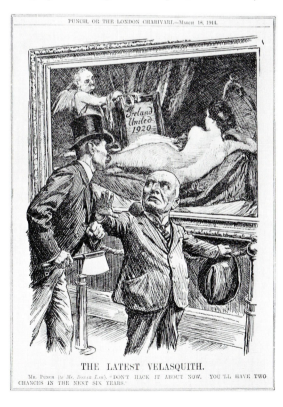

Plate 14 'The Latest Velasquith', *Punch, Or The London Charivari*,
18 March 1914.

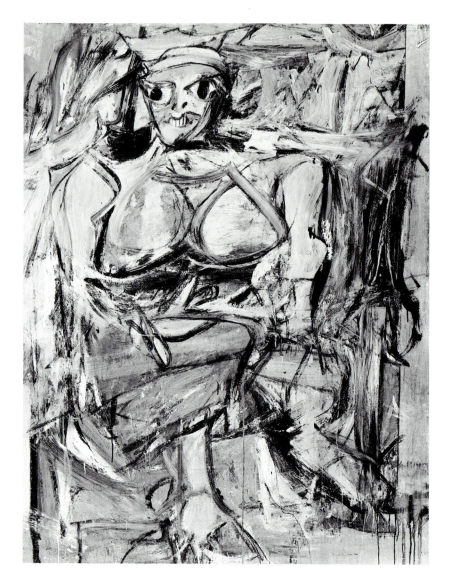

Plate 15 Willem de Kooning, *Woman I*, 1950–2.

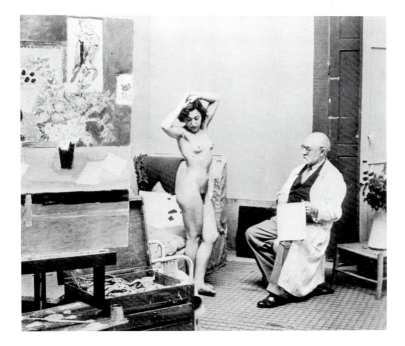

Plate 16 Brassaï, *Matisse with his Model*, n.d.

Plate 17 From F. Serra and J.M. Parramon, *Painting the Nude*.

A model will need frequent rests, as posing in a fixed position is very tiring. In order to reconstruct the pose correctly, draw round the model in chalk at the start of the pose (**left**). The marks can be made on the floor, chair or bed.

The foreshortened body (**facing left**) appears telescoped when viewed straight on — note how the legs seems short and broad while the torso recedes. It is important to learn to measure by eye, or with the aid of a pencil held at arm's length, and to discard preconceived knowledge in favour of the evidence of your own eyes.

A relaxed position (**above**) will enable the model to sit for longer periods than might otherwise be expected. The upright seated position (**left**) is particularly tiring for the model because of the strain placed on the raised arm and outstretched leg. While this may be visually interesting, remember that your working time will be interrupted by frequent rests.

This upright seated pose (**left**) provides the model with a support for her feet and could be maintained for a longer period of time.

Plate 18 'Posing the Model', from Patricia Monahan, *How to Draw and Paint the Nude.*

Proportions

Three-Dimensional Anatomy • Male and Female

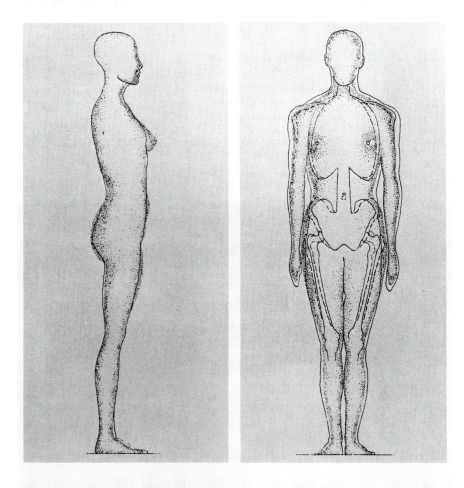

Comparative anatomy of a man and woman with identi-
cal body height.

The continuous outline indicates the male figure while
the dotted areas suggest the female figure.

Plate 19 'Three Dimensional Anatomy: Male and Female', from Klaus
Dunkelberg, *Drawing the Nude: The Body, Figures, Forms*.

Plate 20 Diagrammatic painting from Douglas Graves, *Figure Painting in Oil*.

Plate 21 'Painting from Reference Sources', from Douglas Graves, *Figure Painting in Oil*.

Cross section

direction of nipples

comma shape

Top Left: The breasts are wider than they are high. The nipples point outward from the middle and slightly upward (see diagrams at left). The neck is a cylindrical shape that fits into the torso behind the collarbones.

Center: The breasts attach loosely to the underlying chest muscles. The chest muscles extend out into the arm, forming the front wall of the armpit.

Top Right: Fat extending behind the breast toward the armpit creates a comma shape (see diagram at left). The top outline of the breast is a long, slow curve to the nipple. The bottom outline is a short, sharp curve.

Plate 22 From Joseph Sheppard, *Drawing the Female Figure*.

X
THE FORESHORTENED FIGURE

In the foreshortened figure we have to think of forms as sections, one in front of another. Most measuring devices do not work. It is important not to work too close to the subject, as a near object appears larger than normal, creating a distortion. Intersecting and overlapping lines become important and cast shadows help push one form in front of another. Finding the parts of the body that align with each other is necessary in drawing the foreshortened figure.

Connecting forms become important in laying out a figure in this perspective. The left knee and shoulder intersect. The right knee, elbow, and hand form a triangle (see diagram above).

Plate 23 'The Foreshortened Figure', from Joseph Sheppard, *Drawing the Female Figure*.

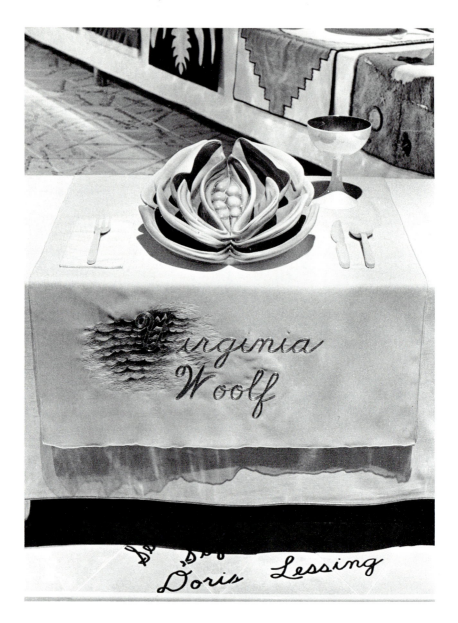

Plate 24 Virginia Woolf place-setting, from Judy Chicago, *The Dinner Party*, 1975–9.

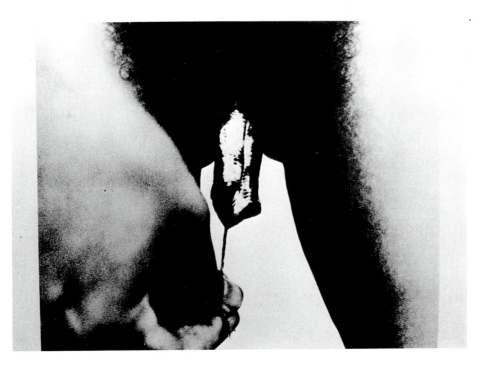

Plate 25 Judy Chicago, *Red Flag*, 1971.

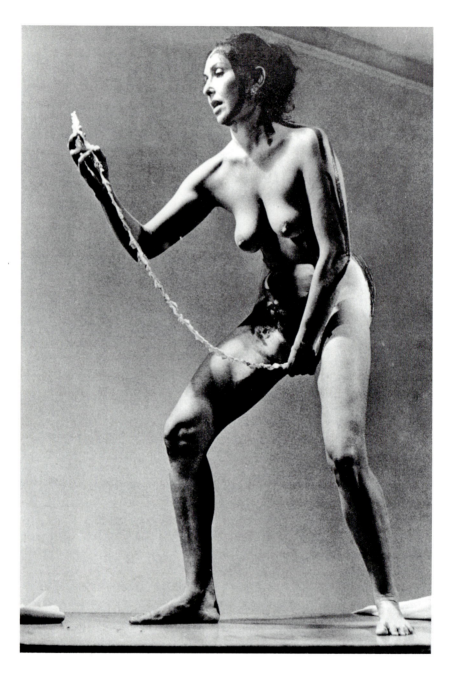

Plate 26 Carolee Schneemann, *Interior Scroll*, 1975.

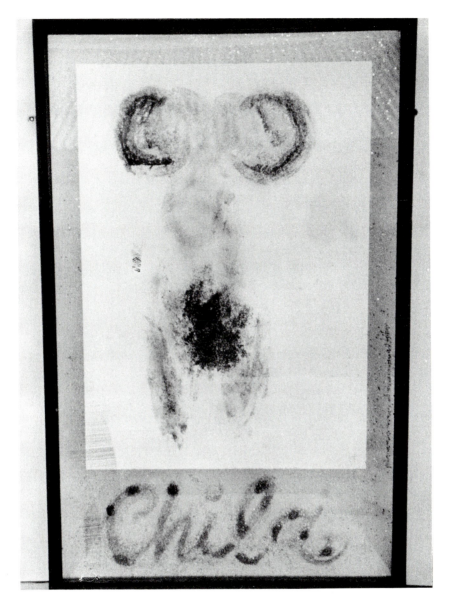

Plate 27 Chila Kumari Burman, 'Body print', 1990.

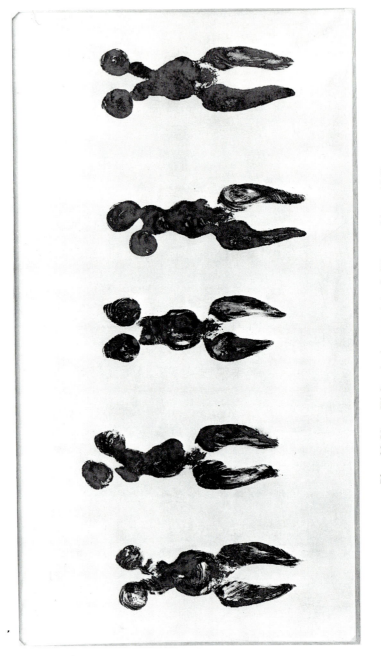

Plate 28 Yves Klein, *Anthropométrie de l'époque bleue*, 1960.

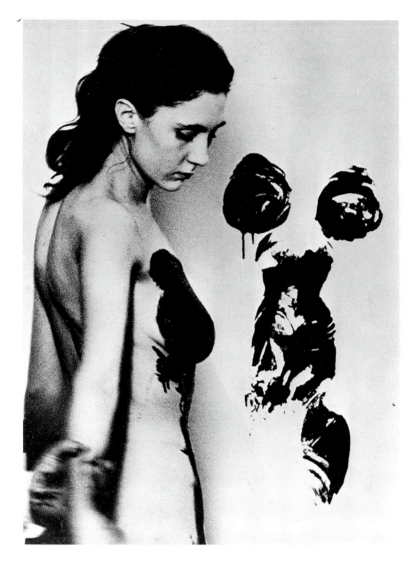

Plate 29 Yves Klein, 'Realisation d'une anthropométrie. Une femme pinceau',
1960.

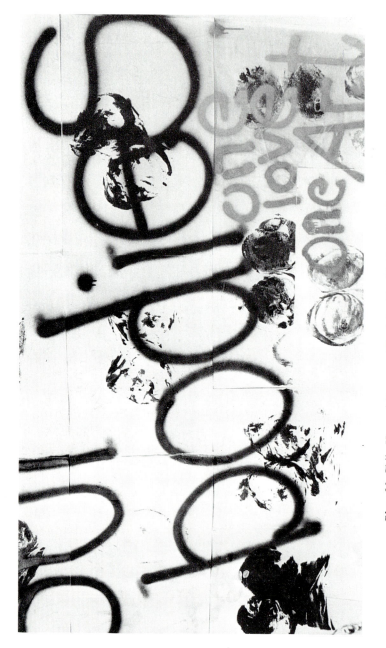

Plate 30 Chila Kumari Burman, 'Reclaim Our Bodies. One Love One Art', detail of installation at the ICA exhibition, *The Thin Black Line*, 1985.

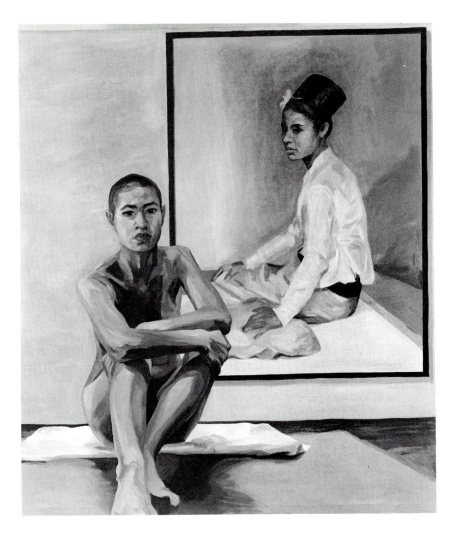

Plate 31 Lesley Sanderson, *Time for a Change*, 1989.

Plate 32 Mary Duffy, from *Cutting the Ties that Bind*, 1987.

Plate 33 Mary Duffy, from *Cutting the Ties that Bind*, 1987.

Plate 34 Mary Duffy, from *Cutting the Ties that Bind*, 1987.

Plate 35 Mary Duffy, from *Stories of a Body*, 1990.

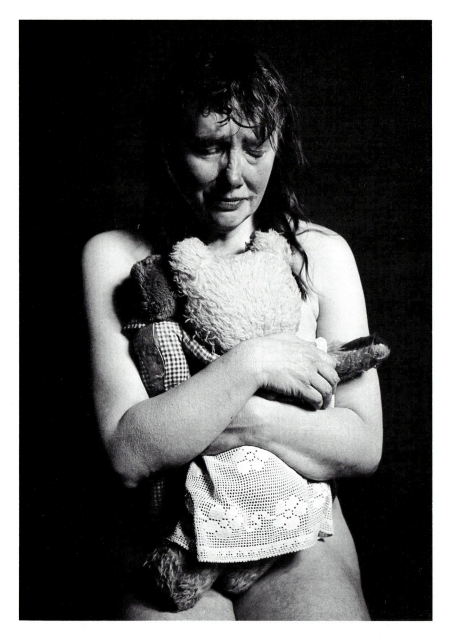

Plate 36 Jo Spence (in collaboration with Tim Sheard), 'Included', from
Narratives of Dis-ease.

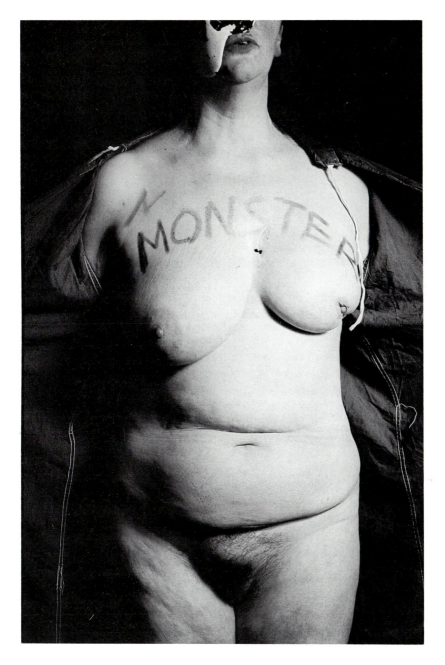

Plate 37 Jo Spence (in collaboration with Tim Sheard), 'Exiled', from *Narratives of Dis-ease*.

Plate 38 Jo Spence (in collaboration with Rosy Martin), installation of *Libido Uprising*.

Plate 39 Jo Spence (in collaboration with Rosy Martin), from *Libido Uprising*.

Plate 40 Jo Spence (in collaboration with Rosy Martin, Ya'acov Khan and David Roberts), from the fifth triptych from *Triple Somersaults*.

Part III

CULTURAL DISTINCTIONS

1 SACRED FRONTIERS

> One cannot fully understand cultural practices unless 'culture', in the restricted, normative sense of ordinary usage, is brought back into 'culture' in the anthropological sense, and the elaborated taste for the most refined objects is reconnected with the elementary taste for the flavours of food.
>
> (Pierre Bourdieu, *Distinction*, 1984)[1]

In *Distinction*, Pierre Bourdieu examines contemporary patterns of cultural consumption. Drawing on models from sociology, he refers to an economy of cultural goods that produces not only commodities for consumption, but also consumers for those goods. For Bourdieu, the hierarchy of cultural goods corresponds to a social hierarchy of consumers. People's cultural tastes and preferences are determined by their upbringing and education, and in this way 'taste' functions as an index of social class. *Distinction* takes as its starting-point a strongly anti-Kantian position. In his analysis of cultural taste, Bourdieu argues for the reintegration of the realms of pure pleasure and sensual pleasure that are so significantly held apart in Kant's *Critique of Aesthetic Judgement*. As we have seen in Part I (Section 4), Kant sought to differentiate the disinterested realm of aesthetic contemplation from the interested judgements of sensual appetite and to prioritize it. In an explicit rejection of this philosophy, Bourdieu calls for a reconnection of high cultural forms ('culture' in its restricted sense) with mass culture ('culture' in its anthropological sense). The point of this process is not to create an undifferentiated cultural mass, but to establish the ways in which the continuum of culture works as a register of social distinction. Bourdieu refers to this anti-Kantian move as a transgression, which abolishes the 'sacred frontier' separating legitimate public culture from the rest of ordinary tastes and preferences in food, music, sport, fashion and so on. To break down the containing frontier of high culture is, at once, to expose

how power is exercised through cultural consumption and, implicitly, to invert the value relations embodied within the Kantian system.

For Bourdieu, the 'pure' gaze that is said to characterize the proper encounter with a work of art is no more than a class-specific mastery of a cipher or code. The pure gaze is that of the individual who possesses the cultural competence or capital to decode the formal elements of an image and place it in a predetermined cultural context. The aesthetic encounter is thus more accurately defined as the recognition and confirmation of cultural power.

The 'pure' gaze prioritizes form over subject and artistic autonomy above illustration or referentiality, which Bourdieu identifies as an attempt to enable legitimate culture to transcend the base level of commodity exchange. Historically, this invention of the aesthetic takes place during the escalation of industrial production in Europe at the end of the eighteenth century. In this context, the pure realm of the aesthetic provides compensation for the commodification of daily life and asserts the superiority of the spirit over economic value and market-inspired appetite. As Terry Eagleton has written in his account of the aesthetic:

> It is just when the artist is becoming debased to a petty commodity producer that he or she will lay claim to transcendent genius . . . What art is now able to offer, in that ideological reading of it known as the aesthetic, is a paradigm of more general social significance – an image of self-referentiality which in an audacious move seizes upon the very functionlessness of artistic practice and transforms it to a vision of the highest good.[2]

Legitimate, or high, culture is thus constituted through the denial of lower, vulgar or venal enjoyment and the assertion of sublimated, refined and disinterested pleasure. From this point on, the choices that we make between the pleasures of the appetite and aesthetic pleasure are acts of cultural and social distinction; as Bourdieu puts it: 'Social subjects, classified by their classifications, distinguish themselves by the distinctions they make' (p. 6).

What are the implications of Bourdieu's model of cultural taste and social classification for representations of the female body? At the end of the introduction to *Distinction*, after having set out the main principles of his argument, Bourdieu provides us with an example of cultural distinction based on the separation of the aesthetic ('pleasure purified of pleasure') and the venal ('pleasure reduced to the pleasure of the senses'). The example takes the form of two contrasting quotations about nudity, obscenity and art. The first is a comment on the inviolable purity of naked dancers in high opera and ballet; the second reflects on the obscenity of a nude scene in the musical *Hair* which is described as commercial and gimmicky. The first quotation, taken from *Le Monde* 1965, is as follows:

'What struck me most is this: nothing could be obscene on the stage of our premier theatre, and the ballerinas of the Opera, even as naked dancers, sylphs, sprites or Bacchae, retain an inviolable purity.' The second quotation, from *Le Monde* 1970, is given here in a shortened version: 'As for the nude scene, what can one say, except that it is brief and theatrically not very effective? I will not say it is chaste or innocent, for nothing commercial can be so described . . . In *Hair*, the nakedness fails to be symbolic.'[3] The quotes are used to demonstrate Bourdieu's point concerning the conventional promotion of cultural value on the basis of the sublimation of the body. High culture is seen to confer a sacred identity on the objects/ situations within its domain, precisely through its repudiation of the body and its pleasures. Bourdieu confesses to being delighted by the quotations but he is, perhaps, unaware of the full significance of his example. As this book has argued, the female nude is not simply one cultural type among many others of equal significance; rather, it is a paradigm of the transforming effects of legitimate high culture. Bourdieu sees the sacred status conferred by high culture as akin to transubstantiation and it is precisely this conversion of ordinary matter into a new sacred substance that is enacted in the high-art female nude. It is significant too, that Bourdieu's examples are drawn from the theatre. If, as we have seen, the purity of the female body depends upon stasis, both of the body that is displayed and the body that is viewing, then movement begins to toy with the possibilities of obscenity.[4] The live performance of theatre is perhaps the most risky situation for the display of the body, straining the 'sacred frontier' between high culture and vulgarity to its limit.

Bourdieu's thesis concerning cultural distinction provides a helpful model for understanding the visual display of the female body within patriarchal culture. If one takes up Bourdieu's cue to transgress the 'sacred frontier' and reintegrate legitimate forms of culture with mass culture, images of the female body can be seen to be dispersed across the full cultural register. The differences, however, between these modes and forms of representation cannot and must not be levelled to identical manifestations of 'sexist' culture; for, as Bourdieu has shown, cultural differences register distinction and it is through these distinctions that power is reproduced.

At either end of the cultural register we have the images of high art and pornography. On the one hand, there is the fine-art female nude as a symbol of the pure, disinterested, functionless gaze and of the female body transubstantiated; and, on the other hand, we have the images of pornography, the realm of the profane and mass culture where sensual desires are stimulated and gratified. Between these two extremes there lies a range of cultural distinctions and a sacred frontier which is drawn and redrawn along the lines of competing definitions of acceptability and unacceptability.

Images of the female body might well be taken as exemplary of Bourdieu's theory of cultural distinction. But what is clear is that their exemplary function depends only partially on the content of the image itself; it is equally a question of where and how the image is seen, who has access to it and how they behave or respond in its presence. All these factors mark the differentiation between legitimate and illicit cultural consumption, between icons of cultural identity such as 'The Rokeby Venus' and the anonymous subjectivities circulated through mass-produced pornography.

Alongside Bourdieu's assertion that social subjects distinguish themselves by the distinctions they make, it is worth recalling Kenneth Clark's words to Lord Longford's committee on pornography. Commenting on sexually explicit works by Géricault and Rodin, he stated: 'Although each of these is a true work of art, I personally feel that the subject comes between me and complete aesthetic enjoyment. It is like too strong a flavour added to a dish.'[5] It is surely no accident that the analogy that Clark draws to illustrate the excess of sex in art is with food and eating. For the connoisseur is also the gourmet and distinguishes himself through his taste both in culture and in cuisine. Pure aesthetic enjoyment is concerned with form rather than subject. Although the female nude may hint at sensual pleasure, the connoisseur's palate is a sensitive one and too strong a flavour corrupts the aesthetic moment through the reintroduction of food, bodies and sex.

Distinctions, then, are not fixed or final but are continuously readjusted. The following sections will examine some of these readjustments and will draw on Bourdieu's theory of cultural distinction to provide an overview of representations of the female body and forms of cultural consumption. As indicated above, this is not so much a question of the content of images as it is an issue of who looks and the contexts of their viewing. The following pages will locate a range of images of the female body – the high-art nude, 'page three' pin-up, pornographic photograph, video and computer program – within the framework of legal and social definitions of art and obscenity, which categorize and classify forms of cultural production and the consumers of those forms. The purpose of such analysis is not to reproduce or secure the categorizations of these images on one side or the other of the frontier that separates art from pornography; nor is it simply to annex one territory to another, in the manner, perhaps, of those who argue that there is no essential difference between 'artistic' and 'pornographic' images of the female body. The point will be to demonstrate the complex interrelationships of the most apparently free-standing example of art or pornography, the most unarguable attribution of an object to one category or another. It is to suggest that the frontier between these categories runs through every point in each grouping; that the sacred frontier is thus to be understood not just as the distinction between the sacred and the profane,

but as a frontier that is itself endlessly policed, invoked, transgressed and replaced – a frontier that is itself, in some sense, sacred.

2 PURE AND MOTIVATED PLEASURE

Cultural distinctions are made through the production of norms of behaviour and expectations concerning the nature of an encounter with a work of art. In this context, illicit culture may be understood in terms of its deviation from these norms of cultural appropriation. Historically, the association of high art with a repudiation of the physical and sensory world emerges within the context of Enlightenment aesthetics. But in earlier periods too, the frontier between publicly acceptable and unacceptable forms of cultural consumption was established in relation to historically specific sexual and moral criteria. It is probably more accurate, therefore, to speak of the internalization of these cultural norms during the Enlightenment, such that the elevated, 'pure' gaze of the public domain was extended to individual responses to high art in private situations as well as in public.

There are a number of myths, which are frequently recirculated, concerning the stimulating effects on male viewers of nude female statues and paintings.[6] In his *Natural History* Pliny describes an assault on Praxiteles' statue of Aphrodite of Cnidos. It seems that a young man had become so infatuated with the statue that he hid himself one night in the shrine and masturbated on the statue, leaving a stain on its thigh – a testimony to the figure's lifelike qualities and the cue for this particular fantasy of male arousal. Of course, the physical dimensions of the free-standing statue might be seen to enhance the potential for sexual arousal. The statue cannot only be touched, but it can also, in fantasy at least, be held and embraced. The inevitable extension of this kinetic experience is the myth of Pygmalion, in which the female statue is not only embraced but also responds to that embrace. In another permutation of this fantasy of male arousal there is the case from sixteenth-century Italy, of Aretino, who so admired the exceptional realism of a painted nude Venus by Sansorino that he claimed 'it will fill the thoughts of all who look at it with lust'. Over two centuries later, there is the example of the bibliophile Henry George Quin, who crept into the Uffizi in Florence when no one was there, in order to admire the Medici Venus and who confessed to having 'fervently kissed several parts of her divine body'. All three of these instances deserve to be fully examined in the light of their specific historical circumstances; but in the context of this discussion of the formation of cultural distinctions, some different kinds of observations can be made. Although all these examples seem to present a view of artistic appreciation that is open to male sexual arousal, this possibility arises, in all three cases, through exceptional

circumstances. For Aretino, the realism of the image seems to draw the viewer directly into a speculation on the female sexual body, rather than towards a meditation on the body in and as art. In the stories from Pliny and Quin in particular, the arousal involves covert behaviour, with the male viewer creeping secretly into the special sanctuary of the statue (the shrine and the gallery), in order to be able to respond sexually to the object, unseen by other viewers. Sexual arousal (and, more precisely, sexual gratification) may be a possible response to an art object, but it is an inappropriate one. The excitement is produced, partly at least, by the transgression of and deviation from norms of public viewing and by the relocation of the work of art within the realm of the forbidden. The viewer's gaze, in all three cases, lacks the elevated intent demanded by high culture and the image is responded to in terms of its content, rather than its formal qualities.

In spite of historical variations, the basic division between respectable, public art and a pure pleasure, and forbidden, private culture and a sensual pleasure is a useful one. Cultural distinctions are, to a certain extent, a matter of defining and controlling the effect of the image or object on the viewer, of drawing the line between the pure gaze of the connoisseur and the motivated gaze of the cultural vandal. The power of representations to *move* their viewers has been the subject of concern within western culture from the outset. For Plato, all representations are debased since they draw attention away from the real world which is itself only a shadow of the ideal. For Aristotle, the viewer's encounter with a representation is a self-contained, cathartic experience. The audience of a tragedy may be moved to pity and fear but these emotions are exhausted within the duration of the drama and do not extend beyond the period of the play.[7] So, the question of whether or not pornographic images have harmful effects on their viewers, which has dominated twentieth-century views on pornography, is part of a much larger and older debate on the power of representations in general. The potential of representations to move is not intrinsically harmful; after all, works of art are sometimes also believed to be moral exemplars and to guide and improve those who come within their domain. The problem arises in relation to the nature of the influence of the image and the kind of action to which the viewer is inclined. For some writers on the subject, the sole aim of the pornographic representation is to bring about a sexual catharsis in the viewer and it is the singularity of this purpose that sets pornography apart from all other kinds of representations. In his study of Victorian pornography entitled *The Other Victorians* Steven Marcus draws some conclusions about pornography generally:

Literature possesses . . . a multitude of intentions, but pornography possesses only one . . . [Pornography's] success is physical, measur-

able, quantifiable; in it the common pursuit of true judgement comes to a dead halt. On this side then, pornography falls into the same category as much simpler forms of literary utterance as propaganda and advertising. Its aim is to move us in the direction of action. Pornography is obsessed with the idea of pleasure, of infinite pleasure, the idea of gratification.[8]

For Marcus, pornography's distinctiveness lies, at once, in measurement and immeasurability. Since its purpose is to move the male viewer towards sexual gratification, this physical response may be easily quantified. But its true character also lies in excess, in offering pleasure and desire beyond boundaries. Marcus's influential study was first published in 1966; six years later, Lord Longford used the same extract to endorse his own view of the damaging effects of pornography. But for Longford, the 'harm' of pornography lies not only in its promiscuous and undifferentiated sexual motivation, but also in the fact that its effects last beyond the duration of exposure to the image. The legacy of pornography, for Longford, is an undiscriminating and sexually motivated society.

It is significant that Marcus draws an analogy between the motivating force of pornography and that of advertising. The analogy draws out the connection between economic and sexual metaphor. Both forms of cultural production are intent on selling and persuading to 'spend'. Both forms might also be said to be promiscuous in their address, in their desire to attract and excite with their images as wide a public as possible. If the pleasures of pornography are defined in terms of motivation, promiscuity and commodification, then the pleasures of art are seen to lie in their opposing values, in contemplation, discrimination and transcendent value. These distinctions have been embodied in legal definitions of obscenity since the nineteenth century. In the debates leading up to the passing of Lord Campbell's Obscene Publications Act in 1857, there was concern that paintings of a sexually explicit nature, held in private collections, might fall within the scope of the proposed Act. Campbell reassured Parliament that this was not the case.

> The pictures in such collections were not intended for sale, but were kept for the owner's contemplation . . . It was not against the masterpieces of Correggio that the Bill was levelled but against the mass of impure publications, which was poured forth on London, to the great injury of the youth of the country.[9]

Art and pornography are being defined here in terms of quality, ownership and access. Art is not on sale; it is reserved for the contemplative viewing of its sole owner. Pornography, on the other hand, is seen as an undifferentiated mass of impurity, bought and sold and wreaking havoc in the public domain. In his attempt to distinguish art and pornography, Campbell's

language begins to reinvoke the boundaries of the body. Art is based on a model of continence; it is kept, held within the body, unlike pornography which pours out beyond the body and into the city streets.

Within the British legal system, pornography itself is not against the law; it is the presence of obscenity that constitutes the legal offence. The first legal definition of obscenity was given by Lord Chief Justice, Sir Alexander Cockburn, in an 1868 case *R.* v. *Hicklin*, in which the term was defined as 'the tendency to deprave and corrupt'.[10] But as we have seen in Part I (Section 5), the etymological roots of 'obscene' also convey the sense of matter that is beyond representation, that cannot be shown. Obscenity therefore signifies that which motivates harmful sexual behaviour and that which is beyond the accepted codes of public visibility.

This structural distinction between the harmful effectiveness of obscenity and the intrinsic value of art was enshrined in the Obscene Publications Act of 1959, which introduced the defence of 'artistic merit' in obscenity trials. The physical, moral or spiritual harm believed to be caused by obscenity was now to be weighed against the perceived artistic merit of the work. Artistic value was defined as a justification or amelioration of obscene material. By introducing this defence, the law effectively gave punitive force to the polarization of art and pornography. 'Absolute' obscenity became synonymous with absolute cultural worthlessness; obscenity was defined as much in terms of its absence of artistic value as in terms of its actual potential to pervert, debase or defile.

The attribution to pornography of the power to affect behaviour has cultural implications that go beyond the particularities of the obscene and bear upon our understanding of the significance of cultural representations in general. These implications are nowhere better demonstrated than in the American Congressional report of the Commission on Obscenity and Pornography, which released its findings on 30 September 1970.[11] The report rejected any clear correlation between pornography and acts of sexual violence and advocated a liberalizing of sex education, in order to foster 'healthy' sexual development. The report resulted in a split between members of the commission and was rejected by the Senate and president. On 25 October 1970, President Nixon's repudiation of the report was published in the *New York Times*:

> The Commission contends that the proliferation of filthy books and plays has no lasting harmful effect on a man's character. If that be true, it must also be true that great books, great paintings and great plays have no ennobling effect on a man's conduct. Centuries of civilization and ten minutes of common sense tell us otherwise.[12]

What Nixon's statement inadvertently reveals is that the supposedly harmful effects of pornography are inseparable from the supposedly beneficial effects of art. Deny the motivating force of pornography and you implicitly

deny the fundamental values traditionally ascribed to western civilization. Art and pornography are caught in a cycle of reciprocal definition, in which each depends on the other for its meaning, significance and status. Momentarily, in the statement in the *New York Times*, this system of cultural distinctions breaks down; but it is only momentary and Nixon marshals the combined authority of civilization and common sense to shore up the framing cultural opposition of moral guidance and corruption, of pure and motivated pleasure.

3 POLICING THE BOUNDARIES

The 1961 trial of Penguin books, who were planning to issue *Lady Chatterley's Lover* in paperback, has become one of the key moments in the regulation of obscenity. During his summary of the case, the judge, Mr Mervyn Griffith-Jones, expressed his concern that:

> once a book goes into circulation it does not spend its time in the rarefied atmosphere of some academic institution . . . it finds its way into the bookshops and on to bookstalls at 3s 6d a time, into the public libraries where it is available to all and sundry.[13]

The concern in 1961 was that the book would fall into the *wrong* hands, a possibility that was exacerbated by cheap printing methods and lending libraries. Public libraries, which had been established in the mid-nineteenth century for the provision of education for the artisan classes, are here transformed, by the spectre of paperback pornography, into disseminators of vice and immorality. What had been intended for the edification of the working classes could, it seemed, turn into a conduit for their degradation. The concern in 1961 was not so much about the content of the novel, as about the constituency of its audience. Later in the trial, the judge told the jury that the question that they should ask themselves was:

> Would you approve of your young sons, young daughters – because girls can read as well as boys – reading this book? Is it a book you would have lying around in your own house? Is it a book that you would even wish your wife or your servants to read?

The successful defence of the publication of the novel was achieved through the expert witnesses who attested to its literary merit. Nevertheless, the advice given to the jury reveals how the policing of boundaries of cultural distinction involves not so much, or not simply, a policing of obscenity in texts, as a regulation of viewers and viewing situations. Put very simply (and this is typified in the judge's advice given at the *Lady Chatterley* trial), obscenity is that which, at any given moment, a

particular dominant group does not wish to see in the hands of another, less dominant, group. This section will therefore examine some of the legislative moves, enacted since the middle of the nineteenth century, to regulate access to the obscene.

In *The Secret Museum* Walter Kendrick traces the emergence of the modern category of pornography and argues that the only possible definition of pornography is in terms of its identity as the illicit or forbidden sphere of culture. Although the latter part of his book adopts a strongly anti-feminist stance, as a whole, it does present some useful insights into the historical relationships of pornography, censorship and modernity. Kendrick holds that the history of pornography is a relatively recent phenomenon that is inseparable from the history of censorship and the developments of modern mass culture. Rejecting the idea that there are any common formal characteristics among pornographic texts, he cites as evidence the range of objects and publications that were regarded as objectionable and potentially harmful during the nineteenth century – from sexually explicit statuettes unearthed at Pompeii, to Victorian sensation novels and investigative studies of prostitution. According to Kendrick, the history of pornography in the twentieth century takes the form of increased specialization and specification of the obscene. As the legal definition of the non-obscene is widened to include technical, medical, educational and artistic representations, so the category of obscenity is narrowed and increasingly takes on the particular label of 'pornography' – the explicit and illicit representation of sex and sexual bodies for the sole purpose of arousal.

Pompeii provides the model for Kendrick's conceptualization of pornography. The Romans had displayed sexually explicit artefacts on street corners and in public buildings. Only in the eighteenth century were 'gentlemen' archaeologists faced with the paradox of the valuable rarity of the objects, alongside the perception of their immorality. The question was how to enable the dissemination of knowledge, whilst restricting access to the corruption of the obscene:

> What was required was a new taxonomy: if Pompeii's priceless obscenities were to be properly managed, they would have to be systematically named and placed. The name chosen for them was 'pornography', and they were housed in the Secret Museum.[14]

It was in this moment of segregation, in the separation of 'dangerous' works from the rest of ordinary culture, that the objects took on their full 'pornographic' meaning. The Secret Museum was perceived as a safe-guard, taken to protect certain, vulnerable sections of the public from corruption and arousal. As one official guide to the Naples collection, published in the 1870s, stated:

> We have endeavoured to make its reading inaccessible, so to speak,

to poorly educated persons, as well as to those whose sex and age forbid any exception to the laws of decency and modesty. With this end in mind, we have done our best to regard each of the objects we have had to describe from an exclusively archaeological and scientific point of view. It has been our intention to remain calm and serious throughout. In the exercise of his holy office, the man of science must neither blush nor smile. We have looked upon our statues as an anatomist contemplates his cadavers.[15]

The guide to the Secret Museum is one of repeated attempts, during the nineteenth century, to secure the Pompeiian artefacts for art and science and to repudiate utterly the debased responses associated with obscenity. So the author insists – over-insists perhaps – on the seriousness and objectivity of the enterprise. It is a sacred project rather than a profane one, and in his search for analogies to reassure himself and his readers he hits upon the anatomist examining a corpse. The pleasure-seeking eye of the voluptuary is dispatched in favour of the dissecting gaze of the scientist. Dead flesh, to be sure, but more animate, nevertheless, than the marble and clay of the statuettes.

In its insistent claims to scientific status, the presentation of the Secret Museum may be compared to nineteenth-century writings on prostitution and public hygiene. The etymology of 'pornography' is the 'writings of harlots' but, as Kendrick points out, this was extended to the precarious status of investigations of prostitution by authors such as Parent-Duchâtelet in France and William Acton in England, in the middle decades of the nineteenth century. Here again, the boundaries between a serious, scientific and moral enterprise and a text of frivolity, arousal and innuendo had to be assiduously maintained. The charts of statistics and tables, the repeated claims to sobriety and objectivity, were attempts to differentiate the social investigation of immorality from the immoral behaviour itself.[16] But in their constant reiteration of social utility and self-control, the texts also served to remind the readers of the possibility of other, more frivolous and forbidden responses to the material. During the nineteenth century, the modern concept of pornography was established by the annexation of texts and objects that seemed to embody 'dangerous' knowledge. At the same time the creation of a legal category of the obscene in the 1857 Obscene Publications Act enabled the pornographic to be constructed as a bounded domain, classified through its identification with the forbidden and the illicit. Pornography in the modern period describes a zone of disorder and irregularity within the standards and rules of moral society.

The drawbacks of Kendrick's analysis have already been alluded to. By conjoining the history of pornography and the history of censorship, Kendrick creates a continuum of social attitudes to the forbidden that makes no attempt to differentiate the various views of censorship held by

different historical groups. For Kendrick, there is little to distinguish the middle-class gentlemen legislators of the nineteenth century from the recent, pro-censorship feminist campaigns against pornography. Whilst it may be true that these groups occupy common ground within a broad history of censorship, it is also essential to examine the particularities of and differences between their political aims and strategies. In addition, by restricting his definition of pornography to that which is defined as forbidden within the dominant culture, Kendrick fails to examine or raise the question of the formal and generic characteristics of pornographic representation at given historical periods. Pornography has also to be understood in terms of the production of particular expectations concerning the formal elements of the representation, such as the deployment of narrative devices, of written and pictorial language, and the accessibility and visibility of the body.[17]

What is most convincing about Kendrick's argument, however, is the connection that he makes between pornography, censorship and modern mass culture. If the boundaries of obscenity are policed through the regulation of audiences, then it follows that the greatest threat will be posed by forms with the greatest potential circulation. Following on from Steven Marcus, Kendrick dates the emergence of pornography to the early nineteenth century and the changing concept of a 'public'. Cheaper printing methods and rising literacy rates, along with the concentration of populations in urban centres, made it less and less certain into whose hands a picture or book might fall. The fear was, increasingly, that dangerous material would fall into the hands of 'vulnerable' groups such as women, children and the poor, those with a predisposition to depravity or without the self-discipline to resist it.

If pornography is identified as a problem of mass culture, then, viewed from another perspective, one of the few stable, legal definitions of art is its uniqueness and authenticity. Legislation in Britain affecting the arts has been enacted in a number of areas, including income tax, copyright laws, customs and excise duties, and museums and galleries. In all these cases there has to be a working definition of the category of art, and frequently the boundary of the aesthetic is drawn in relation to the number of copies of the work and the means of production of the copy. For example, under Customs and Excise regulations, hand-produced copies of paintings, pastels and drawings are granted value-added-tax exemption; whilst mass-produced copies are not.[18] Artistic status is thus awarded in relation to the work's distinction from mass culture. If pornography is popularly held to represent sex devoid of human feeling, then equally it is seen to be produced by means that are mechanical and dehumanized. We might expect, therefore, that the difficult or borderline cases will be those that blur the distinguishing characteristics of art and pornography, those that confuse the media, locations and audiences associated with these cultural

categories. A memorandum from 1970 to the Obscene Publications Squad lists a number of instances where there might be some difficulty in categorizing material, including 'displays in recognized galleries and books expensively published'.[19] In other words, in its legal and criminal classification, pornography tends to be defined in terms of being mass-produced, cheap and new. This understanding could only be formulated against a conception of art as unique, valuable (priceless) and marked with the aura of age.

To a large extent, the policing of the boundaries of art and obscenity is a question of the projection of imagined viewers and audiences and the invocation of norms of moral and sexual values. This has been built into the law through references to the 'public good' and 'community standards'. In the United States, the Supreme Court case of *Miller* v. *California* in 1973 set out three criteria that need to be met for a work to be found obscene. The first of these criteria is that 'the average person, applying contemporary community standards, would find that the work, taken as a whole, appeals to prurient interest'. In the same year, English juries at obscenity trials were enjoined to 'keep in mind the current standards of ordinary decent people'.[20] These criteria are obviously extremely vague and, possibly as a result, it has proved difficult to win an obscenity conviction within these terms. Nevertheless, the prioritizing of community standards and the assumption of moral consensus has encouraged a normalizing of certain sexualities and an outlawing of those sexual identities and desires that are seen to deviate from the accepted norms. The legacy of these assumptions concerning community standards is seen in recent legislation in Britain and the United States. Although this legislation is not a direct revision of existing obscene publications law, it seeks to extend the regulation of obscenity to publicly funded cultural production. What is more alarming is that obscenity, understood in terms of the promotion of harm and the intention to corrupt, is now being targeted specifically in relation to homosexuality. In Britain the passing into law of Section 28 of the Local Government Act (1987–8) prohibits local authority funding of activities that are deemed to 'promote homosexuality'.[21] In 1989, in the United States, Senator Jesse Helms spearheaded a campaign to prohibit the use of public funds from the National Endowment for the Arts, for work that might be deemed to be 'obscene'. During his campaign, Helms chose as one of his main targets an exhibition by the photographer Robert Mapplethorpe, denouncing his photographs of homosexual erotica as pornographic and obscene.[22] In both contexts, the policing of the boundaries of cultural acceptability is, quite blatantly, a policing of the boundaries of sexual acceptability. Within this legislation, homosexuality and the homosexual body is obscene; it is beyond representation and must be rendered invisible. In both cases, the strategy adopted is similar, taking the form of pre-emptive measures that anticipate the regulation of the images themselves by promoting self-regulation and self-censorship, prior to the

95

production of the object or funding of the project. Within these recent developments, the traditional role of obscenity legislation to regulate access to 'dangerous' material has become focused on the representation of homosexuality. Now, however, the aim is not simply to restrict but to ensure that it is never made visible at all.

In the extracts from the trial of *Lady Chatterley's Lover* given at the beginning of this section, what is most striking is the certainty on the part of the judge concerning which categories of the community are in need of protection from obscene material. The unspoken norm here is the middle-class gentleman, who is the addressee of the judge's comments and who may also be trusted to come into contact with obscenity without coming to harm. In the 1990s these assumptions regarding the probable audiences of pornography and the function of legislation appear outmoded and irrelevant. It is no longer accurate to assume a male audience for 'straight', heterosexual pornography. Recent studies of video pornography have shown that female viewers are the largest potential growth-market for pornographic films and that women are beginning to play a more powerful role within the industry itself, as producers and directors, as well as stars.[23] It has been argued that predominantly female companies such as Femme Productions are producing new kinds of pornography, aimed at an audience of women and couples in the home. In her book *Hard Core*, Linda Williams has argued that the pornography being produced by Femme offers a new exploration of female sexual desire, as well as different narratives and better production values. She writes:

> If the new pornography for couples and women exemplified by Femme Productions seems safe, almost too legitimate for some masculine eyes, it could be this legitimacy is needed to enable women to create for themselves the safe space in which they can engage in sex without guilt or fear . . . This much is clear: it is no longer for men alone to decide what is, or is not, exciting in pornography.[24]

Whether or not Williams is right in her characterization of the new pornography for women, she is surely correct in her concluding statement. The middle-class gentleman can no longer maintain exclusive control over the production and consumption of sexual imagery. Rather than ask whom should the law protect from what, the question we should now be putting is, who has the right of access, within the law, to the representation of their sexual desire and pleasure?

4 DISPLAYING THE FEMALE BODY

Since the late 1970s written representations have been removed from the domain of the pornographic. In 1979 the report of the Williams Committee

recommended that the purely written word should be completely exempt from any censorship or legal control related to its supposed obscene character.[25] And in 1986 the Meese Commission in the United States adopted the same position, explaining that:

> the absence of photographs necessarily produces a message that seems to necessitate for its assimilation more real thought and less almost reflexive action than does the more typical photographic item. There remains a difference between reading a book and looking at pictures.[26]

The potential harm of pornography is thus seen to lie in the photographic image. As we have seen, photography is imbued with an ideology of realism; it is regarded as a transparent medium, offering more or less direct access to its image. Within Platonic terms, the visual image is less removed from corrupt reality (and therefore is more debased) than the written word which is regarded as the medium of imagination and self-expression. Within its current definition, therefore, pornography is a category of visual representation and, more specifically, of photographic imagery.

Compared to painting or drawing, the photographic image is seen to be an unmediated representation, both in terms of its means of production and of its consumption. In the process of representation, the photograph is assumed to offer little interference with the truth of its subject. It is an automatized image; it seems to eliminate human agency and reflection, thus enabling direct access not simply to an image but to the represented object itself. If the object in question is the female body, then the photograph can be seen to afford the viewer direct access to that body, and sexual arousal with the minimum of interference from the medium itself. According to the same ideology, 'artistic' representation foregrounds its medium and its making, and this element of artistic intervention inhibits or blocks the immediate sexual gratification that is offered by the 'natural' realism of the photograph. Within contemporary culture, the pornographic effect is believed to be produced through the unmediated visibility of the photographic image.

Pornography exists on the margins of visibility. It circulates in terms of being both explicit and illicit; it is characterized both by a relentless display of sexual difference and the sexualized female body, and by its existence within the covert, hidden and disguised spaces of public and private culture.[27] In *Hard Core* Linda Williams convincingly argues that to trace the history of hard-core pornography is to chart the progressive attempt to uncover the visible truth of feminine pleasure.[28] In most pornographic narratives woman's body is examined and probed for its hidden secrets, according to a principle of maximum visibility. In a brilliant essay on the early history of pornography, Williams locates the pornographic drive for knowledge and its erotic economy of visibility in relation to Michel

Foucault's conceptualization of the science of sexuality. In *The History of Sexuality* Foucault describes two distinct ways of organizing the knowledge of sexuality: *ars erotica* and *scientia sexualis*.[29] The first category is characteristic of ancient and non-western cultures and describes the transmission of knowledge of the sexual, without any attempt to classify the nature of the knowledge itself. *Scientia sexualis* emerges in modern western societies and defines a form of hermeneutics that aims to discover and transmit the scientific truths of sexuality. *Scientia sexualis* is the site for the production of power and knowledge, revealing the truths of sexuality and pleasure that govern bodies and their desires. Foucault refers to the cluster of discursive sites in the nineteenth century – the medical, the psychiatric, the legal and the pornographic – that produced and circulated knowledge of the sexual. But to this analysis, Williams adds the technological: the optical inventions of the late nineteenth century such as magic lanterns, cameras and kinetoscopes, which could make visible the surveillance and investigatory power of *scientia sexualis*. So, rather than being a perverse development of erotic art, cinematic hard-core pornography emerges out of this moment when optical technology and the scientific quest for the truth of sexuality are brought together. Williams plots a prehistory of the subjection of the female body to the interrogation of the camera, citing as examples the photographic portraits of Charcot's hysteria patients and Muybridge's photographs of the human body in movement. In Muybridge's *Animal Locomotion* (1887), the female body is treated differently from the male body. In the sequences showing women in movement, the figure is located within particular narrative structures and placed in settings that involve props and gestures that tend to encode the body with a heightened sexuality. Set into motion by machines like the zoopraxiscope, the sequences brought the figures to life and offered their viewers the unprecedented pleasure of seeing the truth of the hidden mechanics of movement. But more than this, Muybridge's 'prehistoric cinema' also produced a new kind of body, one that was ideally visible – displayed for the viewer and yet apparently unaware of being watched. In Foucauldian terms, the new optical technologies perpetuated the production of knowledge, power and pleasure in relation to the body and sexuality. From this line of argument, pornography can be understood as the restructuring of sexuality into a visual form within the same drive for the truth of sexual difference. For Williams, the optimization of visibility is the characteristic that distinguishes hard-core and soft-core pornography. In contrast to the coy strategies of soft core, hard-core pornography obsessively seeks to show, deploying close-ups, lighting and poses to ensure maximum visibility. The history of hard-core pornography, according to Williams, is the history of visual strategies to overcome the anatomical invisibility of the female orgasm.

Linda Williams has identified the origins and meaning of the drive to

visibility in pornographic representation. In many ways, pornography can be seen to reenact continually the boundary dividing visibility and invisibility. In each repeated attempt to 'show' the truth of female sexuality, pornography inevitably reinstates the impossibility of this project. In its endless quest for clarity, objectivity and disclosure, it endlessly reinvokes that alternative, anxious sense of the female body as dark, mysterious and formless. As it seeks to render the female body knowable and possessable, so it calls up the frightening possibility that it is beyond knowledge or absolute possession.

This movement between the visible and invisible within the pornographic image is reduplicated in the social regulation of pornography. In terms of its modes of circulation and sites of consumption, pornography itself moves between the social conditions of visibility and invisibility. As the category of 'indecent' visual culture, pornography marks out the changing boundaries between the public (visibility, openness) and the private (invisibility, closure). If art represents the public and legitimate display of the female body, then pornography is its 'other', in which the display of the body is illicit and confined to the marginal spaces of public and private culture.

The modern concept of pornography can be seen as a product of new definitions of both the public and the private which emerged in the nineteenth century. As we have already seen, pornography is commonly held to be a phenomenon of mass culture, a consequence of new printing technologies and new forms of distribution and public display. Introducing his Obscene Publications Bill to the House of Lords in 1857, Lord Campbell compared the open sale of obscene books and prints to a deadly poison.[30] Campbell's legislation was intended to prevent the public exposure of obscenity; it was a measure dedicated to the interests of public hygiene and the cleaning up of public morals. Pornography was able to corrupt because of its public visibility; but its effects were twofold. They were felt both at the level of public social life and through the corruption of every individual who came into contact with the poisonous material.

But at the same time as historical changes were affecting the experience and perception of public life, so the private domain was also undergoing a significant reformulation. Increasingly, the private sphere was defined as the space of domestic, individual and personal values – the place where individual identity could be explored and expressed, away from the pressures, crowds and display of the public world. In his history of sexuality, Foucault argues that in the nineteenth century sexuality took its place as the key component of individual identity, that it became the key to individuality, the essential core of human character and behaviour. Within respectable ideologies, sex and sexuality were annexed to the private sphere; they belonged to the world of personal values and were to be hidden from the promiscuous specular regime of the public. Sex, from the

nineteenth century, is thus segregated and separated from other aspects of human behaviour and activity, and is located in particular and specified private spaces.[31]

As a regime of sexualized representation, pornography moves unpredictably between the public and the private, shifting the boundary between these two domains. Since the nineteenth century, the law has increasingly focused on the regulation of public decency and has ceased to be the guardian of private morality. This reduction in legislative control over personal conduct, combined with a more rigorous policing of the public domain, is enshrined in the Wolfenden Report (1959) which argued that the function of criminal law was to 'preserve public order and decency' and to protect the citizen from offence and exploitation.[32] The recommendations of the Wolfenden Report therefore amounted to a retreat from the legal regulation of private, individual behaviour. The general direction of Wolfenden was reiterated in the recommendations of the Williams Committee on pornography in 1979. The Williams Report advocated that an individual's behaviour should be interfered with as little as possible in private, but it recommended an intensification of controls relating to the public display of pornographic material. And yet, according to the Williams Committee, pornography represented a violation of the private sphere, even prior to its public display:

> Pornography crosses the line between the private and the public since it makes available in the form, for instance, of a photograph, some sexual act of a private kind and makes it available for a voyeuristic interest: since it is itself a public thing, a picture book or a film show, it represents already the projection into public of the private world – private, that is to say, to its participants – of sexual activity.[33]

The crime of pornography is thus the reintroduction of sex into the public sphere. Pornography makes sex visible; it takes what has become the most profound and private aspect of individual being and transforms it into a public commodity, exposed to the public gaze. For these reasons, pornography is located both at the centre and at the margins of contemporary society: at the centre, in that its drive to render visible, its function as spectacle, is characteristic of postmodern capitalism in general; but also at the margins, since it represents the illicit commodity within that specular economy.[34]

The regulation of obscenity takes the form of the regulation of the spaces and sites of cultural consumption. The pornographic oscillation between visibility and invisibility is reenacted in the social organization of its consumption. In order to understand how pornographic representation acquires its illicit status, it is helpful to compare its conditions of visibility to the conditions pertaining to legitimate culture; a case-study might usefully compare the viewing situation within an art gallery and that within

an adult bookstore. Within the gallery, the female body is displayed as a symbol of legitimate public culture; within the adult bookstore, its display becomes a sign of the covert and irregular aspects of cultural consumption.[35] Although these two spaces might seem to represent extremes of cultural distinction, they also share certain characteristics. Both are clearly bounded places that construct an environment that is set apart from other forms of social experience. They are havens, providing appropriate and safe conditions for the consumption of the objects that they house. But whereas in the art gallery the female body undergoes (in Bourdieu's term) a transubstantiation, in the adult bookstore the female body is displayed in terms of its corporeality and for its potential to move the body of the viewer. The legitimacy of viewing within the art gallery is symbolized by the viewer's distance from the displayed object, and viewing protocols within the gallery are organized in order to enhance contemplative viewing and to eliminate the possibilities of a physical response. The viewing habit within the adult bookstore is browsing, of proximity to the image without the danger of total merger. The bookstore also frequently provides hidden, enclosed spaces within its boundaries, arcades of rooms for the private viewing of videos and films, where the viewer's response to the image can be unseen by others.

The purpose of this brief comparison is to emphasize that the pornographic is a designation that is made not only in relation to the form and content of an image but also in terms of its modes and sites of consumption. Pornography sets the limits of the public (the visible) and the private (the hidden), but this boundary is continually changing in relation to new social, moral and political discourses and through the circulation of new technologies and media. Adult bookstores now rent video tapes as well as selling them, thus enabling the customer to view them within the supreme privacy of the home. At the same time, as Michael Stein has pointed out: 'the rented tape is not a permanent possession needed to be stashed after use, but something which can be returned to its "rightful place" in the dirty bookstore.'[36] On the one hand, the home-rented video seems to extend the encroachments of pornography into the private, domestic sphere; but on the other hand, the act of returning the tape to the bookstore shores up the boundary between the private and the public once again.

Official investigations of obscenity on television and in related technologies (VCR and cable) have focused on the threat of the erosion of the sanctity of the home.[37] In December 1985 an Obscene Publications Bill was introduced to the House of Commons, designed to deal with the more 'extreme' manifestations of obscenity and violence in broadcasting and to bring radio and television into the net of the 1959 Obscene Publications Act. The bill was ultimately defeated, but in its final form it included a special amendment introduced by the Labour MP Clare Short, to ban pictures in newspapers of naked or partially naked women in sexually

101

provocative poses.[38] Short's amendment was intended to shift the obscenity debate away from the notion of excess and extremity, towards the more everyday and apparently acceptable images of women published on page three of the *Sun* and in other national newspapers. The parliamentary debates on this bill reveal a struggle for the definition of obscenity. Short's amendment forced this struggle into the open, an effect that should not be undervalued. One of the central concerns was the particular threat of the representation of sex and violence on television. Amongst supporters of the bill, television was described as an invader from the public domain, disseminating an endless stream of potentially corrupting programmes; Tory MP David Mellor stated, 'Broadcasting has the power to deliver its message into the heart of a family in the intimacy of its own home.'[39] This, then, was the unique character of television; it was a Trojan horse, a friendly offering turned vicious, within the privacy of people's sitting-rooms. In order to protect privacy, the law would, paradoxically, have to control the nature of broadcasting and viewing in the home.

Although there was some agreement amongst Tory and Labour MPs that sex and violence on television could affect social behaviour, there was less consensus concerning the boundaries that separated these harmful images from others that were harmless and pleasurable. This was the issue at stake in Short's attack on page three 'pin-ups'. Short argued that these displays of women in daily newspapers influenced the sexual culture of society and affected men's attitudes towards women. Opponents of the bill challenged this view. 'Pin-ups' were defined as friendly and fun, possibly naughty but definitely nice, perhaps not to everyone's taste but certainly not depraved.

So it appears that whilst sexualized images of female bodies in newspapers could be defined as a harmless and pleasurable feature of modern British society, television presented a far more threatening and potentially corrupting influence. The debates over this bill highlighted, momentarily, the assumptions, values and interests from which cultural distinctions are drawn. The dissemination of television, cable and VCR technology has forced a re-examination of areas that have hitherto been outside the legal category of the obscene. Clare Short's amendment forced legislators to address the media on the margins of obscenity and to assess the category of the obscene as a whole. As a short-term political strategy, Short's move can be regarded as a reasonably effective one, but in the long-run, it is unlikely that banning page three could bring about any substantial social change. As this book has attempted to show, particular regimes of representation such as page three 'pin-ups' work in relation to and distinction from other representations of the female body within both legitimized and illicit forms of culture. Combating patriarchy in the media is a more complicated issue than hiving off all the female nudes and banning them.

The power attributed to television is undoubtedly partly a result of the power that is associated with visual technologies generally. This would suggest that the whole question of art, obscenity and sexuality will become even more complex in the future, with the development and proliferation of new optical technologies. Throughout the 1980s there has been a steady increase in pornographic computer software, digitized graphics that enable the operator to strip a full-colour, high-resolution female figure, with relevant sound accompaniment.[40] This kind of program already crops up on compact discs on office and home hardware. Bearing in mind the speed of advances within computer technology, programs may soon be able to offer 'Virtual Reality', with three-dimensional images and tactile interaction. In this kind of world, the precarious categories of private and public will be totally inadequate for comprehending the display and visibility of the female body. Our concept of representation will need to be reformulated in order to accommodate the new relations between image and viewer. But the potential of this kind of technology must surely not be missed by feminism. Recalling Linda Williams's caveat, what we must ensure is that women also decide what is exciting and pleasurable in relation to the new visual technologies.

5 EROTIC ART: A FRAME FOR DESIRE

In this final section of the book, the move is back to the boundary of high culture and the legitimization of sexual representation through the category of erotic art. As we have seen, art and pornography cannot be seen as isolated regimes of representation, but should be recognized as elements within a cultural continuum that distinguishes good and bad representations of the female body, allowable and forbidden forms of cultural consumption and that defines what can or cannot be seen. The erotic represents aestheticized sexual representation; it marks out the limits of the sexual within legitimate culture. 'Erotic art' is the term that defines the degree of sexuality that is permissible within the category of the aesthetic.

We saw in Part I that it is often at the very edge of categories where the work of definition takes place most energetically and where meaning is anchored most forcefully. For art, the female nude is both at the centre and at the margins. It is at the centre because within art historical discourse paintings of the female body are seen as the visual culmination of Renaissance and Enlightenment aesthetics, but this authority is nevertheless always under threat, for the female nude also stands at the edge of the art category, where it risks losing its respectability and spilling out and over into the pornographic. Since pornography may be defined as any visual representation that achieves a certain degree of sexual explicitness, art has to be protected from being engulfed by pornography, in order to maintain

its position as the opposing term to pornography. The erotic plays a critical role within this system; it is the borderline of respectability and non-respectability, between pure and impure desire.

The erotic is not a fixed or innate property of any given image, but is historically specific and open to competing definitions. Since the erotic describes the space of permissible sexual representation, there is a great deal at stake in where the boundaries of this category are placed. Philosophers, cultural critics and historians are drawn up in a constant battle for the differentiation of erotic art and pornography. Steven Marcus identifies the difference between literature and pornography as the distinction between complexity and simplicity.[41] Whereas literature is characterized by a multiplicity of intentions, pornography's sole concern is arousal. The structure of pornographic narrative is repetition and its language is literal and unmetaphoric. Whereas literature explores the richness of human relations, pornography describes the responses of human organs.

For Roger Scruton pornography and 'genuinely' erotic work are distinguished by their viewpoints. The pornographic point of view is voyeuristic; it is the perspective of the keyhole. The erotic work, on the other hand, 'is one which invites the reader to re-create in imagination the first-person point of view of someone party to an erotic encounter'.[42] Obscenity invites a depersonalized view, whereas eroticism involves a process of identification with the human relations depicted. Elsewhere in the same book Scruton offers a more basic distinction. Obscenity is the representation of sexual arousal through the depiction of 'the "interesting condition" of bodily parts, which bear witness to arousal' (p. 139). There is a degree of contradiction between the two accounts of viewing offered here. In the first definition erotic art is defined in terms of the empathetic identification of the viewer with the depicted sexual action. But according to the second definition the erect penis is a sign of active sexual arousal, which contravenes the static and contemplative viewing usually associated with the work of art.

Peter Webb's *The Erotic Arts* is probably one of the most exhaustive attempts to define the field of erotic art and to trace its history and various cultural manifestations. Once again, the result is uneven and idiosyncratic but it is worth examining in relation to its own cultural and sexual contexts. Webb's book was first published in 1975 and can be seen as a paradigm of the sexual libertarianism that emerged in the late 1960s and continued into the 1970s. For Webb, sexual freedom is synonymous with social freedom and sexual liberation is seen as the first step towards social revolution. The origin of these ideas is in the 1960s. In Britain there was a series of legislative reforms in the sphere of moral and sexual conduct. Stuart Hall has described the general tendency of British national legislation in the 1960s as the shift towards 'increased regulation coupled with selective privatisation through contract or consent'.[43] The Sexual Offences Act of

1967 changed the laws on male homosexuality, decriminalizing private sexual relations between adult males. In the same year, the Abortion Act extended the grounds for a lawful termination of pregnancy, and the Family Planning Act introduced wider provision of contraceptives by local authorities. Other legislation made divorce more accessible (1969) and introduced the defence of literary and artistic merit into obscenity trials (1959 and 1964). At the same time modification of cinema and theatre censorship allowed more explicit portrayals of sexuality in film and on the stage.

In 1968 the first international exhibition of erotic art was held in Sweden and Denmark. The resulting two-volume catalogue was distributed throughout Europe and the United States and propagated the organizers' message concerning erotic art:

> Erotic art expresses the demand for sexual freedom – a freedom vital to individual happiness and mental well-being. In that sense, erotic art carries a truly revolutionary message: it demands no less than extension of freedom, not only in the sexual area, but in every sphere of social life.[44]

The volumes were dedicated to 'the people of Sweden and Denmark', where radical legislative moves had eliminated censorship of obscene materials and had legalized all forms of pornography.

Beginning in the late 1960s, the notion of permissiveness began to take on a particular symbolic importance.[45] With signs of a breakdown in the old order, a growing sense of social crisis gave way, by the early 1970s, to a generalized moral panic – a moral backlash against the permissive legislation of the 1960s. On the Left, the women's movement and the gay liberation movement challenged the extent of the liberalism of the reforms, while on the Right, there was a revival of moral traditionalism, led, with evangelical fervour, by individuals such as Malcolm Muggeridge, Mary Whitehouse and Lord Longford. According to this new authoritarian morality, the 1960s legislation had been the final nail in the coffin of traditional values and Christian morality. Its leaders called for a return to family values and retrenchment behind the institutions of law and order. The focus for this moral panic was the issue of pornography. Obscene and blasphemous material was seen to be the source of social and moral decay. As Jeffrey Weeks has commented, pornography became for the moral crusaders of the 1970s what prostitution had been for the social puritans of the 1880s – a symbol of decay and social breakdown.[46]

The new moralism of the 1970s focused on the image and the word. In the early 1970s there was a cluster of prosecutions for obscenity; the National Viewers and Listeners Association organized a popular campaign against immorality in broadcasting; and in 1972 Lord Longford published his report on pornography. The most important point to be made about all

these tactics is that moral regulation in the 1970s took the form of the regulation of representations of sexuality as opposed to the regulation of sexual behaviour. Indeed, representation was at the centre of discourses on sexuality during the period.

In the context of this public debate, cultural distinctions became particularly significant, and the differentiation of erotic art and obscenity took on a heightened importance. The aesthetic had to distinguished from the titillating; art had to be sealed off from pornography. In the early 1970s there was a cluster of books on the subject of erotic art, produced by respectable 'art' publishers.[47] This is the context for the publication of Peter Webb's *The Erotic Arts* in 1975. Webb explicitly challenged the anti-pornography lobby and the obscenity trials of a few years earlier. He was also keen to isolate a category of good erotic art from that of pornography:

> Although some people may find a pornographic picture erotic, most people associate eroticism with love, rather than sex alone, and love has little or no part to play in pornography . . . Eroticism, therefore, has none of the pejorative associations of pornography; it concerns something vital to us, the passion of love. Erotic art is art on a sexual theme related specifically to emotions rather than merely actions, and sexual depictions which are justifiable on aesthetic grounds. The difference between eroticism and pornography is the difference between celebratory and masturbatory sex.[48]

In his attempt to distinguish erotic art and pornography, Webb relies on a familiar set of oppositions: aesthetic value versus bad art, emotion versus action and love versus sex. Again, as in the arguments of Steven Marcus and Roger Scruton discussed above, there is a juggling of aesthetic and moral criteria in order to justify one category of representations and to invalidate another. In all three cases love is lined up on the side of eroticism and pornography is dismissed as the base depiction of sex. Of course, what is missing in all these examples, and what therefore renders all three analyses redundant, is the question of power. The evocation of blanket terms such as 'love' and 'human relations' can, as we have seen, work to hide a range of cultural, sexual and moral norms in a hazy mist of universal consensus.

In 1990 an exhibition held in San Francisco and called *Drawing the Line* presented a radically different framework for understanding categories such as the erotic and the pornographic. The show was organized by a three-woman art collective called 'Kiss & Tell' and consisted of a suite of sexually explicit photographs.[49] The photographs depicted, and were taken by, the three members of the collective and were arranged on the wall according to their degree of sexual explicitness, running from depictions of everyday physical contact such as hugging to more extreme images of voyeurism and sado-masochism. Visitors to the exhibition were asked to

106

consider at what point they would draw the line between the erotic and the obscene, between acceptability and unacceptability, and were invited to write their responses to this question and their reactions to the images on the walls, alongside the photographs. Only women visitors were allowed to make this visible form of contribution; men were asked to give their responses in a separate 'comments' book.

This exhibition constitutes a brilliant intervention in discourses on sexuality and representation. By exposing viewers to a range of images and inviting them to judge and classify, the exhibition forced a recognition of the interests, values and intentions that are involved in the production of cultural distinctions. Together, the exhibits and visitors' contributions produced a discourse on female sexual desire, the visual image and codes of cultural acceptability. Whilst the diversity and strength of disagreement between the female viewers' responses could be seen as a disturbing indication of the extent of dissension amongst women, it also mapped out the multiplicity of positions taken up by women viewing lesbian sexual imagery. In an article on lesbian photography Jan Zita Grover analyses this range of responses in relation to a 'burden of scarcity' carried by lesbian imagery and lesbian sexual imagery, in particular. Within mainstream, patriarchal culture lesbians are either represented as sexual deviants, appropriated for male heterosexual fantasy, or rendered socially invisible. The lesbian sexual body remains a forbidden object outside of the stereotypes of patriarchy. Within this context, Grover suggests, the few images that explore lesbian desire and sexual practice carry a huge burden of expectations: 'So few representations, so many expectations: how can any image possibly satisfy the yearning that it is born into?'[50] This is the cultural experience that is partly enacted on the walls of the exhibition. It speaks of the struggle for ownership of categories such as the erotic and the pornographic and the right for representations of the female body to explore self-defined desires, rather than those desires that are projected on to the female body by male heterosexuality.

In Part II we saw that the representation of the female body is at the centre of feminist cultural politics and that women artists are using images of the female body in order to make visible a range of feminist identities. The fight for visibility on one's own terms is also the principle at stake in the production of lesbian sexual imagery. It is no coincidence that the title of the exhibition *Drawing the Lines* is a concept that has recurred throughout this book. For feminists to reclaim the female body means to challenge the authority of patriarchal boundaries – boundaries of gender and identity, between art and obscenity, the permissible and the forbidden. The issues that this feminist project of reclamation involves go to the heart of patriarchal culture and its founding principles. The aim of such a project should not be once and for all to draw the lines, to establish once and for all the absolute nature and value of different kinds of representation of the

female body, but instead to open up the constituency of those who are involved in drawing the lines and framing the definitions. It is an ongoing struggle, but the proliferation of media in the 1990s and the emergence of new producers of and audiences for images suggest not only that the struggle will be a complex one but also that there will be more spaces opening out for feminist voices to be heard and for feminist images to be seen.

NOTES

INTRODUCTION

1 I am thinking here of articles such as Wendy Leeks, 'Ingres Other-Wise', *The Oxford Art Journal*, 9:1 (1986): 29–37; Carol M. Armstrong, 'Edgar Degas and the Representation of the Female Body', in Susan Rubin Suleiman, ed., *The Female Body in Western Culture: Contemporary Perspectives* (Cambridge, Mass. and London: Harvard University Press, 1986): 223–42; and Eunice Lipton, 'Women, Pleasure and Painting', *Genders*, 7 (Spring 1990): 69–86.

PART I THEORIZING THE FEMALE NUDE

1 Kenneth Clark, *The Nude: A Study of Ideal Art* (London: John Murray, 1956): 79.
2 Mary Douglas, *Purity and Danger: An Analysis of Concepts of Pollution and Taboo* (London: Routledge & Kegan Paul, 1966): 121.
3 Jacques Derrida, *The Truth in Painting*, trans. by Geoff Bennington and Ian McLeod (Chicago and London: University of Chicago Press, 1987): 45.
4 Aristotle from *Metaphysics*, Book XIII, in Albert Hofstadter and Richard Kuhns, eds, *Philosophies of Art and Beauty: Selected Readings in Aesthetics from Plato to Heidegger* (New York: Random House, 1964): 96.
5 Sigmund Freud, 'The Ego and the Id', in *The Standard Edition of the Complete Psychological Works*, trans. and ed. James Strachey, vol. XIX (London: Hogarth Press, 1961): 26.
6 This painting is also illustrated by Marina Warner in *Monuments and Maidens: The Allegory of the Female Form* (London: Weidenfeld & Nicolson, 1985): fig. 69. Her chapter 'The Sieve of Tuccia' is an excellent account of the imagery of the female body as vessel or container.
7 For feminist responses to the book see Silvia Kolbowski, 'Covering Mapplethorpe's "Lady" ', *Art in America* (Summer 1983): 10–11, and Susan Butler, 'Revising Femininity? Review of *Lady*: Photographs of Lisa Lyon by Robert Mapplethorpe', first published in *Creative Camera*, September 1983, reprinted in Rosemary Betterton, ed., *Looking On: Images of Femininity in the Visual Arts and Media* (London and New York: Pandora, 1987): 120–6.
8 Samuel Wagstaff, 'Foreword', *Lady: Lisa Lyon by Robert Mapplethorpe* (New York: Viking, 1983; London: Blond & Briggs, 1983): 8.
9 Bruce Chatwin, 'An Eye and Some Body', *Lady: Lisa Lyon*: 9, 11.
10 Ibid.: 12.
11 These issues are discussed in Nicky Diamond, 'Thin Is the Feminist Issue', *Feminist Review*, 19 (Spring 1985): 45–64.

12 Michel Foucault, *The History of Sexuality. Volume 1: An Introduction*, trans. by Robert Hurley (Harmondsworth: Penguin, 1981).

13 Jane Fonda, as quoted in Diamond, 'Thin Is the Feminist Issue': 56.

14 For important discussions of anorexia nervosa see Sheila MacLeod, *The Art of Starvation* (London: Virago, 1981); Susie Orbach, *Hunger Strike: The Anorectic's Struggle as a Metaphor for Our Age* (London: Faber & Faber, 1986); Susan Bordo, 'Reading the Slender Body', in Mary Jacobus, Evelyn Fox Keller, Sally Shuttleworth, eds, *Body/Politics: Women and the Discourses of Science* (New York and London: Routledge, 1990): 83–112. In the following brief discussion I will not cover the question of anorexia nervosa as a form of protest or its clinical aspects but will concentrate on the issue of female body image.

15 There is, of course, John Berger's revision of Clark's arguments in *Ways of Seeing* (London and Harmondsworth: BBC and Penguin, 1972) which is discussed below.

16 For details of Clark's early influences such as Roger Fry, Bernard Berenson and Aby Warburg, as well as of his later career, see the two volumes of his autobiography *Another Part of the Wood* (London: John Murray, 1974) and *The Other Half: A Self-Portrait* (London: John Murray, 1977).

17 Clark, *The Nude*: 6.

18 For a definition of the Freudian concept of sublimation see J. Laplanche and J.-B. Pontalis, *The Language of Psychoanalysis*, trans. by Donald Nicholson-Smith (London: Hogarth, 1973): 431–3. Freud was drawing on the concept of sublimation within chemistry which describes the conversion of an object from a solid state to vapour.

19 The designation of the female nude simply as 'the nude' is now a cultural norm. Most mainstream books on the visual arts with the phrase 'the nude' in the title only discuss and illustrate images of the female nude. The supposedly neutral category of the nude now describes the female nude and it is more usual for a discussion of the male nude to have to be specified as such: cf. Margaret Walters, *The Nude Male* (New York and London: Paddington Press, 1978).

20 Clark, *The Nude*: 1.

21 Berger, *Ways of Seeing*: 54.

22 See T.J. Clark, 'Preliminaries to a Possible Treatment of *Olympia* in 1865', *Screen*, 21:1 (Spring 1980): 18–41. The argument is elaborated in *The Painting of Modern Life: Paris in the Art of Manet and his Followers* (London: Thames & Hudson, 1985): 79–146.

23 T.J. Clark, *Painting of Modern Life*: 131.

24 Clark, *The Nude*: 34, 37.

25 Klaus Theweleit, *Male Fantasies. II. Male Bodies: Psychoanalyzing the White Terror*, introductory essay by Jessica Benjamin and Anson Rabinach, trans. by Chris Turner and Erica Carter in collaboration with Stephen Conway (Oxford: Polity Press, 1989).

26 The two Venuses are discussed in Plato's *Symposium*; see Erwin Panofsky, *Studies in Iconology: Humanistic Themes in the Art of the Renaissance* (Oxford: Oxford University Press, 1939): 142–3. For an excellent study of the renegotiation of the two Venuses in eighteenth-century aesthetics see John Barrell, ' "The Dangerous Goddess": Masculinity, Prestige, and the Aesthetic in Early Eighteenth-Century Britain', *Cultural Critique*, 12 (Spring 1989): 101–31.

27 For a definition of the sublime in terms of awe and fear see Edmund Burke, *A Philosophical Enquiry into the Origin of Our Ideas of the Sublime and Beautiful* (1757), ed. J.T. Boulton (London: Routledge & Kegan Paul, 1958) esp. Part II,

'Section 1. 'Of the Passion Caused by the Sublime' and Section II. 'Terror'.

28 *The Ideology of the Aesthetic* (Oxford: Basil Blackwell, 1990): 13.

29 The following discussion of Descartes is highly abbreviated but for a fuller consideration of the implications of Cartesian thought from a feminist viewpoint see Susan Bordo 'The Cartesian Masculinization of Thought', *Signs*, 11:3 (Spring 1986): 439–56.

30 On the gendering of binary oppositions in the *Meditations* see Jacquelyn N. Zita, 'Transsexualized Origins: Reflections on Descartes's *Meditations*', *Genders*, 5 (Summer 1989): 86–105. See also Alice Jardine, *Gynesis: Configurations of Woman and Modernity* (Ithaca and London: Cornell University Press, 1985): 72–4.

31 On the 'masculinization' of science see Evelyn Fox Keller, 'Feminism and Science', *Signs*, 7:3 (Spring 1982): 589–602 and also by Keller, *Reflections on Gender and Science* (New Haven and London: Yale University Press, 1985).

32 For a helpful summary of Kant's *Critique of Aesthetic Judgement* see Roger Scruton, *Kant* (Oxford: Oxford University Press, 1982) on which the following discussion is based. For views on Kant's notion of the aesthetic see Salim Kemal, *Kant and Fine Art: An Essay on Kant and the Philosophy of Fine Art and Culture* (Oxford: Clarendon Press, 1986) and Eagleton, *The Ideology of the Aesthetic*: 70–101.

33 Immanuel Kant, *Critique of Aesthetic Judgement*, trans. by J.C. Meredith (Oxford: Clarendon Press, 1911): 90.

34 The aesthetic of the sublime and its reworking within postmodernist philosophy is considered by Dick Hebdige in his fascinating article 'The Impossible Object: Towards a Sociology of the Sublime', *New Formations*, 1 (Spring 1987): 47–76. For an excellent discussion of eighteenth-century notions of rhetoric, propriety and perspective as strategies to regulate the disruption threatened by the sublime see Peter de Bolla, *The Discourse of the Sublime: Readings in History, Aesthetics and the Subject* (Oxford: Basil Blackwell, 1989).

35 Peter de Bolla discusses the connections between this description of sublime experience and certain figurations of male sexual arousal and fulfilment in *Discourse of the Sublime*: 57.

36 Quoted in *Pornography: The Longford Report* (London: Coronet, 1972): 99–100. There is an interesting example of this distinction between art and pornography in James Joyce's *A Portrait of the Artist as a Young Man* (1916). The novel presents a dramatized version of Joyce's own early aesthetic. In one passage Stephen Dedalus discusses the function of art with Lynch, a fellow undergraduate. The discussion is provoked by the fact that Lynch has scrawled graffiti on the bottom of the *Venus* of Praxiteles. Lynch argues that his action was stimulated by desire, Stephen replies:

> The feelings excited by improper art are kinetic, desire or loathing. Desire urges us to possess, to go *to* something; loathing urges us to abandon, to go *from* something. The arts which excite them, pornographical or didactic, are therefore improper arts. The aesthetic emotion . . . is therefore static. The mind is arrested and raised above desire and loathing.
>
> (Harmondsworth: Penguin, 1960): 204–5.

37 Lacan's formulation of the relationship between the perception of tactile information and visual perception is discussed in Elizabeth Grosz, 'The Body of Signification', in J. Fletcher and A. Benjamin, eds, *Abjection, Melancholia and Love: The Work of Julia Kristeva* (London and New York: Routledge, 1990):

83–4.

38 Kant, *Critique of Aesthetic Judgement*: 91.

39 De Bolla, *Discourse of the Sublime*: 37.

40 Burke, *Philosophical Enquiry*: Part II, Section xvi: 116.

41 Immanuel Kant, *Observations on the Feeling of the Beautiful and Sublime* (1764), trans. by J.H. Goldthwait (Berkeley and Los Angeles: University of California Press, 1960): 76–7.

42 The work of Jean-François Lyotard is at the centre of the reformulation of the sublime in relation to theories of postmodernity. See in particular 'Presenting the Unpresentable: The Sublime', *Artforum*, 20:8 (1982): 64–9; 'Answering the Question: What is Postmodernism?', in *The Postmodern Condition: A Report on Knowledge*, trans. by Geoff Bennington and Brian Massumi (Manchester: Manchester University Press, 1984): 71–82; 'The Sublime and the Avant-Garde', *Artforum*, 22:8 (1984): 36–43; *The Differend: Phrases in Dispute*, trans. by George Van Den Abbeele (Manchester: Manchester University Press, 1988). Thanks to Steve Connor for informative and helpful discussions on the sublime and postmodernity.

43 'Answering the Question': 81.

44 See Meaghan Morris, 'Postmodernity and Lyotard's Sublime', in *The Pirate's Fiancée: Feminism, Reading, Postmodernism* (London: Verso, 1988): 213–39.

45 Patricia Yaeger, 'Toward a Female Sublime', in Linda Kauffmann, ed., *Gender and Theory: Dialogues on Feminist Criticism* (Oxford: Basil Blackwell, 1989): 192. See also the reponse to Yaeger's argument in the same collection: Lee Edelman, 'At Risk in the Sublime: The Politics of Gender and Theory': 213–24.

46 Luce Irigaray, 'When Our Lips Speak Together', trans. by Carolyn Burke, *Signs*, 6:1 (1980): 75.

47 Rita Felski, *Beyond Feminist Aesthetics: Feminist Literature and Social Change* (London: Hutchinson Radius, 1989): 5–6. The issue of feminist aesthetics will be considered in greater depth in Part II.

48 Douglas, *Purity and Danger*: 41–57.

49 Ibid.: 54.

50 Julia Kristeva, *Powers of Horror: An Essay on Abjection*, trans. by Leon S. Roudiez (New York and London: Columbia University Press, 1982). Kristeva's understanding of the body and, specifically, the significance of abjection is brilliantly summarized and analysed in Grosz, 'Body of Signification', on which the following discussion is based.

51 Kristeva, *Powers of Horror*: 4.

52 Kristeva discusses the relationship between the abject and the sublime in *Powers of Horror*: 11–12.

53 Douglas, *Purity and Danger*: 121.

PART II REDRAWING THE LINES

1 The section heading is taken from the headline in *The Times*, 12 March 1914: 6.

2 Facsimile of Richardson's handwritten statement reprinted in Midge Mackenzie, ed., *Shoulder to Shoulder: A Documentary* (New York: Vintage Books, 1988): 261. Detailed reports of the 'Rokeby Venus' attack can be found in *The Times*, 11 March 1914: 8–10, 12 March 1914: 12; *Daily Sketch*, 11 March 1914: 1, 6; *Manchester Guardian*, 11 March 1914: 7, 9; *Daily Mirror*, 11 March 1914: 1, 4, 12 March 1914: 4; *Daily Telegraph*, 11 March 1914: 11–12, 14; *Evening Standard and St. James's Gazette*, 11 March 1914: 1–2, 12 March 1914: 3; *Evening News*, 11 March 1914: 5, 12 March 1914: 1, 5; *Daily Express*, 11 March

1914: 1, 6; *Daily Mail*, 11 March 1914: 7–8; and in *Votes for Women*, 13 March 1914: 366, 20 March 1914: 384; the *Suffragette*, 13 March 1914: 491.

3 This account of the attack and its aftermath is drawn from contemporary newspaper reports and from Richardson's own description of the incident given in her autobiography *Laugh a Defiance* (London: Weidenfeld & Nicolson, 1953): 165–70.

4 Richardson's attack is briefly and inconclusively discussed in David Freedberg, *Iconoclasts and their Motives* (Maarsen: Gary Schwartz, n.d. ?1985): 15–16.

5 In May 1914 five works by Giovanni and Gentile Bellini in the National Gallery were attacked by a militant suffragist, following which the Gallery was closed for three months; see Charles Holmes and C.H. Collins Baker, *The Making of the National Gallery, 1824–1924* (London: The National Gallery, 1924): 73, and National Gallery Minutes of Board Meetings, Friday 22 May 1914, 8: 188. I am grateful to Jacqui McCormish, archivist at the National Gallery, for her friendly assistance.

6 Quotations taken from *The Times*, 14 December 1905: 9, and 11 March 1914: 10.

7 On 11 March 1914 the front page of the *Daily Express* ran the headline 'The Nation's Venus', with a picture of the damaged painting.

8 Lisa Tickner, *The Spectacle of Women: Imagery of the Suffrage Campaign 1907–14* (London: Chatto & Windus, 1987): 135.

9 See the *Daily Telegraph*, 11 March 1914: 11; *The Times*, 11 March 1914: 10; *Daily Sketch*, 11 March 1914: 1.

10 Interview printed in the London *Star*, 22 February 1952. See National Gallery Archive, 'Dossier 2057–Velazquez'.

11 I am reminded here of a more recent construction of this sort, the jilted mistress played by Glenn Close in the film *Fatal Attraction* (Adrian Lyne, USA, 1987).

12 Tickner, *Spectacle of Women*: 204–5.

13 *Daily Mirror*, 11 March 1914: 4 and *The Times*, 11 March 1914: 9 respectively.

14 For a discussion of the vocabulary of male violence against women, formulated in the nineteenth century, see Judith Walkowitz, 'Jack the Ripper and the Myth of Male Violence', *Feminist Studies*, 8:3 (Fall 1982): 542–74; and Nicole Ward Jouve, *The Street Cleaner: The Yorkshire Ripper Case on Trial* (London and New York: Marion Boyars, 1986): 166–76.

15 For an assessment of the damage during a more recent cleaning see Helmut Ruhemann, *The Cleaning of Paintings: Problems and Potentialities* (London: Faber & Faber, 1968): 264, 293–300.

16 Rachel Bowlby, *Just Looking: Consumer Culture in Dreiser, Gissing and Zola* (London and New York: Methuen, 1985): 32–4.

17 Edward Snow, 'Theorizing the Male Gaze: Some Problems', *Representations*, 25 (Winter 1989): 30–41.

18 Filson Young, *Venus and Cupid: An Impression in Prose after Velazquez in Colour Done By Filson Young* (London: Elisina Grant Richards, 1906): n.p.

19 *Daily Telegraph*, 11 March 1914: 11.

20 On the Home Rule Bill and its subsequent amendments see Roy Foster, *Modern Ireland 1600–1972* (Harmondsworth: Penguin, 1989): 461–72.

21 Tom Phillips, 'Naked Rubbish', *Observer*, 6 August 1989: 37.

22 Neil Maclaren, *Velazquez: The Rokeby Venus in the National Gallery, London* (London: Percy Lund Humphries, 1943): 1.

23 Marcia Pointon has indicated the historical problems in describing the nude as an academic genre: see *Naked Authority: The Body in Western Painting 1830–1908* (Cambridge: Cambridge University Press, 1990): 12.

24 Raymond Williams, *Keywords: A Vocabulary of Culture and Society* (London: Croom Helm, 1976): 268–9; see also Eric Hobsbawm, 'Introduction: Inventing Traditions', in Eric Hobsbawm and Terence Ranger, eds, *The Invention of Tradition* (Cambridge: Cambridge University Press, 1983): 1–14.

25 Carol Duncan, 'Virility and Domination in Early Twentieth-Century Vanguard Painting', *Artforum*, 12 (December 1973): 30–9; revised version published in Norma Broude and Mary D. Garrard, eds, *Feminism and Art History: Questioning the Litany* (New York and London: Harper & Row, 1982): 293–313 (quotation taken from Broude and Garrard: 297). For an extension of these arguments see also Duncan, 'The Esthetics of Power in Modern Erotic Art', *Heresies*, 1 (1977): 46–50.

26 Carol Duncan, 'The MoMA's Hot Mamas', *Art Journal*, 48:2 (Summer 1989): 171–8.

27 Douglas R. Graves, *Figure Painting in Oil* (New York: Watson Guptill, London: Pitman, 1979): 9.

28 For the classic account of academic training see Nikolaus Pevsner, *Academies of Art, Past and Present* (Cambridge: Cambridge University Press, 1940); for a more specific examination of the role of the life class see Ilaria Bignamini and Martin Postle, *The Artist's Model: Its Role in British Art from Lely to Etty* (University Art Gallery, Nottingham, 30 April–31 May 1991; The Iveagh Bequest, Kenwood, 19 June–31 August 1991), on which my own survey is based. Thanks also to Helen Valentine at the Royal Academy of Arts for information concerning the use of the female model in the RA Life School.

29 For an elaboration of these ideas on femininity see Lynda Nead, *Myths of Sexuality: Representations of Women in Victorian Britain* (Oxford: Basil Blackwell, 1988).

30 Pointon, *Naked Authority*: 54.

31 Georg Eisler, *From Naked to Nude: Life Drawing in the Twentieth Century* (London: Thames & Hudson, 1977): 5. And compare Roy Spencer, *Draw the Human Body* (London: Adam & Charles Black, n.d. ?1981): 18: 'Throughout this book, I have not distinguished between the male and female figure – using female models almost always because, for psychological reasons, there have always been more nude females than males in art.'

32 For a full account of the artist/model relationship see Frances Borzello, *The Artist's Model* (London: Junction Books, 1982).

33 Klaus Dunkelberg, *Drawing the Nude: The Body, Figures, Forms* (New York: Van Nostrand Reinhold Company, 1984): 106.

34 Joseph Sheppard, *Drawing the Female Figure* (New York: Watson Guptill; London: Pitman, 1975): 9.

35 Francesc Serra and J.M. Parramon, *Painting the Nude* (Kings Langley: Fountain Press, 1976): 91.

36 Janet Hobhouse, *The Bride Stripped Bare: The Artist and the Nude in the Twentieth Century* (London: Jonathan Cape, 1988): 9.

37 Statement by the photographer Lucien Clergue in Jain Kelly, ed., *Nude: Theory* (New York: Lustrum, 1979): 51–2.

38 Mervyn Levy, *The Artist and the Nude: An Anthology of Drawings* (London: Barrie & Rockliff, 1965): 27.

39 *To Deprave and Corrupt: Technical Reports of the United States Commission on Obscenity and Pornography*, edited and abridged by Alan Burns (London: Davis-Poynter, 1972): 26. See also Geoffrey Robertson, *Obscenity: An Account of Censorship Laws and their Enforcement in England and Wales* (London: Weidenfeld & Nicolson, 1979): 206. This issue of the connotations of visual

media in the classification of pornography will be discussed in greater detail in Part III.

40 Jacques Derrida, *Of Grammatology*, trans. by Gayatri Chakravorty Spivak (Baltimore and London: Johns Hopkins University Press, 1976): 141–64.

41 Graves, *Figure Painting in Oil*: 69.

42 Wendon Blake, *Figures in Oil* (New York: Watson Guptill; London: Pitman, 1980): 65.

43 Jan De Ruth, *Painting the Nude* (New York: Watson Guptill; London: Pitman, 1976): 122.

44 Many thanks to Roxane Permar for discussing with me her courses on 'The Nude and Sexual Politics', taught at St Martins School of Art 1985–7. Some of these issues concerning feminism, the life class and the artist–model relationship are explored by Angela Clarke, Françoise Dupre, Julia Gash and Roxane Permar in an exhibition entitled 'Watching You Watching Me', held at The Small Mansion Arts Centre, London, 5 November–4 December 1988.

45 Edward W. Said, 'Opponents, Audiences, Constituencies, and Community', in W.J.T. Mitchell, ed., *The Politics of Interpretation* (Chicago and London: University of Chicago Press, 1983): 7. I have also referred to *The World, the Text, and the Critic* (Cambridge, Mass.: Harvard University Press, 1983): esp. the section on 'Secular Criticism'.

46 In this vein see, for example, Michael Jacobs, *Nude Painting* (Oxford: Phaidon, 1979): 60, and Edward Lucie-Smith, *The Body: Images of the Nude* (London: Thames & Hudson, 1981): 72.

47 As cited in Hobhouse, *The Bride Stripped Bare*: 135. For an important discussion of the metaphor of penis-as-paintbrush see Carol Duncan 'The Esthetics of Power in Modern Erotic Art', *Heresies*, 1 (1977): 46–50, and on the metaphors of literary paternity see Sandra M. Gilbert and Susan Gubar, *The Madwoman in the Attic: The Woman Writer and the Nineteenth-Century Literary Imagination* (New Haven and London: Yale University Press, 1979): 3–7.

48 As quoted in Max Kozloff, 'The Authoritarian Personality in Modern Art', *Artforum* (May 1974): 46.

49 Jacques Derrida, *Spurs: Nietzsche's Styles*, trans. by Barbara Harlow (Chicago and London: University of Chicago Press, 1979): 37, 39. For its characterization of woman as the unknowable, unformed 'other', this essay has been justifiably criticized by some feminist philosophers. Although these objections cannot be examined in the present context see Margaret Whitford, *Luce Irigaray: Philosophy in the Feminine* (London and New York: Routledge, 1991): 129–31, and Gayatri Chakravorty Spivak, *In Other Worlds: Essays in Cultural Politics* (New York and London: Methuen, 1987): *passim*.

50 Eisler, *From Naked to Nude*: 9. See also Howard Munce, *Drawing the Nude* (London: Pitman; New York: Watson Guptill, 1980): 18.

51 Elizabeth Hollander, 'On the Pedestal: Notes on Being an Artist's Model', *Raritan*, VI (Summer 1986): 30.

52 Mary Kelly, 'Re-Viewing Modernist Criticism', *Screen*, 22:3 (1981): 44.

53 Quotations from Lawrence Gowing, *Matisse* (London: Thames & Hudson, 1979): 63; Jacobs, *Nude Painting*: 24; Malcolm Cormack, *The Nude in Western Art* (Oxford: Phaidon, 1976): 25.

54 William Feaver in the *Observer*, 25 March 1986: 25.

55 John Barrell, ' "The Dangerous Goddess": Masculinity, Prestige, and the Aesthetic in Early Eighteenth-Century Britain', *Cultural Critique*, 12 (Spring 1989): 101–31.

56 Kenneth Clark, *The Nude: A Study of Ideal Art* (London: John Murray, 1956): 139.

57 Said, *The World*: 53.

58 Berger, *Ways of Seeing*: 47; Rozsika Parker and Griselda Pollock, *Old Mistresses: Women, Art and Ideology* (London: Routledge & Kegan Paul, 1981): 116.

59 Griselda Pollock, 'Feminism and Modernism', in Rozsika Parker and Griselda Pollock, eds, *Framing Feminism: Art and the Women's Movement 1970–1985* (London and New York: Pandora, 1987): 93.

60 Rita Felski, *Beyond Feminist Aesthetics: Feminist Literature and Social Change* (London: Hutchinson Radius, 1989), 171.

61 Teresa de Lauretis, 'Aesthetics and Feminist Theory: Rethinking Women's Cinema', *New German Critique*, 34 (Winter 1985): 164.

62 Lisa Tickner, 'The Body Politic: Female Sexuality and Women Artists since 1970', *Art History*, 1:2 (June 1978): 236–51; reprinted, with related correspondence in Parker and Pollock, *Framing Feminism*: 263–77, and in Rosemary Betterton, ed., *Looking on: Images of Femininity in the Visual Arts and Media* (London and New York: Pandora, 1987): 235–53. For two further important and related texts on women's body art see Lucy Lippard, 'What Is Female Imagery?' (1975) and 'The Pains and Pleasures of Rebirth: European and American Women's Body Art' (1976), both reprinted in *From the Center: Feminist Essays on Women's Art* (New York: E.P. Dutton, 1976): 80–9 and 121–38 respectively.

63 Tickner, 'Body Politic', *Art History*: 239.

64 Michèle Barrett, 'Feminism and the Definition of Cultural Politics', in Rosalind Brunt and Caroline Rowan, eds, *Feminism, Culture and Politics* (London: Lawrence & Wishart, 1982): 45.

65 Quoted in Rozsika Parker, 'Censored', *Spare Rib*, 54 (January 1977): 44.

66 Laura Mulvey, 'A Phantasmagoria of the Female Body: The Work of Cindy Sherman', *New Left Review*, 188 (July/August 1991): 136–50.

67 Lippard, 'Pains and Pleasures', *From the Center*: 125.

68 From Carolee Schneemann, *Cézanne She Was a Great Painter* (1975), as quoted in Lippard, 'Pains and Pleasures', *From the Center*: 126.

69 For her account of *Interior Scroll* see Schneemann, *More than Meat Joy: Complete Performance Works and Selected Writings*, selected by Bruce MacPherson (New York: Documentext, 1979): 234–9. See also Henry M. Sayre, *The Object of Performance: The American Avant-Garde since 1970* (Chicago and London: University of Chicago Press, 1989): 90–2, 166–73.

70 These arguments are put by Sally Potter in 'Our Shows', Institute of Contemporary Arts, *About Time: Video, Performance and Installation by 21 Women Artists* (London: ICA, 1980): n.p.

71 Jeannie Forte, 'Women's Performance Art: Feminism and Postmodernism', *Theatre Journal*, 40:2 (May 1988): 217–35. For a critique of Forte's position see Steven Connor, *Postmodernist Culture: An Introduction to Theories of the Contemporary* (Oxford: Basil Blackwell, 1989): 145–6.

72 Catherine Elwes, 'Floating Femininity: A Look at Performance Art by Women', in Sarah Kent and Jacqueline Morreau, eds, *Women's Images of Men* (London: Pandora, 1990): 172.

73 Elinor Fuchs, 'Staging the Obscene Body', *The Drama Review*, 33:1 (Spring 1989): 33–58. For Georges Bataille's theories of erotic transgression see 'Sexual Plethora and Death', in *Eroticism* (San Francisco: City Lights Books, 1986): 94–108. This work and others by Bataille are discussed in Susan Suleiman,

'Pornography, Transgression, and the Avant-Garde: Bataille's "Story of the Eye" ', in Nancy K. Miller, ed., *The Poetics of Gender* (New York: Columbia University Press, 1986): 117–36. For further accounts of Finley's work see Cindy Carr, 'Unspeakable Practices, Unnatural Acts: The Taboo Art of Karen Finley', *The Village Voice* (24 June 1986): 17–20, 86, and Jill Dolan, 'The Dynamics of Desire: Sexuality and Gender in Pornography and Performance', *Theatre Journal*, 39:2 (May 1987): 161–3.

74 See, for example, the articles in the special edition on 'the body' of *Australian Feminist Studies*, 5 (Summer 1987). Elizabeth Grosz's contribution to this volume will be discussed in the following section.

75 Quotation from Cecil Grayson, ed., *Leon Battista Alberti: On Painting and On Sculpture* (London: Phaidon, 1972): 135.

76 Quotation from documentation accompanying Martha Gener's 'An interview with Martha Rosler', *Afterimage*, 9 (October 1981): 13.

77 Elizabeth Grosz, 'Corporeal Feminism', *Australian Feminist Studies*, 5 (Summer 1987): 1–16.

78 'Très vite je me suis aperçu que c'était le bloc du corps lui-même, c'est-à-dire le tronc et encore une partie des cuisses qui me fascinaient. Les mains, les bras, la tête, les jambes étaient sans importance. Le corps seul vit, tout-puissant et ne pense pas' (quoted in Pierre Restany, *Yves Klein* [Paris: Editions du Chêne, 1982]: 90). See also Centre Georges Pompidou, *Yves Klein* (Centre Georges Pompidou, Musée National d'Art Moderne, Paris, 3 March–23 May 1983): 351–7.

79 See Chila Kumari Burman, 'Mash It Up', *Spare Rib*, 128 (March 1983): 55–6, and Chila Kumari Burman and Bhajan Hunjan, 'Mash It Up', in Parker and Pollock, *Framing Feminism*: 326–7. Also Hiroko Hagiwara, 'Chila Kumari Burman', *Feminist Art News*, 3:1 (1989): 28–9.

80 For an elaboration of this see Rasheed Araeen, 'From Primitivism to Ethnic Arts', *Third Text*, 1 (Autumn 1987): 6–25 and Gilane Tawadros, 'Beyond the Boundary: The Work of Three Black Women Artists in Britain', *Third Text*, 8/9 (Autumn/Winter 1989): esp. 125–7.

81 Sander Gilman, *Difference and Pathology: Stereotypes of Sexuality, Race and Madness* (Ithaca and London: Cornell University Press, 1985): esp. 76–108, 109–30.

82 Claudette Johnson, 'Issues Surrounding the Representation of the Naked Body of a Woman', *Feminist Art News*, 3:8 (1991): 12.

83 Lesley Sanderson in the Cooper Gallery, *Along the Lines of Resistance: An Exhibition of Contemporary Feminist Art* (Cooper Gallery, Barnsley, 7 December 1988–22 January 1989): 32. For a discussion of the exhibition and Sanderson's painting see the interview with the organizers in 'Resistance, Continuity, Struggle', *Feminist Art News*, 2:9 (1988): 4–7.

84 Peter Gidal and Mary Kelly quoted by Janet Wolff in 'Reinstating Corporeality: Feminism and Body Politics', *Feminine Sentences: Essays on Women and Culture* (Cambridge: Polity Press, 1990): 120.

85 Laura Mulvey, 'Impending Time: Mary Kelly's *Corpus*', first published 1986, reprinted in *Visual and Other Pleasures* (London: Macmillan, 1989): 154.

86 See Micheline Mason and Richard Rieser, *Disability Equality in the Classroom: A Human Rights Issue* (London: ILEA, March 1990); Anne Karpf, *Doctoring the Media: The Reporting of Health and Medicine* (London: Routledge, 1988); Camerawork, *A Sense of Self*, with introduction and essays by Chris Davies and Liz Crow (Camerawork Gallery, London, 1 July–6 August 1988); Jo Campling, ed., *Images of Ourselves: Women with Disabilities Talking* (London: Routledge

& Kegan Paul, 1981). Thanks to Patricia Potts and Disability Arts in London for help and time with this material.

87 Mary Duffy, as quoted in Hilary Robinson, 'The Subtle Abyss: Sexuality and Body Image in Contemporary Feminist Art' (unpublished MA dissertation, Royal College of Art, 1987): 124. See also Mary Duffy, 'Cutting the Ties that Bind', *Feminist Art News*, 2:10 (1989), 6–7.

88 Mary Duffy, 'Redressing the Balance', *Feminist Art News*, 3:8 (1991): 15.

89 Peter Fuller, 'The Venus and "Internal Objects" ', in *Art and Psychoanalysis* (London: Writers and Readers, 1980): 71–129. See also Adrian Stokes, *Reflections on the Nude* (London: Tavistock, 1967).

90 See Rosalind Coward and Jo Spence, 'Body Talk?', in Patricia Holland, Jo Spence and Simon Watney, eds, *Photography/Politics: Two* (London: Commedia, 1986): 24–39; Jo Spence, *Putting Myself in the Picture: A Political, Personal and Photographic Autobiography* (London: Camden Press, 1986). For a discussion of Spence's work in relation to Mary Kelly and Cindy Sherman see Darcy Grimaldo Grigsby, 'Dilemmas of Visibility: Contemporary Women Artists' Representations of Female Bodies', *Michigan Quarterly Review*, XXIX: 4 (Fall 1990): 584–618. For a more detailed discussion of Spence's recent collaborative works see Lynda Nead, *Missing Persons/Damaged Lives* (Leeds City Art Galleries, 6 June–14 July 1991).

PART III CULTURAL DISTINCTIONS

1 Pierre Bourdieu, *Distinction: A Social Critique of the Judgement of Taste*, trans. by Richard Nice (London and New York: Routledge & Kegan Paul, 1984): 1.

2 Terry Eagleton, *The Ideology of the Aesthetic* (Oxford: Basil Blackwell, 1990): 65.

3 Bourdieu, *Distinction*: 6.

4 Historically, obscenity legislation has taken the criterion of stasis for its definition of an acceptable display of the naked female body. See Carolee Schneemann's comments on her 'kinetic theatre' piece of 1968: 'The law at this time stated that persons could appear on stage naked without moving – that is, if they became statues. Movement or physical contact between nude persons was criminal', *More than Meat Joy: Complete Performance Works and Selected Writings*, selected by Bruce MacPherson (New York: Documentext, 1979): 169.

5 Kenneth Clark, as quoted in *Pornography: The Longford Report* (London: Coronet, 1972): 99–100. (The quotation is given in full in Part I, Section 5.)

6 The following three examples are given in Nicholas Penny, 'Goddesses and Girls', *London Review of Books*, 2–29 December 1982: 20. The anecdote from Pliny is also used in Simon Wilson, 'Short History of Western Erotic Art', in Robert Melville, *Erotic Art of the West* (London: Weidenfeld & Nicolson, 1973): 16.

7 See A. Hofstadter and R. Kuhns, eds, *Philosophies of Art and Beauty: Selected Readings in Aesthetics from Plato to Heidegger* (New York: Random House, 1964), 3–138.

8 Steven Marcus, *The Other Victorians: A Study of Sexuality and Pornography in Mid-Nineteenth Century England* (London: Weidenfeld & Nicolson, 1966): 278. Part of this extract is quoted in *Pornography: The Longford Report*: 409.

9 *Hansard Parliamentary Debates*, 3rd series, vol. 146 (25 June 1857): col. 329.

10 The clearest history of British obscenity laws, including the 1868 ruling, is

given in Geoffrey Robertson, *Obscenity: An Account of Censorship Laws and their Enforcement in England and Wales* (London: Weidenfeld & Nicolson, 1979).

11 *Report of the Commission on Obscenity and Pornography, September 1970* (Washington DC: Government Printing Office, 1970).

12 *New York Times*, 25 October 1970: 71.

13 As quoted in C.H. Rolph, *The Trial of Lady Chatterley* (Harmondsworth: Penguin, 1961): 17; this book gives full details of the trial.

14 Walter Kendrick, *The Secret Museum: Pornography in Modern Culture* (New York: Viking, 1987): 11.

15 From M.L. Barré, *Herculanum et Pompéi, Receuil général des peintures, bronzes, mosaiques etc. découverts jusqu'à ce jour et reproduits d'après Le Antichita di Ercolano, Il Museo Borbonico et tous les ouvrages analogues*, 8 vols (Paris, 1875–77), as quoted in Kendrick, *The Secret Museum*: 15. Kendrick also refers to the establishment of the *Museum Secretum* and the 'Private Case' at the British Museum.

16 For a full discussion of nineteenth-century writing on prostitution see Nead, *Myths of Sexuality*: 97–107, 141–55.

17 For a clear demonstration of the importance of examining specific generic forms of pornography see Linda Williams's outstanding study *Hard Core: Power, Pleasure, and the 'Frenzy of the Visible'* (London, Sydney, Wellington: Pandora, 1990).

18 P.H. Karlen, 'What Is Art? A Sketch for a Legal Definition', *Law Quarterly Review*, 94 (July 1978): 393.

19 'Confidential Memorandum, Assistant Commissioner (Crime) to Commander C Division, 15 March 1970', as quoted in Robertson, *Obscenity*: 82.

20 See Robertson, *Obscenity*: 67–8.

21 For a discussion of Section 28 and its implictions for lesbian representation see Anna Marie Smith, 'Which One's the Pretender? Section 28 and Lesbian Representation', in Tessa Boffin and Jean Fraser, eds, *Stolen Glances: Lesbians Take Photographs* (London: Pandora, 1991): 128–39.

22 See Carole S. Vance, 'Misunderstanding Obscenity', *Art in America* (May 1990): 49–55 and other articles in this special issue on the Helms Amendment.

23 For contrasting views of the new pornography for women and couples see Williams, *Hard Core* and Andrew Ross, 'The Popularity of Pornography', in *No Respect: Intellectuals and Popular Culture* (London and New York: Routledge, 1989): 171–208.

24 Williams, *Hard Core*: 264. Williams is partly characterizing Ross's view of Femme Productions here.

25 *Report of the Committee on Obscenity and Film Censorship*, Chairman, Bernard Williams (London: Her Majesty's Stationery Office, 1979), Cmnd. 7772. For a summary of the report see A.W.B. Simpson, *Pornography and Politics: The Williams Committee in Retrospect* (London: Waterlow, 1983).

26 *The Attorney General's Commission on Pornography – the Meese Commission – Final Report* (Washington DC: US Government Printing Office, 1986): 1, 383. For a discussion of the relation of feminism to this report see Williams, *Hard Core*: 16–23.

27 See Rosalind Coward, 'Sexual Violence and Sexuality', *Feminist Review*, 11 (1982): 9–22.

28 See Williams, 'Prehistory: The "Frenzy of the Visible" ', *Hard Core*: 34–57. The main arguments of Williams's chapter are summarized in the following paragraph.

29 Foucault, *History of Sexuality*: 51–73.

30 For a detailed discussion of the passage of this legislation through Parliament see M.J.D. Roberts, 'Morals, Art, and the Law: The Passing of the Obscene Publications Act, 1857', *Victorian Studies*, 28 (Summer 1985): 609–29.

31 On the privatization of respectable sexuality see Foucault, *History of Sexuality*: 106–14.

32 For discussion of the Wolfenden Report see Jeffrey Weeks, *Sex, Politics and Society: The Regulation of Sexuality since 1800* (London and New York: Longman, 1981): 239–44.

33 *Report of the* [Williams] *Committee*: para. 7.6. For discussion of the Report in relation to its distinction between public and private see Beverley Brown, 'Private Faces in Public Places', *Ideology and Consciousness: Technologies of the Human Sciences*, 7 (Autumn 1980): 3–16.

34 For the excess of visibility that Baudrillard calls 'obscenity' see Jean Baudrillard, *The Ecstasy of Communication*, trans. by Bernard and Caroline Schutzer, ed. Sylvère Lotringer (New York: Semiotext(e), 1988): 11–27.

35 The models for this comparison are drawn from Donald Horne, *The Great Museum: The Re-Presentation of History* (London and Sydney: Pluto Press, 1984) and Michael Stein, *The Ethnography of an Adult Bookstore: Private Scenes, Public Places* (Lewiston, Queenston, Lampeter: Edwin Mellen, 1990).

36 Stein, *Ethnography*: 123.

37 *Report of the Committee on the Future of Broadcasting*, Chairman, Lord Annan (London: HMSO, 1977), Cmnd. 6753; esp. c. 16, para. 3.

38 Short's amendment was introduced in the form of an Indecent Displays Bill. For her account of this campaign and the correspondence that she received in relation to it, see Clare Short, *Dear Clare . . . This Is What Women Feel about Page 3*, letters edited and selected by Kiri Tunks and Diane Hutchinson (London: Hutchinson Radius, 1991).

39 *Hansard Parliamentary Debates*, 6th series, vol. 90 (24 January 1986): col. 609. For further debate of the bill see *Hansard Parliamentary Debates*, 6th series, vol. 93 (12 March 1986): cols 937–40.

40 For discussion of pornography and computer software see Ivor Benjamin, 'Dirty Macs', *City Limits*, 529 (21–28 November 1991): 10–12.

41 Marcus, *The Other Victorians*: 278–80.

42 Roger Scruton, *Sexual Desire: A Philosophical Investigation* (London: Weidenfeld & Nicolson, 1986): 139.

43 Stuart Hall, 'Reformism and the Legislation of Consent', in National Deviancy Conference, ed., *Permissiveness and Control: The Fate of the Sixties Legislation* (London: Macmillan, 1980): 18.

44 Phyllis and Eberhard Kronhausen, *Erotic Art: A Survey of Erotic Fact and Fancy in the Fine Arts*, 1 (New York: Grove Press, 1968): 8. See also Eberhard and Phyllis Kronhausen, *Pornography and the Law: The Psychology of Erotic Realism and Pornography* (New York: Ballantine Books, 1959).

45 For a contemporary discussion of permissiveness see John Selwyn Gummer, *The Permissive Society: Fact or Fantasy?* (London: Cassell, 1971).

46 Weeks, *Sex, Politics and Society*: 273–88, on which this discussion of 1970s moralism is based.

47 For example Edward Lucie-Smith, *Eroticism in Western Art* (London: Thames & Hudson, 1972) and Robert Melville, *Erotic Art of the West* (London: Weidenfeld & Nicolson, 1973).

48 Peter Webb, *The Erotic Arts* (London: Secker & Warburg, 1975): 2.

49 This account of the exhibition is based on that given in Jan Zita Grover, 'Framing the Questions: Positive Imaging and Scarcity in Lesbian Photographs', in Boffin and Fraser, eds, *Stolen Glances*: 184–90.
50 Ibid.: 187.

WORKS CITED

Adams, Parveen, 'Versions of the Body', *m/f*, 11–12 (1986): 27–34.

Allen, Judith and Grosz, Elizabeth, eds, *Australian Feminist Studies*, 5 (Summer 1987).

Araeen, Rasheed, 'From Primitivism to Ethnic Arts', *Third Text*, 1 (Autumn 1987): 6–25.

—— *The Other Story: Afro-Asian Artists in Post-War Britain*, Hayward Gallery, London, 29 November 1989–4 February 1990; Wolverhampton Art Gallery, 10 March–22 April 1990; Manchester City Art Gallery and Cornerhouse, 5 May–10 June 1990.

Armstrong, Carol M., 'Edgar Degas and the Representation of the Female Body', in Susan Rubin Suleiman, ed., *The Female Body in Western Culture: Contemporary Perspectives*, Cambridge, Mass. and London: Harvard University Press, 1986, pp. 223–42.

Barrell, John, ' "The Dangerous Goddess": Masculinity, Prestige, and the Aesthetic in Early Eighteenth-Century Britain', *Cultural Critique*, 12 (Spring 1989): 101–31.

Barrett, Michèle, 'Feminism and the Definition of Cultural Politics', in Rosalind Brunt and Caroline Rowan, eds, *Feminism, Culture and Politics* (London: Lawrence & Wishart, 1982), pp. 37–58.

Bataille, Georges, *Eroticism*, San Francisco: City Lights Books, 1986.

Benjamin, Ivor, 'Dirty Macs', *City Limits*, 529 (21–28 November 1991): 10–12.

Berger, John, *Ways of Seeing*, London and Harmondsworth: BBC and Penguin, 1972.

Betterton, Rosemary, ed., *Looking on: Images of Femininity in the Visual Arts and Media*, London and New York: Pandora, 1987.

Bignamini, Ilaria and Postle, Martin, *The Artist's Model: Its Role in British Art from Lely to Etty*, University Art Gallery, Nottingham, 30 April–31 May 1991; The Iveagh Bequest, Kenwood, 19 June–31 August 1991.

Blake, Wendon, *Figures in Oil*, New York: Watson Guptill; London: Pitman, 1980.

Boffin, Tessa and Fraser, Jean, eds, *Stolen Glances: Lesbians Take Photographs*, London: Pandora, 1991.

de Bolla, Peter, *The Discourse of the Sublime: Readings in History, Aesthetics and the Subject*, Oxford: Basil Blackwell, 1989.

Bordo, Susan, 'The Cartesian Masculinization of Thought', *Signs*, 11:3 (Spring 1986): 439–56.

—— *The Flight to Objectivity: Essays on Cartesianism and Culture*, Albany, NY: State University of New York Press, 1987.

—— 'Reading the Slender Body', in Mary Jacobus, Evelyn Fox Keller, Sally Shuttleworth, eds, *Body/Politics: Women and the Discourses of Science* (New York and London: Routledge, 1990), pp. 83–112.

Borzello, Frances, *The Artist's Model*, London: Junction Books, 1982.

Bourdieu, Pierre, *Distinction: A Social Critique of the Judgement of Taste*, trans. Richard Nice, London and New York: Routledge & Kegan Paul, 1984.

Bowlby, Rachel, *Just Looking: Consumer Culture in Dreiser, Gissing and Zola*, London and New York: Methuen, 1985.

Brown, Beverley, 'Private Faces in Public Places', *Ideology and Consciousness: Technologies of the Human Sciences*, 7 (Autumn 1980): 3–16.

Burke, Edmund, *A Philosophical Enquiry into the Origin of Our Ideas of the Sublime and Beautiful* (1757), ed. J.T. Boulton, London: Routledge & Kegan Paul, 1958.

Burman, Chila Kumari, 'Mash It Up', *Spare Rib*, 128 (March 1983): 55–6.

—— and Hunjan, Bhajan, 'Mash It Up', in Rozsika Parker and Griselda Pollock, eds, *Framing Feminism: Art and the Women's Movement 1970–1985* (London and New York: Pandora, 1987), pp. 326–7.

Busselle, Michael, *Nude and Glamour Photography*, London: Macdonald, 1981.

Butler, Susan, 'Revising Femininity? Review of *Lady*: Photographs of Lisa Lyon by Robert Mapplethorpe', in Rosemary Betterton, ed., *Looking On: Images of Femininity in the Visual Arts and Media* (London and New York: Pandora, 1987), pp. 120–6.

Camerawork, *A Sense of Self*, intro. and essays by Chris Davies and Liz Crow, Camerawork Gallery, London, 1 July–6 August 1988.

—— *Beyond the Boundaries (Disability, Sexuality and Personal Relationships)*, Camerawork Touring Exhibiton, no date.

Campling, Jo, ed., *Images of Ourselves: Women with Disabilities Talking*, London: Routledge & Kegan Paul, 1981.

Carr, Cindy, 'Unspeakable Practices, Unnatural Acts: The Taboo Art of Karen Finley', *The Village Voice* (24 June 1986): 17–20, 86.

Centre Georges Pompidou, *Yves Klein*, Musée National d'Art Moderne, Paris, 3 March–23 May 1983.

Cixous, Hélène, *The Newly Born Woman*, trans. Betsy Wing, Manchester: Manchester University Press, 1986.

Clark, Kenneth, *The Nude: A Study of Ideal Art*, London: John Murray, 1956.

—— *Another Part of the Wood*, London: John Murray, 1974.

—— *The Other Half: A Self-Portrait*, London: John Murray, 1977.

Clark, T.J., 'Preliminaries to a Possible Treatment of *Olympia* in 1865', *Screen*, 21:1 (1980): 18–41.

—— *The Painting of Modern Life: Paris in the Art of Manet and his Followers*, London: Thames & Hudson, 1985.

Clarke, Angela, Dupre, Françoise, Gash, Julia and Permar, Roxane, *"Watching You Watching Me": An Exhibition Exploring the Artist/Model Relationship and Re-Evaluating the Tradition of the Life Class*, The Small Mansion Arts Centre, London, 5 November–4 December 1988.

Commission on Obscenity and Film Censorship, *Report of the Committee on Obscenity and Film Censorship*, Chairman, Bernard Williams, London: Her Majesty's Stationery Office, 1979, Cmnd. 7772.

Commission on Obscenity and Pornography, *Report of the Commission on Obscenity and Pornography, September 1970*. Washington DC: Government Printing Office, 1970.

—— *To Deprave and Corrupt, Technical Reports of the United States Commission*

on Obscenity and Pornography, ed. and abridged Alan Burns, London: Davis-Poynter, 1972.

Committee on the Future of Broadcasting, *Report of the Committee on the Future of Broadcasting*, Chairman, Lord Annan, London: Her Majesty's Stationery Office, 1977, Cmnd. 6753.

Connor, Steven, *Postmodernist Culture: An Introduction to Theories of the Contemporary*, Oxford: Basil Blackwell, 1989.

Cooper Gallery, *Along the Lines of Resistance: An Exhibition of Contemporary Feminist Art*, Cooper Gallery, Barnsley, 7 December 1988–22 January 1989.

Cormack, Malcolm, *The Nude in Western Art*, Oxford: Phaidon, 1976.

Coward, Rosalind, 'Sexual Violence and Sexuality', *Feminist Review*, 11 (1982): 9–22.

Coward, Rosalind and Spence, Jo, 'Body Talk?', in Patricia Holland, Jo Spence and Simon Watney, eds, *Photography/Politics: Two* (London: Commedia, 1986), pp. 24–39.

Derrida, Jacques, *Of Grammatology*, trans. Gayatri Chakravorty Spivak, Baltimore and London: Johns Hopkins University Press, 1976.

—— *Spurs: Nietzsche's Styles*, trans. Barbara Harlow, Chicago and London: University of Chicago Press, 1979.

—— *The Truth in Painting*, trans. Geoff Bennington and Ian McLeod, Chicago and London: University of Chicago Press, 1987.

De Ruth, Jan, *Painting the Nude*, New York: Watson Guptill; London: Pitman, 1976.

Diamond, Nicky, 'Thin Is the Feminist Issue', *Feminist Review*, 19 (Spring 1985): 45–64.

Dolan, Jill, 'The Dynamics of Desire: Sexuality and Gender in Pornography and Performance', *Theatre Journal*, 39:2 (May 1987): 156–74.

Douglas, Mary, *Purity and Danger: An Analysis of Concepts of Pollution and Taboo*, London: Routledge & Kegan Paul, 1966.

Duffy, Mary, 'Cutting the Ties that Bind', *Feminist Art News*, 2:10 (1989): 6–7.

—— 'Redressing the Balance', *Feminist Art News*, 3:8 (1991): 15–18.

Duncan, Carol, 'The Esthetics of Power in Modern Erotic Art', *Heresies*, 1 (1977): 46–50.

—— 'Virility and Domination in Early Twentieth-Century Vanguard Painting', in N. Broude and M.D. Garrard, eds, *Feminism and Art History: Questioning the Litany* (New York and London: Harper & Row, 1982), pp. 293–313.

—— 'The MoMA's Hot Mamas', *Art Journal*, 48:2 (Summer 1989): 171–8.

Dunkelberg, Klaus, *Drawing the Nude: The Body, Figures, Forms*, New York: Van Nostrand Reinhold Company, 1984.

Eagleton, Terry, *The Ideology of the Aesthetic*, Oxford: Basil Blackwell, 1990.

Edelman, Lee, 'At Risk in the Sublime: The Politics of Gender and Theory', in Linda Kauffmann, ed., *Gender and Theory: Dialogues on Feminist Criticism* (Oxford: Basil Blackwell, 1989), pp. 213–24.

Eisler, Georg, *From Naked to Nude: Life Drawing in the Twentieth Century*, London: Thames & Hudson, 1977.

Elwes, Catherine, 'Floating Femininity: A Look at Performance Art by Women', in Sarah Kent and Jacqueline Morreau, eds, *Women's Images of Men* (London: Pandora, 1990), pp. 164–93.

Felski, Rita, *Beyond Feminist Aesthetics: Feminist Literature and Social Change*, London: Hutchinson Radius, 1989.

Feminist Art News, 'Resistance, Continuity, Struggle', *Feminist Art News*, 2:9

(1988): 4–7.

—— 'Disability Arts: The Real Missing Culture', *Feminist Art News*, 2:10 (1989).

Forte, Jeannie, 'Women's Performance Art: Feminism and Postmodernism', *Theatre Journal*, 40:2 (May 1988): 217–35.

Foster, Roy, *Modern Ireland 1600–1972*, Harmondsworth: Penguin, 1989.

Foucault, Michel, *The History of Sexuality. Volume 1: An Introduction*, trans. Robert Hurley, Harmondsworth: Penguin, 1981.

Freedberg, David, *Iconoclasts and their Motives*, Maarsen: Gary Schwartz, n.d., ?1985.

Freud, Sigmund, 'The Ego and the Id', *The Standard Edition of the Complete Psychological Works*, trans. and ed. James Strachey. vol. XIX (London: Hogarth Press, 1961), pp. 12–66.

Fuchs, Elinor, 'Staging the Obscene Body', *The Drama Review*, 33:1 (Spring 1989): 33–58.

Fuller, Peter, *Art and Psychoanalysis*, London: Writers and Readers, 1980.

Gener, Martha, 'An interview with Martha Rosler', *Afterimage*, 9 (October 1981): 10–17.

Gilbert, Sandra M. and Gubar, Susan, *The Madwoman in the Attic: The Woman Writer and the Nineteenth-Century Literary Imagination*, New Haven and London: Yale University Press, 1979.

Gilman, Sander, *Difference and Pathology: Stereotypes of Sexuality, Race and Madness*, Ithaca and London: Cornell University Press, 1985.

Gowing, Lawrence, *Matisse*, London: Thames & Hudson, 1979.

Graves, Douglas R., *Figure Painting in Oil*, New York: Watson Guptill; London: Pitman, 1979.

Grayson, Cecil, ed., *Leon Battista Alberti: On Painting and On Sculpture*, London: Phaidon, 1972.

Grigsby, Darcy Grimaldo, 'Dilemmas of Visibility: Contemporary Women Artists' Representations of Female Bodies', *Michigan Quarterly Review*, XXIX:4 (Fall 1990): 584–618.

Grosz, Elizabeth, 'Corporeal Feminism', *Australian Feminist Studies*, 5 (Summer 1987): 1–16.

—— 'The Body of Signification', in John Fletcher and Andrew Benjamin, eds, *Abjection, Melancholia and Love: The Work of Julia Kristeva* (London and New York: Routledge, 1990), pp. 80–103.

Grover, Jan Zita, 'Framing the Questions: Positive Imaging and Scarcity in Lesbian Photographs', in Tessa Boffin and Jean Fraser, eds, *Stolen Glances* (London: Pandora, 1991), pp. 184–90.

Gummer, John Selwyn, *The Permissive Society: Fact or Fantasy?*, London: Cassell, 1971.

Hagiwara, Hiroko, 'Chila Kumari Burman', *Feminist Art News*, 3:1 (1989): 28–9.

Hall, Stuart, 'Reformism and the Legislation of Consent', in National Deviancy Conference, ed., *Permissiveness and Control: The Fate of the Sixties Legislation* (London: Macmillan, 1980), pp. 1–43.

Hebdige, Dick, 'The Impossible Object: Towards a Sociology of the Sublime', *New Formations*, 1 (Spring 1987): 47–76.

Hobhouse, Janet, *The Bride Stripped Bare: The Artist and the Nude in the Twentieth Century*, London: Jonathan Cape, 1988.

Hobsbawm, Eric, 'Introduction: Inventing Traditions', in Eric Hobsbawm and Terence Ranger, eds, *The Invention of Tradition* (Cambridge: Cambridge University Press, 1983), pp. 1–14.

Hofstadter, Albert and Kuhns, Richard, eds, *Philosophies of Art and Beauty:*

Selected Readings in Aesthetics from Plato to Heidegger, New York: Random House, 1964.

Hollander, Elizabeth, 'On the Pedestal: Notes on Being an Artist's Model', *Raritan*, VI (Summer 1986): 26–37.

Holmes, Charles and Baker, C.H. Collins, *The Making of the National Gallery 1824–1924*, London: The National Gallery, 1924.

Horne, Donald, *The Great Museum: The Re-Presentation of History*, London and Sydney: Pluto Press, 1984.

Institute of Contemporary Arts, *Women's Images of Men*, Institute of Contemporary Arts, London, 4–26 October 1980.

—— *About Time: Video, Performance and Installation by 21 Women Artists*, Institute of Contemporary Arts, London, 30 October–9 November 1980.

Irigaray, Luce, 'When Our Lips Speak Together', trans. Carolyn Burke, *Signs*, 6:1 (1980): 69–79.

Jacobs, Michael, *Nude Painting*, Oxford: Phaidon, 1979.

Jardine, Alice, *Gynesis: Configurations of Woman and Modernity*, Ithaca and London: Cornell University Press, 1985.

Johnson, Claudette, 'Issues Surrounding the Representation of the Naked Body of a Woman', *Feminist Art News*, 3:8 (1991): 12–14.

Jouve, Nicole Ward, *The Street Cleaner: The Yorkshire Ripper Case on Trial*, London and New York: Marion Boyars, 1986.

Joyce, James, *A Portrait of the Artist as a Young Man*, Harmondsworth: Penguin, 1960.

Kant, Immanuel, *Critique of Aesthetic Judgement*, trans. James Creed Meredith, Oxford: Clarendon Press, 1911.

—— *Observations on the Feeling of the Beautiful and the Sublime*, trans. John H. Goldthwait, Berkeley and Los Angeles: University of California Press, 1960.

Karlen, P.H., 'What Is Art? A Sketch for a Legal Definition', *Law Quarterly Review*, 94 (July 1978): 383–407.

Karpf, Anne, *Doctoring the Media: The Reporting of Health and Medicine*, London: Routledge, 1988.

Keller, Evelyn Fox, 'Feminism and Science', *Signs*, 7:3 (Spring 1982): 589–602.

—— *Reflections on Gender and Science*, New Haven and London: Yale University Press, 1985.

Kelly, Jain, ed., *Nude: Theory*, New York: Lustrum, 1979.

Kelly, Mary, 'Re-Viewing Modernist Criticism', *Screen*, 22:3 (1981): 41–62.

Kemal, Salim, *Kant and Fine Art: An Essay on Kant and the Philosophy of Fine Art and Culture*, Oxford: Clarendon Press, 1986.

Kendrick, Walter, *The Secret Museum: Pornography in Modern Culture*, New York: Viking, 1987.

Kent, Sarah and Morreau, Jacqueline, eds, *Women's Images of Men*, London: Writers and Readers, 1985.

Kolbowski, Silvia, 'Covering Mapplethorpe's "Lady" ', *Art in America* (Summer 1983): 10–11.

Kozloff, Max, 'The Authoritarian Personality in Modern Art', *Artforum* (May 1974): 40–7.

Kristeva, Julia, *Powers of Horror: An Essay on Abjection*, trans. Leon S. Roudiez, New York and London: Columbia University Press, 1982.

Kronhausen, Eberhard and Kronhausen, Phyllis, *Pornography and the Law: The Psychology of Erotic Realism and Pornography*, New York: Ballantine Books, 1959.

Kronhausen, Phyllis and Kronhausen, Eberhard, *Erotic Art: A Survey of Erotic*

Fact and Fancy in the Fine Arts, 2 vols, New York: Grove Press, 1968.

Laplanche, J. and Pontalis, J.-B., *The Language of Psychoanalysis*, trans. Donald Nicholson-Smith, London: Hogarth, 1973.

de Lauretis, Teresa, 'Aesthetics and Feminist Theory: Rethinking Women's Cinema', *New German Critique*, 34 (Winter 1985): 154–75.

Leeks, Wendy, 'Ingres Other-Wise', *The Oxford Art Journal*, 9:1 (1986): 29–37.

Levy, Mervyn, *The Human Form in Art: The Appreciation and Practice of Figure Drawing and Painting*, London: Odhams Press, 1961.

—— *The Artist and the Nude: An Anthology of Drawings*, London: Barrie & Rockliff, 1965.

Lippard, Lucy, 'The Pains and Pleasures of Rebirth: European and American Women's Body Art', in *From the Center: Feminist Essays on Women's Art* (New York: E.P. Dutton, 1976), pp. 121–38.

—— 'What Is Female Imagery?', in *From the Center: Feminist Essays on Women's Art* (New York: E.P. Dutton, 1976), pp. 80–9.

Lipton, Eunice, 'Women, Pleasure and Painting', *Genders*, 7 (Spring 1990): 69–86.

Longford, Lord, *Pornography: The Longford Report*, London: Coronet, 1972.

Lucie-Smith, Edward, *Eroticism in Western Art*, London: Thames & Hudson, 1972.

—— *The Body: Images of the Nude*, London: Thames & Hudson, 1981.

Lyotard, Jean-François, 'Presenting the Unpresentable: The Sublime', *Artforum*, 20:8 (1982): 64–9.

—— 'Answering the Question: What Is Postmodernism?', in *The Postmodern Condition: A Report on Knowledge*, trans. Geoff Bennington and Brian Massumi (Manchester: Manchester University Press, 1984) pp. 71–82.

—— 'The Sublime and the Avant-Garde', *Artforum*, 22:8 (1984), 36–43.

—— *The Differend: Phrases in Dispute*, trans. George Van Den Abbeele, Manchester: Manchester University Press, 1988.

Mackenzie, Midge, ed., *Shoulder to Shoulder: A Documentary*, New York: Vintage Books, 1988.

Maclaren, Neil, *Velazquez: The Rokeby Venus in the National Gallery, London*, London: Percy Lund Humphries, 1943.

MacLeod, Sheila, *The Art of Starvation*, London: Virago, 1981.

Mapplethorpe, Robert, *Lady: Lisa Lyon by Robert Mapplethorpe*, text by Bruce Chatwin, New York: Viking; London: Blond & Briggs, 1983.

Marcus, Steven, *The Other Victorians: A Study of Sexuality and Pornography in Mid-Nineteenth Century England*, London: Weidenfeld & Nicolson, 1966.

Mason, Micheline and Rieser, Richard, *Disability Equality in the Classroom: A Human Rights Issue*, London: ILEA, March 1990.

Meese Commission, *The Attorney General's Commission on Pornography – the Meese Commission – Final Report*, Washington DC: US Government Printing Office, 1986.

Melville, Robert, *Erotic Art of the West*, London: Weidenfeld & Nicolson, 1973.

Meredith, J.C., *Kant's Critique of Aesthetic Judgement*, Oxford: Clarendon Press, 1911.

Monahan, Patricia, *How to Draw and Paint the Nude*, The Macdonald Academy of Art, London and Sydney: Macdonald, 1986.

Morris, Meaghan, *The Pirate's Fiancée: Feminism, Reading, Postmodernism*, London: Verso, 1988.

Mulvey, Laura, *Visual and Other Pleasures*, London: Macmillan, 1989.

—— 'A Phantasmagoria of the Female Body: The Work of Cindy Sherman', *New Left Review*, 188 (July–August 1991): 136–50.

Munce, Howard, *Drawing the Nude*, illustrations by Robert Fawcett, London: Pitman; New York: Watson Guptill, 1980.

Nead, Lynda, *Myths of Sexuality: Representations of Women in Victorian Britain*, Oxford: Basil Blackwell, 1988.

—— *Missing Persons/Damaged Lives. Jo Spence: Recent Collaborative Works*, Leeds City Art Galleries, 6 June–14 July 1991.

Orbach, Susie, *Hunger Strike: The Anorectic's Struggle as a Metaphor for Our Age*, London: Faber & Faber, 1986.

Panofsky, Erwin, *Studies in Iconology: Humanistic Themes in the Art of the Renaissance*, Oxford: Oxford University Press, 1939.

Parker, Rozsika, 'Censored', *Spare Rib*, 54 (January 1977): 43–5.

—— and Pollock, Griselda, eds, *Old Mistresses: Women, Art and Ideology*, Routledge & Kegan Paul, 1981.

—— *Framing Feminism: Art and the Women's Movement 1970–1985*, London and New York: Pandora, 1987.

Penny, Nicholas, 'Goddesses and Girls', *London Review of Books* (2–29 December 1982): 20–1.

Pevsner, Nikolaus, *Academies of Art, Past and Present*, Cambridge: Cambridge University Press, 1940.

Pointon, Marcia, *Naked Authority: The Body in Western Painting 1830–1908*, Cambridge: Cambridge University Press, 1990.

Restany, Pierre, *Yves Klein*, Paris: Éditions du Chêne, 1982.

Richardson, Mary R., *Laugh a Defiance*, London: Weidenfeld & Nicolson, 1953.

Roberts, M.J.D., 'Morals, Art, and the Law: The Passing of the Obscene Publications Act, 1857', *Victorian Studies*, 28 (Summer 1985): 609–29.

Robertson, Geoffrey, *Obscenity: An Account of Censorship Laws and their Enforcement in England and Wales*, London: Weidenfeld & Nicolson, 1979.

Robinson, Hilary, 'The Subtle Abyss: Sexuality and Body Image in Contemporary Feminist Art', unpublished MA diss., Royal College of Art, 1987.

Rolph, C.H., *The Trial of Lady Chatterley*, Harmondsworth: Penguin, 1961.

Root, Jane, *Pictures of Women: Sexuality*, London: Routledge & Kegan Paul, 1984.

Ross, Andrew, 'The Popularity of Pornography', in *No Respect: Intellectuals and Popular Culture* (London and New York: Routledge, 1989), pp. 171–208.

Ruhemann, Helmut, *The Cleaning of Paintings: Problems and Potentialities*, London: Faber & Faber, 1968.

Said, Edward, 'Opponents, Audiences, Constituencies and Community', in W.J.T. Mitchell, ed., *The Politics of Interpretation* (Chicago and London: University of Chicago Press, 1983), pp. 7–32.

—— *The World, the Text and the Critic*, Cambridge, Mass.: Harvard University Press, 1983.

Saunders, Gill, *The Nude: A New Perspective*, Victoria and Albert Museum, London, 24 May–3 September 1989.

Sayre, Henry M., *The Object of Performance: The American Avant-Garde since 1970*, Chicago and London: University of Chicago Press, 1989.

Schneemann, Carolee, *More than Meat Joy: Complete Performance Works and Selected Writings*, selected by Bruce MacPherson, New York: Documentext, 1979.

Scruton, Roger, *Kant*, Oxford: Oxford University Press, 1982.

—— *Sexual Desire: A Philosophical Investigation*, London: Weidenfeld & Nicolson, 1986.

Serra, Francesc and Parramon, J.M., *Painting the Nude*, Kings Langley: Fountain

Press, 1976.

Sheppard, Joseph, *Drawing the Female Figure*, New York: Watson Guptill; London: Pitman, 1975.

Short, Clare, *Dear Clare . . . This Is What Women Feel about Page 3*, letters ed. and selected Kiri Tunks and Diane Hutchinson, London: Hutchinson Radius, 1991.

Simpson, A.W.B., *Pornography and Politics: The Williams Committee in Retrospect*, London: Waterlow, 1983.

Smith, Anna Marie, 'Which One's the Pretender? Section 28 and Lesbian Representation', in Tessa Boffin and Jean Fraser, eds, *Stolen Glances: Lesbians Take Photographs*, London: Pandora, 1991, pp. 128–39.

Snow, Edward, 'Theorizing the Male Gaze: Some Problems', *Representations*, 25 (Winter 1989): 30–41.

Spence, Jo, *Putting Myself in the Picture: A Political, Personal and Photographic Autobiography*, London: Camden Press, 1986.

Spencer, Roy, *Draw the Human Body*, London: Adam & Charles Black, n.d. ?1981.

Spivak, Gayatri Chakravorty, *In Other Worlds: Essays in Cultural Politics*, New York and London: Methuen, 1987: *passim*.

Stein, Michael, *The Ethnography of an Adult Bookstore: Private Scenes, Public Places*, Lewiston, Queenston, Lampeter: Edwin Mellen Press, 1990.

St John Stevas, Norman, *Obscenity and the Law*, London: Secker & Warburg, 1956.

Stokes, Adrian, *Reflections on the Nude*, London: Tavistock, 1967.

Suleiman, Susan Rubin, 'Pornography, Transgression, and the Avant-Garde: Bataille's "Story of the Eye" ', in Nancy K. Miller, ed., *The Poetics of Gender* (New York: Columbia University Press, 1986), pp. 117–36.

—— ed. *The Female Body in Western Culture: Contemporary Perspectives*, Cambridge, Mass. and London: Harvard University Press, 1986.

Tawadros, Gilane, 'Beyond the Boundary: The Work of Three Black Women Artists in Britain', *Third Text*, 8/9 (Autumn/Winter 1989): 121–50.

Theweleit, Klaus, *Male Fantasies. II. Male Bodies: Psychoanalyzing the White Terror*, introductory essay by Jessica Benjamin and Anson Rabinach, trans. Chris Turner and Erica Carter in collaboration with Stephen Conway, Oxford: Polity Press, 1989.

Tickner, Lisa, 'The Body Politic: Female Sexuality and Women Artists since 1970', *Art History*, 1:2 (June 1978): 236–51.

—— *The Spectacle of Women: Imagery of the Suffrage Campaign 1907–14*, London: Chatto & Windus, 1987.

Vance, Carole, S. 'Misunderstanding Obscenity', *Art in America* (May 1990): 49–55.

Walkowitz, Judith, 'Jack the Ripper and the Myth of Male Violence', *Feminist Studies*, 8:3 (Fall 1982): 542–74.

Walters, Margaret, *The Nude Male*, New York and London: Paddington Press, 1978.

Warner, Marina, *Monuments and Maidens: The Allegory of the Female Form*, London: Weidenfeld & Nicolson, 1985.

Webb, Peter, *The Erotic Arts*, London: Secker & Warburg, 1975.

Weeks, Jeffrey, *Sex, Politics and Society: The Regulation of Sexuality since 1800*, London and New York: Longman, 1981.

Whitford, Margaret, *Luce Irigaray: Philosophy in the Feminine*, London and New York: Routledge, 1991: 129–31.

Williams, Linda, *Hard Core: Power, Pleasure, and the 'Frenzy of the Visible'*,

London, Sydney, Wellington: Pandora, 1990.

Williams, Raymond, *Keywords: A Vocabulary of Culture and Society*, London: Croom Helm, 1976.

Wilson, Simon, 'Short History of Western Erotic Art', in Robert Melville, *Erotic Art of the West* (London: Weidenfeld & Nicolson, 1973), pp. 11–31.

Wolff, Janet, *Feminine Sentences: Essays on Women and Culture*, Cambridge: Polity Press, 1990.

Yaeger, Patricia, 'Towards a Female Sublime', in Linda Kauffman, ed., *Gender and Theory: Dialogues on Feminist Criticism* (Oxford: Basil Blackwell, 1989), pp. 191–212.

Young, Filson, *Venus and Cupid: An Impression in Prose after Velazquez in Colour Done by Filson Young*, London: Elisina Grant Richards, 1906.

Zita, Jacquelyn N., 'Transsexualized Origins: Reflections on Descartes's *Meditations*', *Genders*, 5 (Summer 1989): 86–105.

INDEX